MUSTS, MAYBES, AND NEVERS

A BOOK ABOUT THE MOVIES

DAVID V. PICKER

ISBN: 1482649926
ISBN-13: 9781482649925
Library of Congress Control Number: 2013905659
CreateSpace Independent Publishing Platform,
North Charleston, South Carolina

*One day at lunch Billy Wilder said to me,
"There are only three kinds of movies -
musts, maybes, and nevers."*

That's what this book is about.

For my daughters, Caryn and Pam,
my grandson Asher, my sister, Jean,
and for my wife, Sandra, without whom
there would be no love, no book.

Author's Note

This book came to life for two reasons. One: for years I have enjoyed telling my family and friends stories of the unusual and rarified world of celebrity and art that I have been part of in my movie career. They continually asked when I was going to put it in writing. Two: I've been contacted more times than I can count by authors doing research for their own books, looking for quotes or background stories about movies I've made, studios I've run, or people with whom I've worked. I've been quoted, misquoted, inaccurately credited with a film's success or failure, and sometimes omitted entirely from projects where I was a major participant. I've long wanted to set the record straight. With this book, I hope I can accomplish both goals.

Here are the stories about the movies and the people who made them, from the executive floor to the soundstage, from a writer's unique idea to a director's brilliant execution, the failures and successes, all of them told because I was fortunate to be part of each one. Each chapter is a look behind the deals, the challenges on the set, the thrill of working with the best filmmakers in the world, the friendships made, and the friendships lost.

In telling these stories, I have to thank each person mentioned in every one of them, because without them there would be no story. I also want to thank my editor, Leslie Wells, whose insight and support were invaluable, and thanks to Janis Donnaud who brought us together.

I particularly want to mention a few (of the many) people who encouraged me to start this journey several years ago, answered

countless questions, provided moral support and, finally, told me to just write the damn thing: James Schamus, William Goldman, Peter Gethers, David Ives, and Jim Dodson. You have my deepest gratitude.

Along this road there have also been friends, colleagues, and family who have been full of suggestions, and always available to recall stories and names - contributions for which I'm grateful. Among them are my PGA colleagues Vance Van Petten, Hawk Koch, Mark Gordon, Jo-Ann West, and Mitzie Rothzeid, as well as Bob Gazzale at the American Film Institute, Sandra Archer at the Academy of Motion Picture Arts and Sciences Library, Freddie Gershon, David Chasman, Lee Pfeiffer, John Heyman, Peter Bart, Kate Lear, and Jon LaPook. People cheering loudly from the sidelines, and annoying all their friends with my stories, include Steve Dubrovsky, Anne Atchison-Dubrovsky at FisherMears Associates (who designed this book's website), Ellen and Stephen Tucker, Wendy Dodson, and Ilana and Tom Stewart. Family can be a great sounding board, and mine is the best - with thanks to Debra and Michael Kushma, Barbara Jetton, Suzanne and Doug Firstenberg, Sharon Jetton and Chris White.

Finally, I'd like to acknowledge the influence of some people who are no longer with us. My days at Dartmouth had a positive impact on me in many ways, and even today I think about conversations and discussions with my roommates Bob Callender, James West and Ed Rose as we planned our futures. And some very special teachers - Moses Bradstreet Perkins, George Frost, John Lynch, and Robert Frost - whose voices I still hear.

Preface

There is an utterly false narrative about American film culture of the past quarter century that claims that something called American Independent Cinema came into being in the late 1980s, alongside and perhaps because of the rise to prominence like the Sundance Film Festival and the cohort of upstart independent distributors and studio specialized divisions, whose scrappy low-budget films suddenly and shockingly came out of seemingly nowhere to start winning box office and Oscar gold. In the preface to some other yet-to-be-written book I'll explain how that self-serving and howlingly short-sighted myth has more to do with the economics of the then-nascent home video market than with the self-styled heroics of us "indies". In the meantime, you have in hand David Picker's utterly delightful and entertaining account of a life - in fact many lives - in a film business more "independent" than anything the likes of us working in the trenches today will ever know.

Take instruction from this volume, for it is no mere exercise in nostalgia. As Picker points out, movies exist at the intersection of capital and creativity, and as one of the most successful and inventive film executives and producers to have inhabited that intersection, he knows that the medium of exchange between those two seemingly irreconcilable categories is story. So this is, on the one hand, a business history, but it comes in the form of a kind of Thousand and One Nights of inspired and often hilarious narratives.

A remarkable facet of the career you are about to encounter is the seemingly incomprehensible jumble of movies both high

and low, mass and arthouse, that populate these pages without hierarchy or segmentation. Today, we cling to these distinctions as if they had some metaphysical essence - we mistake audience segmentation for aesthetic identity. For Picker, and for the film culture he helped facilitate and nurture, great movies are great movies, period - and great movies are of necessity made by great filmmakers. Sometimes, in the pages that follow here, those great filmmakers will come in the form of scheming producers, egotistical directors, manic actors, and calculating agents. But even at their most entertainingly appalling, Picker knows and loves them all as human beings. His love not only for the product but for the people shines through on every page.

So imagine yourself sharing a booth at the long-gone Vesuvio restaurant on 47th Street (OK, here's a tinge of nostalgia); the lunch dishes are being cleared and David Picker has ordered a round of martinis. It's time for the maître d' to bring over the house phone so you can call your office and cancel your afternoon appointments, for you're about to hear some wonderfully well-told tales, and to learn more than a thing or two about how genuine respect for the creative process can survive and, yes, even thrive in this most rough-and-tumble of businesses.

<div align="right">- James Schamus</div>

Contents

The Disasters

PEOPLE

The Good, The Bad and The Ugly (alphabetically, not definitively)

BIG BUSINESS AND THE MOVIES

PRODUCED BY

FINAL THOUGHTS

Introduction

"I was born a poor a black child."
- The opening line in "The Jerk"

In 2007, I was invited by the Wharton Graduate School of Education at the University of Pennsylvania to join the Jedi Conference, a diverse group of men and women brought together to talk about what our educational system would look like if we had the opportunity to start over from scratch. When I looked over the list of invitees, I wasn't sure why I was there. The roster included scientists of all sorts, a few media game makers, a children's museum director, one person from TV - and me from the movies.

Intrigued and perplexed, I decided to attend. At a dinner the night before the conference, I was convinced more than ever that I was surely a stranger in a strange land. Everyone was cordial, but there seemed to be very little we all had in common, and some of the chat between the more scientific types was way beyond my understanding. The next morning at 8 a.m. we sat around a large U-shaped table and were asked to say a few words about our backgrounds. I happened to be sitting next to Dr. Henry Kelly, whose low-key introduction of himself was beyond impressive. A Presidential Commission on this, a scientific commission on that, major awards - you name it, he had it and had done it. His persona was quiet and dignified, soft-spoken and direct.

When he finished it was my turn. I named a few of my studio jobs, United Artists, Paramount, a movie or two as producer, *Lenny* and *The Jerk,* and then turned it over to the person on my right. As I did, this scientific whiz sitting next to me leaned over and whispered in my ear *"I was born a poor black child."* Then he said with a smile, "I can quote the whole script." Suddenly, I knew why I was there.

Everyone talks about movies and everyone is a critic. I am constantly amazed when people refer to the impact an individual film has had on them. The power of film has never failed to fascinate, start and end trends, satirize, expose, investigate, entertain, make a difference, and reach across every strata, division, parameter, language, culture, and aspect of life in the civilized world. As my grandfather purportedly said, "Everyone has two businesses; their own and the movies."

Yet it's a business that very few people understand. It's a business that is fun, perplexing, glamourous, thrilling, honest, and dishonest. It has always capitalized on the creativity of its artisans, as well as the endless fascination of an insatiable public that really doesn't understand how the industry works. They talk about it, fantasize about it, blog about it, criticize it, are manipulated by it, and are teased by it. The very nature of the business itself is a combination of tough realities and utter creativity, all accessible to the public every day, in all media outlets.

This is the world I grew up in and have worked in for sixty years, through the golden years of the 60's and 70's, the not-so-golden years of the 80's and 90's, until today as I sit writing this. I've run companies, I've produced movies, I've seen all the changes; from a picture opening in only one theater, Radio City Music Hall, to a film opening on 4,000 screens at midnight; from only being able to see a movie in a theater, to watching one on an object in your pocket; from major studios supplying the product, to making your own film on your computer. I've seen it all.

Today there are new opportunities and excitement in the changing delivery systems, the constant accessibility to Twitter, Facebook, blogs, and YouTube. All that just expands an audience

that wants to know more, see more, and be turned on to the latest offering, whether it's in your neighborhood multiplex, on your laptop, or on your iPad. There's always an audience. That's why there has not been one day, even in the worst times, that I haven't known how lucky I have been to work in this world.

This is a book of stories about that world: the movies, the people who made them, how they got made, and about the hinge between capital and creativity. But it is also a book of fairytales, each and every one of which came true.

What Movie Did You See Today?

"I ran screaming from the
projection room."
- The Author

It all began in 1912 when my Russian-born grandfather went bankrupt in the clothing business. For reasons no one ever explained to me, he borrowed some money from his brother and opened a nickelodeon in the Bronx. He built a small chain of theaters, merging them with his friend Marcus Loews' company. A few years later they became part of the Loews chain. In 1926, he repaid his forgiven debt plus 50% interest to his creditors, and I have the thank-you letters and the news articles to prove it. He was an honorable man. He had four sons who all went into the film business, my dad being the oldest. My grandfather died in 1928. I was born in 1931, and was named after him.

In the late fall of 1937, I saw my first movie. My dad let me invite my schoolmates to my birthday party in the projection room of Loews Theaters on the eighteenth floor at 1540 Broadway. The movie was *Snow White and the Seven Dwarfs*. When the wicked queen came on the screen, I ran screaming from the projection room. It was more than four decades until I could finally sit through a scary movie without a twinge in the pit of my stomach.

My father's job at Loews Theaters in those years was chief buyer and booker for the New York chain, 64 theaters in all - four theaters

in Times Square, and in every borough of the city except Staten Island. I never knew why no Staten Island. Maybe he didn't want to take the ferry. He decided the pictures that would play, when and where they would play them, and what pictures would be the A picture and the B picture. In those days, all neighborhood theaters played double features. These were the details - *in order to do what he did, he had to see all the movies.* You got it: my dad made a living by seeing movies. How many kids growing up in the twentieth century had a father who saw movies for a living? At day's end when I heard his key turn in the lock to our apartment on the Upper West Side of New York City, I ran up with a hug and a question. "Dad, what movies did you see today?"

Kids today are computer literate by the time they're old enough to read and write, maybe sooner. Many of them use Final Cut software, aiming to be the next Spielberg or Lucas by the time they are ten. When I was young, I became more and more movie-literate every day of my life. Because I was Eugene Picker's son, I could go into any movie theater in New York without paying. I could even bring a friend if I wanted to. I drove around to the theaters with my dad when school schedules permitted. I sat and watched the movies as dad talked to the managers about the state of their theater. If it was a Loews theater, it had to be the best. I'd see ten minutes of a movie in one theater, then move on to the next and another ten minutes; not necessarily in continuity, but did I get to see movies!

As I got a little older, I would go to the Loews projection room with its muted mottled blue walls and watch the movies weeks, sometimes months, before they opened. I read every trade paper, two New York dailies, two New York weeklies, *Variety* and *The Hollywood Reporter* from Los Angeles; I knew every studio's pictures in prep, in pre-production, in production, and in post. I knew the name of every actor, actress, and director for every movie, and I knew the visual styles of MGM (the studio owned by Loews Theaters), and Paramount and Warner's and Fox and so on. I knew what pictures were going to play the Radio City Music Hall, the Roxy, the Capitol, the Paramount, the Strand, and all the Times Square and

New York neighborhood theaters. I knew it all, I absorbed it all, I loved it all, and my dad loved my loving it.

That's how it began, and it has never ended – not yet, thankfully. My dad's three brothers all went into the industry, two as producers and his youngest, Arnold, as an eventual partner in United Artists. My sister, Jean Picker Firstenberg, retired recently after 27 years of directing, growing, and guiding The American Film Institute into one of the premier film schools in the world.

It all seemed so natural. I was a New York kid, educated in New England for the most part, an avid sports fan, an avid reader, and most of all an aspiring movie maker. The conversation at home was about movies and sports. My family loved these worlds and loved each other unconditionally.

In my college years Dad insisted that I intern each summer in a different area of the business. So it was Universal's New York sales office the summer of 1950, the Capitol Theater as an assistant manager in 1951, and another in United Artists' publicity department. Wherever I worked, they knew I was Eugene Picker's son, but they also welcomed me because they knew that I knew something about the business. The summer of 1952, I interned at United Artists helping to set up some of the stunts we hoped would get covered with photographs in the New York newspapers. I tried to plant some publicity items with the lower-tier columnists, and one day I was assigned to take an actress, the ingénue lead in a film of ours that was about to open, to a photo session for *The Daily News* on the roof of the Beekman Place Hotel. I arrived promptly at an East 66th Street address to pick her up, dressed in my appropriately preppy jacket and tie of the day. She was very beautiful, very soft-spoken, and extremely polite. There wasn't an ounce of condescension in her manner. I was smitten immediately. From that day on I followed her career as if she was a close personal friend (I wish). The photo session went well, and when we returned to 66th Street, she thanked me with a very warm smile and a pat on the arm. I never saw her in person again. The movie was *High Noon*, and the actress was Grace Kelly.

That's how I grew up, and boy, I couldn't wait to get started full-time.

Graduating from Dartmouth College in 1953 and knowing I'd be drafted into the Army soon, I looked for a short-term job. Along came Herman Goldstein. Several movies that had been shot in 3D were being released by the majors, and Loews and RKO, the two big chains, needed somebody to deliver 3D glasses (red and green, just like today). By local law the glasses were to be picked up after each usage, returned to a warehouse in Long Island City to be sterilized, and then re-circulated to the theaters all over town – a challenging proposition, especially since Mr. Goldstein didn't know where all the theaters were. My dad suggested to him that I might be of help. I was 22 years old, and Mr. Goldstein paid me $250 a week (a fortune in those days) to organize the routes for the pickup and delivery of those flimsy, cardboard 3D glasses. You couldn't see *Bwana Devil* or *Fort Ti* without them, and truth be told, I'm not sure the sterilization technique that Mr. Goldstein used served any real protective function. But for three or four months at $250 a week, I got them routed out and back.

Then I served two years in Uncle Sam's U.S. Army (fortunately, it was between the Korean War and Vietnam). After basic training, I was assigned to the Signal School at Fort Monmouth, where I was taught photography and wound up with a military occupational specialty number 1845 – still photographer and photo lab technician. I was lucky once again when as a college graduate I was assigned to teach what I had just learned to officers and enlisted men who would be PR specialists around the world. My classroom was at the Army Information School at Fort Slocum, on an island just off New Rochelle, New York. While teaching at Fort Slocum, I was offered an opportunity to join a top-secret army group without a name if I would enlist for a third year of service, but I quickly passed. It was time for my future to begin.

Of course I had choices; I was Eugene Picker's son. Actually, my choice was clear to me. Theaters didn't fascinate me, but production and distribution did. The summer I spent at United Artists (and perhaps meeting Grace Kelly) was what turned me on. I liked the people; I liked being involved in the movies - how they got chosen for production, how they were marketed, what the people who made them were like. I'd been around it long

enough to know that this was the direction in which I wanted to go. Dad may have been disappointed, but he took it well. I think he knew that theaters were not my main interest, aside from what was on their screens. So I got a job at United Artists starting in January 1956, in the Advertising, Publicity Department (today called Marketing).

My first job was as the liaison between sales and marketing. It was an invented one, but it turned out to not only be useful for corporate reasons, but prepared me in ways that little else could have. I would sit in on marketing meetings as campaigns were readied to be shown for approval to the partner in charge, Max Youngstein. I sat in on sales meetings as they talked about the recommendations for the distribution pattern before they went to the partner responsible, Bill Heineman. I was the fly on the wall at the very core of UA pictures' future after delivery by the producers of the completed film. So I was in on the meetings as the eyes and ears of everybody involved. I saw the culture clashes between the various groups, and could feel the extremely diverse reactions to the films they had to work on together, and I drank it all in. It was also very clear to me that what the distribution team (that sold movies to theaters across the country) thought was salable was totally different from the marketing people. The distribution department liked what was easy to sell. Robert Mitchum in *Thunder Road* – that was good. Moonshiners, fast cars, good guys, bootleggers, bad guys - that was easy. Even today, that picture holds the record for the most playdates in UA history. Of course, in the 50's, pictures played in thousands of theaters and drive-ins, often coming back over and over again for flat fees anywhere from $100 down to $25 for a few days' showing. *Thunder Road* had played over 38,000 play dates just in my years at UA, and it's still a favorite DVD of the fast car crowd. That was the ideal for the sales department – easy to watch, easy to sell.

The marketing department was far more sophisticated. They had to try to persuade people to come see a movie that might not have been so easy to sell. It was at this time I began to realize that I would never ask a sales executive whether we should make a specific picture. In today's world, greenlight committees are made up

of executives of every division of the company's operations, from theatrical distribution in this country to international to DVDs to who knows what. It's not clear to me that their track record is any better now than it was then.

That's what I did, and it was an incredible education. I listened, I learned, and I was making $110 a week.

I would go to the theaters when one of our pictures opened to see how it played. I would get the weekend grosses as early as possible for the Monday morning staff meetings. The head of marketing was amazed I did that, since coming from the advertising world, he was only thinking about his next campaign. I explained that I did it because I wanted to see how our pictures were playing. What was the reaction of the public? What were they saying as they left the theater? Since I was just another face, I would pretend to be one of them and ask questions or make a comment to get a reaction. This amazed the man; he just didn't get it. When I asked him for a raise to $125 a month because my first daughter had arrived, he turned me down. "Too soon," he said. I didn't care.

Two years went by quickly. I made my presence felt to those with responsibility, and those to whom they were responsible. I got my first and second raise two years later. It was 1958 when Max Youngstein called me into his office and asked if I would like to be his assistant. I'd had no idea he had contemplated this, nor what direction my work at the company would take me, but I was thrilled. Being Max's assistant sounded too good to be true. And it changed my life.

I've never known anyone remotely like Max. I don't know if he had ever dealt with anyone else as he did with me, but quite simply, he opened his entire business and personal life to me without any hesitation. From the day I started working with him I became aware of all his ideas, his commitments (personal as well as business), and his likes and dislikes. He shared his entire world with his young assistant. I knew he wanted to teach me. I also knew it was a corporate guideline to create a chain of command in every department so that if someone left, there was someone ready to move in. Max, who had

never stayed at any company for very long, had already been a UA partner for seven years. Maybe he knew that he would pick a fight someday, wanted to have someone ready to move in, and elected me, his 27-year-old new assistant, to be the prime candidate. I didn't know that then, nor do I know it now.

Not long after I started working for Max in 1961, he said that I was to come with him to Los Angeles, my first business trip for the company. We were going to make a stop along the way. John Huston was directing *The Misfits*, based on a script by Arthur Miller, starring Clark Gable, Marilyn Monroe (Mrs. Miller), and Montgomery Clift. It was shooting on location in Nevada, and we were going to visit. Some first trip! We flew to Reno and then drove to Lake Tahoe to the Cal-Neva Lodge, one of the great resorts of its day. Max told me that instead of visiting the location, we'd be having dinner at the invitation of Frank Sinatra, who'd been appearing there and had invited all the principals - except Monty Clift who had slightly injured himself in that day's shooting and could not attend - to join us for dinner. Sinatra had made movies for UA so it was to be kind of a "family evening". Some family! In fact, he'd been a major part of UA, both producing and acting, going back to 1954. His acting credits for us included Otto Preminger's successful *The Man With the Golden Arm* and the ridiculous Stanley Kramer film *The Pride and the Passion*, which also had Cary Grant and Sophia Loren. His acting and producing credits included the 1954 thriller *Suddenly* (really worth seeing again) where he played a man attempting to assassinate the President of the United States. He also was in Frank Capra's *A Hole in the Head*, *Sergeants Three*, the western comedy rip-off of *Gunga Din*, and John Frankenheimer's *The Manchurian Candidate*. Max knew Frank well, and I was about to meet this amazing group of people on my first trip.

I was attending this dinner as an *assistant* to the key partner. These giants of celebrity had no interest or awareness of my existence on the planet; I simply came with Max. We went to the lounge where we met the Gables, the Millers and Mr. Huston. I was starstruck. Who wouldn't be? I'd been around the business; Eddie Cantor had been at my bar mitzvah, I'd met Milton Berle once, and of course, I'd

escorted Grace Kelly to a photo shoot. But this was the big time, a social event with transcendent Hollywood.

We had dinner. I said little, if anything. I chatted some with Arthur Miller since I was sitting next to him, but mostly I was listening, trying to keep my mouth shut and not get caught staring impolitely – or in any other way – at Mrs. Miller, who was stunning. Some actresses might be a disappointment when you see them in person, but that was *not* the case with Marilyn Monroe. The evening went by in a blur. Sinatra performed his set before an adoring crowd, and afterwards the group had a nightcap in the lounge. Part of our group prepared to leave because they had an early call. As they said their goodbyes, the strangest thing happened. It was the clearest image of the evening. The Gables, Millers, and Mr. Huston stood up and left the table shortly after Sinatra joined us from his dressing room. As they left the table, there was, using a movie term, a *dissolve*, where, without missing a beat, smoother than any dissolve you've ever seen in any film, their chairs were filled with another group of people. On either side of Sinatra, there appeared a beautiful woman, and the rest of the table was filled with FOF, friends of Frank. I looked at Max, who was already talking to the girl sitting next to him. I was at the end and had a well-dressed gentleman sitting at one side and air on the other. Sinatra nodded at the newcomers, then looking at someone hovering nearby, he snapped his fingers twice. Without missing a beat the "snapee" approached the "snapper", who whispered something in his ear. The "snapee" then whispered in someone else's ear nearby, and in a flash, two stacks of chips were put in front of Mr. S. Each chip had $100 on it. He pushed one stack to each of the girls sitting next to him and said the immortal line, "Go play, girls."

After chatting for an hour or so, Max and I left to go to our room with a final thanks to Frank for hosting such a special evening. We had touched base with our creative partners, and it was an evening to remember.

The next day we continued on to the Beverly Hills Hotel, the hangout for the movers and shakers of Hollywood royalty. Deals were made and broken at breakfast, lunch and dinner. Hearts were

broken, too, and so were marriages and affairs. Max always stayed in a bungalow, and this time, because he had his young assistant with him, it was a two-bedroom bungalow. Visiting royalty indeed.

Driving up the famous entrance to the most famous hotel in LaLaLand was a thrill. "Welcome back, Mr. Youngstein, and you too Mr. Picker." My god, *Mr. Picker* – no more David. At least not there.

We entered the stand-alone building that housed our suite. Max looked at both bedrooms and said to me, "Kiddie, I'll take the bigger one since you work for me, but let me show you something." He escorted me into the larger of the two bedrooms. The giant king-size bed had been turned down by the housekeeper the night before. "Watch this carefully," he said as he walked to where the pillows were laid on each other in perfect position. He took the top pillow and turned it halfway around so that it was no longer aligned perfectly. I had no idea what he was doing. "I took the bigger room because I'm your boss, but I'm doing this so that when the housekeeper comes in the morning, she'll have something to do." He never slept one night in our suite. It was the only part of Max's life that I wasn't invited to join.

During that time I was a witness to such historic events as an orange-throwing fight between him and John Wayne in the Duke's suite at the Palace Hotel in Madrid, Spain in 1958, where the great star was shooting what turned out to be a dreadful film, *Legend of the Lost.* Arriving at the hotel where I would join Max and Mr. Wayne for dinner, I pushed the door open and had to duck as an orange just missed my head by a few inches. It seemed that my boss and Mr. Wayne, having had a few drinks together earlier in the evening, were behaving like two unruly teenagers hurling oranges from a gift basket, ducking and hiding behind the furniture, and laughing hysterically. That's what being Max's assistant meant; being ready to duck at all times, as well as to listen, learn and laugh.

So it was that I met the Duke and Bob Hope and Burt Lancaster and Kirk Douglas and Billy Wilder and Harry Belafonte and Stanley Kubrick and Richard Brooks and Otto Preminger and Joe

Mankewicz and Dino De Laurentiis, and on and on....occasionally ducking, occasionally embarrassed, but always and ever enthralled by the world I had now entered.

In the fall of 1959, we scheduled a preview of our new Sidney Lumet film, *The Fugitive Kind*. It was based on Tennessee Williams' play *Orpheus Descending* and starred the great Anna Magnani, Marlon Brando, and Joanne Woodward. In those days, audiences who attended previews had no idea what picture they were about to see. The age of focus groups and predetermined audience configuration had not yet arrived. We chose one of my father's top East Side theaters, the beautiful Loews 72nd Street. Max was scheduled to attend, as well as my father, and naturally I would be there. The producers, Marty Jurow and Richard Shepherd, asked us not to invite anyone else since the film was not yet finalized. This showing would point out its strengths and weaknesses, from which they would make their final adjustments. At the last moment Max had to cancel, so that left me as the only UA executive at the screening.

There was an excited response from the audience when they saw that Marlon Brando was one of the stars of the movie. Unfortunately, that was the last positive thing that happened. The picture was a dud. A significant part of the audience left before it ended. As the lights came up, there we were; the producers, the director Sidney Lumet and Max Youngstein's young assistant staring at each other. There wasn't a lot to say. It was clear the film didn't work, and could never be made to work. My dad avoided me, figuring his son could deal with the moment. A very disappointed group of filmmakers left, and a very unhappy assistant would have to report the bad news the next day. It was an evening I hadn't anticipated, and one that would happen frequently in the years to come. With the best of intentions, and even with a talented filmmaker, it just doesn't always work.

I learned a lot from Max in those years. I learned how to talk to filmmakers, to agents, to talent, to lawyers, to managers and to other studio executives. I was tossed into the perfect storm of believing in talent, trusting my judgment, evaluating others' opinions, and

running a division of a company. This was about to become very important.

Max had been with the company as a partner since 1951, and ten years at one place was a lot for him He got antsy. And he felt the Mirisch Company, our single most important Los Angeles-based producing partner, was becoming too important to United Artists. We were on our way to making over 70 films with the Mirisch brothers over the coming years, and he felt they wielded too much power in our front office. He thought it was time to prove that he could run his own operation. So he picked a fight with his partners. It wasn't nasty – neither he nor they were built that way. I believe that he really felt that if he split from the company, many of the filmmakers would follow him to whatever new entity he created. I watched him get increasingly uncomfortable and then one day it happened. I was out of the city, and he called to say he and his partners had worked out a deal and he would be leaving the company. I knew it was coming, but in my heart I hoped it wouldn't. UA was such a special place, and this was like breaking up a family.

Max was larger than life. Of all the partners, he was the most gregarious, the most outspoken, the one who lived a complex, ego-driven lifestyle that in some ways was by far the most giving, but in other ways, the most self-deluding. Arthur, Bob, and Arnold were incredibly smart but had their egos under control. Max believed he was the special one, and his own way was more important than the company. In fact, it was the company who was more special than he. I learned an enormous amount from watching him in the months after he left the company. He truly believed that *his* creative relationships were so special that they would follow him in whatever endeavor he chose to establish. He would put together a new UA, and they would all join him. The problem was that he had no idea how to do it. Arthur and Bob had the legal and financial acumen to kick-start and nurse an exciting concept into a financially sound structure. Max only had the desire to do so, and when he wound up with only one production company prepared to go with him, he was devastated. The ironic allegiance of that company, owned by the actor Robert Mitchum, was that Reva Fredericks,

Mitchum's right hand, was soon to be Max's wife when his divorce was finalized. Willie Sutton said it best – banks get robbed because that's where the money is. UA had the money. Max couldn't raise any, and he never recovered from his decision to leave.

And I got his job. At thirty-one years old, I was made head of production and marketing at United Artists. I never forgot Max and what he went through after leaving the protection of the corporation. In one day, your phone call list shrinks from 100 to 5. Creativity and capital are joined at the hip in this land of make-believe.

United Artists (The Rebirth)

"One of these sons of bitches is redundant."
- Mike Todd referring to
Robert Benjamin and
Arthur Krim

Let me tell you how this all came about. In 1951 the company was about to disappear into an old film can when two young lawyers from the firm of Phillips Nizer Benjamin Krim and Ballon - Arthur Krim and Bob Benjamin - made a deal with UA owners Charlie Chaplin and Mary Pickford to acquire fifty percent of the company for $1.5 million. This offer included a proviso that if in several years the company turned profitable, they could buy the balance for another $1.5 million. The two lawyers had film experience, having represented companies and individuals in the business. They raised the money from friends, including an independent producer named Edward Small, and several banks. They were starting from scratch. The company had a library of old films, but nothing worth anything in production or development.

They did, however, have an original idea, and a simple one. It was that UA would finance every film as an *independent production.* On approval of budget, script, director and cast, the producing entity would have *total creative control and final cut of the film.* UA would fund the production costs, the prints and advertising, and distribute the films worldwide. Since UA did not have a studio, the

film could be shot wherever appropriate to the content and budget. UA would not screen dailies, and the producer would have no obligation to show the film to UA until final delivery. Only if the film went over-budget would UA have the right to step in and get involved creatively. *AND THAT WAS IT. THAT WAS ALL OF IT.* The basic deal with each project, in its simplest form, was that United Artists would collect a distribution fee worldwide, recoup its marketing and print costs, then recoup the cost of actually making the film, and thereafter any income would be split with the producing entity, usually on a 50/50 basis. Obviously there were hundreds of variations, but each deal came from this basic premise, and it was this premise that was totally alien to the established studio way of filmmaking. The studios owned everything, approved everything, had total control of final cut and content of the film, and often had the stars and directors under contract. They shot the films on their own lots, looked at and approved dailies, and so on. The great studios of the 30's, 40's and 50's were still flourishing, and the logos from the MGM lion to the Paramount mountain to the Fox searchlight to the Warner Bros. shield and the RKO radio tower were known all over the world. The concept of giving creative control to the filmmaker was beyond their comprehension.

Then along came UA. Arthur and Bob started slowly because they had to. They had brought in three other partners to run the day-to-day operations of the company. Bill Heineman ran domestic sales, and his contribution was totally limited to that area with no involvement in any other aspect of the company's operation. The other two partners were the key players: Arnold Picker, the number two man in Columbia's international division was brought over to run UA's foreign operation. Thirty-seven years old, educated at the City College of New York and the London School of Economics, he was in his time the most respected executive in foreign distribution. A creative businessman, he eventually took UA's foreign distribution to heretofore unreached industry levels. Arnold thought fast, talked fast, was innovative in his thinking, loyal to his friends, and along with his partners, totally true to his word. He demanded and

got from his department clear thinking and execution. He was also my uncle, my dad's youngest brother.

Max Youngstein had been head of marketing at Paramount, Fox, and Eagle Lion, a smallish distribution and production company tied to a British operation where he had gotten to know Krim and Benjamin. As a UA partner he was responsible for production and marketing. He and Arnold were almost the exact opposite. Arnold demanded performance, competence at the highest level and loyalty; Max demanded loyalty, fealty, obligation, and in return delivered jobs, goodies, more goodies and good times. Although they were very different, they laughed with each other and liked each other enormously. Arnold was tall, trim, neat, a devoted husband, sober and a cigar smoker; Max was tall, bald, paunchy and drank scotch. Let's leave it at that. Krim and Benjamin were law partners, friends for life and equally short; one a family man and the other a bachelor until his late forties. They also had enormous affection for each other. They couldn't have been more different in their styles, but they always found a way to agree. Mike Todd, whose film *Around the World in 80 Days* was partially financed and distributed by United Artists, once said of Benjamin and Krim, "One of these sons of bitches is redundant."

Bob was taller than Arthur, but not by much. He was a pipe smoker, a thinker, totally accessible to anyone at all times. He was sweet, a dear, a gift. He cared about his family, United Artists and the world. He gave his time to the United Nations and other causes in which he believed. If you needed a quiet moment to talk, you went to Bob. If you had a problem, you went to Bob. He always seemed to have the time; he surely did for me.

For Arthur Krim, there was little time for small talk. No matter the subject, when a few words were spoken, he was already ahead of you and onto the next topic. His mind was like a bear trap. Once something got into his head, it never got out. He was number one in his law class at Columbia, number one at conceiving deals that seemed unmakeable, number one in recognizing values invisible to others. He was the brains of the gang. He did, however, have some shortcomings. He had one grey suit – or five, I don't know,

but he looked the same every day. He shuffled when he walked, and he never paid any attention to his office. One fine day his beloved secretary Florence Abramson couldn't stand it anymore, and when he left for a trip she had the rug in his office replaced by one of the same color. She simply couldn't stand the worn-out patches anymore. She waited to see how long it would take before Arthur noticed the new rug after his return. The answer was two weeks.

Arthur, Bob, Arnold and Max did share some characteristics. They really, really liked, respected, and worked well with each other. They talked to each other constantly, usually at lunch at a restaurant called Vesuvio around the corner from their office at 729 Seventh Avenue. It was the UA commissary. There, decisions were made, stories were swapped, and life at UA was defined. I never dared to hope that one day I could become part of that.

This was how show business was done at UA. I've told this to various people over the years and they always look at me as if I'm from a different planet, but it is the absolute truth. UA made deals with producers to make films, agents to hire talent, banks to borrow money, foreign distributors when they didn't have their own distribution, paid profits to producers on successful pictures, repaid bank loans on films that had not recouped costs, and they did all of this – dealing with banks, talent, lawyers, agents - almost always without a signed piece of paper. Oh yes, pieces of paper did eventually get signed, but UA's word was its bond. People relied on it and that's how business was done. Within two years Arthur and Bob repaid Chaplin and Pickford the remaining 50%, and then they owned it all.

United Artists had a screening room on the executive floor on 729 Seventh Avenue, and every Tuesday night key executives were invited to watch other companies' films. Courtesies like these were exchanged quite often in the industry, and all the companies agreed to let the top executives screen films before their release. Occasionally Arthur Krim would come, but mostly it was Max Youngstein, Arnold Picker, and other executives including their wives. Every now and then Arthur would show up, and one

night we screened a film from one of our competitors that was truly appalling. It was clearly going to be a major financial disaster. When the lights came on at the end of the film, Arthur turned around to the rest of the group – there were probably 12 or 15 of us there – and he shared his opinion, "It could have been worse. It could have been ours."

My respect and admiration for what Krim, Benjamin and partners created has lasted to this day. That's not to say it was perfect. They never got around to creating a pension plan for their loyal, dedicated, as well as underpaid, group of employees – they said they were going to, but it just never happened. Nonetheless, those years were remarkable.

Tom Jones

"This picture is unreleasable in the U.K."
- Montague C. Morton,
Managing Director,
United Artists U.K.

I was 30 years old, the Vice President of United Artists in charge of marketing and production, as well as head of United Artists Records and Music Publishing Operations. I was making a salary equal to the partners, but had no ownership or stock in the company. The partners in the company paid themselves $52,000 a year, so they set that as the salary ceiling. Pretty smart, eh? Although expense accounts were very liberal, UA had by far the lowest salary structure in the business, but it was such a great place to work that people rarely left.

The ifs and whys of Arthur's and Bob's decision to pass Max's job on to me were never revealed, but it was clear that they were taking a real gamble. Their policy was to promote from within, and every department head understood this. But this was not a promotion from within to another step on the ladder; this was giving an opportunity to a young man to get to the top step from an assistant's perch, and to a young man who was the nephew of one of the owners of the company. The scale of the decision didn't have the impact on me then that it does now looking back. They took a giant chance that could have backfired. It could have easily

been described as nepotism (and maybe it was), and it could have put the company in a very bad media spotlight if it had gone awry. Fortunately media coverage then was far less focused on executives than today. Nonetheless, I had the new responsibilities, and I couldn't wait to plunge in.

I had just read a script from our London office, an adaptation of *Tom Jones*, the Henry Fielding novel, one of the greatest novels in English, and one of the earliest. The script by the playwright John Osborne was very stylized, but I got it. The director was Tony Richardson, a partner in a small production company called Woodfall which had made some brilliant films. Tony directed *The Loneliness of the Long Distance Runner*, *A Taste of Honey*, and *The Entertainer*, and he produced *Saturday Night and Sunday Morning* directed by Karel Reisz. *Tom Jones* was budgeted at $1.1 million, not a small amount in 1962, but its period background, its action and a large cast contributed to the cost. The British film company that had developed it had put an absolute ceiling of $1 million as their commitment, but Richardson was not prepared to make any compromises. He got permission to set it up elsewhere if he could, so it was sent to Bud Ornstein, head of our London production office, who sent it on to me.

I was excited about the project; it was the first recommendation I was prepared to make to my bosses. So I went to Arthur and Bob. They responded to my excitement and suggested I fly to London, meet with Richardson, and call them with my reaction. Meanwhile they would read the script. Flying to London as head of production, staying in a suite at the Dorchester Hotel, having a car and driver – it was heady stuff and it was overwhelming. (As an aside, the cost of the Dorchester suite on that trip was £24 a day. The last time I checked it was £2400 a day. Even given inflation over this time period, that's quite a rate hike!) The film community's restaurant of choice in those days in London was The White Elephant on Curzon Street, a few blocks' walking distance from the hotel. I arrived and met a very tall, very thin Tony Richardson and his agent Cecil Tennant. Educated at Oxford, Tony had directed in the theater, notably John Osborne's *Look*

Back in Anger. He, Osborne, and Oscar Lewenstein had formed Woodfall Films.

Tony's vision of the film was very clear. It was going to totally deviate in style from the traditional British costume film. I felt this was an attempt at breaking the rules, and I was very drawn to it. Tony was pleased in his rather haughty style. His background was upperclass and so was his accent, but his film style was just the opposite. I felt that the script's highly original approach to storytelling and Tony's clear talent as a director made this project a risk well worth taking, and I was prepared to fight for it as my first recommendation to my bosses. Little did I know that it was my passion for the project, not the project itself, that led them to give it the okay.

I knew that Tony and I would be comfortable working together. There was an urgency in making a decision because his hold on the cast had time limits, so a quick answer was necessary. I'd been trained by Max to respond quickly and I've always done so my entire career. Typically it's difficult for filmmakers to get any answers on a timely basis, but at United Artists, one of our most appreciated policies was respecting the need for this. I answered every phone call I received every day. I tended to make the calls short (and to this day I still do, often to the frustration of family and friends), but answers were given and appreciated.

Some years later I attended a dinner party at the home of Sue Mengers, the reigning diva of Hollywood agents. When I arrived, she took me aside, thanked me for coming, and asked if I was mad at her. "For what?" I said. "Well," she said, "every time we talk it lasts for 30 seconds or so." (Sue was famous for her long, chatty, caustic, gossipy conversations.) "Sue," I explained, "that's how I talk to everyone."

So I wanted to give Tony a fast answer. I asked to be excused to call New York. The maitre d' let me use the phone in the restaurant's office, and I called Arthur and Bob. I told him the meeting with Tony had gone well, I was very enthusiastic about the project, and wanted their okay to make the deal. I still didn't know whether they had read the script, and I didn't ask. Arthur's response was

positive. "Okay, make the deal, but make it a two-picture deal." Cross-collateralizing gave UA the protection that if one of the pictures was a failure, it could be recouped from the second film's success, and vice versa. I told them I would make it a condition.

I went back to the table with a smile on my face and I said we'd make a two-picture deal. I knew that they would happily accept that, and they did. *Tom Jones* was greenlit over dinner. It was my first deal at the company; the first film I had gone on the line for to my bosses. Tony was ecstatic. He now knew that he was going to make his film, and it seemed almost too easy in a business where "easy" is not the normal path.

The extraordinary aspect about this decision was that years later, my uncle Arnold told me that Arthur had indeed read the script and really didn't "get it". With all his intelligence, Arthur was not really a picture person; instead, he was more of a people person. The nuances of an offbeat project like *Tom Jones* were not really within his ken. He was an Otto Preminger person, or a Harold Mirisch person, or a Stanley Kramer person, and years after I left the company, a Woody Allen person. But what was remarkable about Arthur and Bob was that they agreed to go for *Tom Jones* because of my excitement. It was the first picture I pushed for, and they didn't want to discourage me. They had given me the chance and they would support my enthusiasm. That's what Arnold told me years later.

The second picture in the deal turned out to be a lovely small film called *The Girl with Green Eyes*, starring Rita Tushingham and Peter Finch.

Tony put together an extraordinary team to make *Tom Jones*. From John Osborne's script to Walter Lassally's camera, Tony Gibbs' editing and John Addison's score, it was a coming together of wonderful talents. It happens that way sometimes. So Tony went off to make his film. He was just somewhere in England making a film for United Artists. No dailies - the screening of the film's previous day's work - a practice that in today's digital world has been discontinued. Today you can see the work on a dvd as you shoot it, taking it to watch later if needed. In the era of *Tom Jones*,

the shooting day ended and the director, producer, and department heads would screen the previous day's work and comment on anything that needed adjusting or reshooting. But they had no obligation to send it to their financer or distributor, UA.

Production ended, and Arnold Picker set up a meeting with Tony Richardson in London to introduce himself as a partner at United Artists and head of distribution outside of the United States. Tony asked Arnold if he'd like to see a little scene from the film. He must have liked him, but I have no idea how or why he was motivated to make the offer. Of course Arnold accepted.

Peggy, my secretary, said to me, "Your uncle's on the phone from London."

"Hi, what's up?"

"Your friend Tony Richardson offered to show me a scene from his movie."

"Wow," I said, "he must have really liked you." I hadn't been there since it wrapped, and I hadn't seen a foot of it. "How was it?"

"Well, I've never seen a scene like it."

"What do you mean?"

"I mean, I've never seen a scene like it."

"What do you mean?"

"Well...I think it may be the sexiest, or most erotic moment I've ever seen. Albert Finney is talking to this woman, this actress (Joyce Redman), and they're feeding each other food. I've never seen anything like it."

"Okay, so you've never seen anything like it, but was it good?"

"I don't know, I've never seen anything like it."

That was all he would say.

The film had obviously caught Arnold's attention, and as it happened, he was in London when Tony said he was ready to show me a cut of the film. I asked Arnold to join us at the screening, and Arnold invited Montague C. Morton, the head of United Artists distribution in London. Monty was of the old school – stuffy, self-important and devoted mostly to his poodle. I never quite understood how he got the job, but Arnold said that Monty had the

personality needed to deal with the majority of British exhibitors, who were our customers.

The screening took place in our offices on Wardour Street in Soho – just the three of us and Tony with his editor, Tony Gibbs. The lights dimmed and 129 minutes later, the film ended. I was stunned by its originality, energy, fun, and eroticism. Arnold shook Tony's hand and we went back upstairs to talk, just Arnold, Monty and me.

"This picture is unreleasable in the United Kingdom," Monty said as we sat down in his office. All I could think was that this guy is a fucking idiot, and why did Arnold invite him, and what is he doing working for us? But actually I think it was that idiotic statement that crystallized in Arnold's head what we had to do to market this extraordinary, but at the same time extremely challenging, film. Monty's reaction was undoubtedly going to reflect the majority of the staid and stuffy British film community, particularly our biggest customer, the J. Arthur Rank theater chain. Named after one of the greatest names in British film production in the 30s, 40s and 50s, and owner and operator of the biggest and best theater chain in England, they were our No. 1 customer. There was no way you could maximize any film's box office potential without playing the Rank circuit. Arnold had established a wonderful relationship with them, which Monty had followed through on. And Monty was right. The Rank Organization probably would not give us one of their premiere West End movie palaces or a circuit booking for a film like *Tom Jones*.

When we were alone, Arnold told me what he was thinking of doing, and it was mind-blowing. He and I agreed that the picture was extraordinary, but that it would take a specially designed plan to maximize its potential. He suggested we start by opening the film in London – after all, it was a great English novel, an English film, an English cast headed by a hot, sexy English actor named Albert Finney. Arnold's surprising idea was to BUY a theater in the West End and open *Tom Jones* exclusively there. When it performed as well as he believed it would, Rank would then have to play it on its circuit. This idea would eliminate the initial problem with our

most important customer. It was brilliant. Arnold knew the theater that he wanted and believed he could get. Right smack in the middle of Piccadilly Circus was The Pavilion. You couldn't miss it; its giant billboard on top of the marquee was seen by everyone driving in London. So UA bought it. Arnold had one other idea he thought he could pull off – a royal premiere. The royal family occasionally lent themselves to events, usually for their favorite charities, and sure enough, they agreed.

It bloody well worked. The film opened in September 1963, and was a giant success.

When it came to the United States, we decided on a totally different plan. We leaked a story to *The Hollywood Reporter* saying UA had an unusual plan for releasing *Tom Jones* in the United States, believing it had a serious chance to win the Oscar for Best Picture of the Year.

In 1963, movies could play long runs at a single theater to build up word of mouth and keep marketing costs reasonable. In today's world of 2013, you can spend as much on marketing as on the film itself. How scary is that? But this was then. Word of mouth, buzz, must see – this was what we were hoping for. The plan: one theater in New York in October and one theater in Los Angeles in December, which would qualify it to be eligible for the Oscars. And when we won – and we were hoping we would – we would open the picture around the country as "Best Picture of the Year". How crazy and arrogant was that?

Tom Jones opened in New York on October 8, 1963. Bosley Crowther, the film critic for *The New York Times*, wrote the following: "Prepare yourself for what is surely one of the wildest, bawdiest and funniest comedies that a refreshingly agile filmmaker has ever brought to the screen." The other reviews were much the same.

The word was out. The picture was a hit. It was hard to see, and everybody wanted to see it. It worked in New York and it worked in Los Angeles, and it worked when it came time for the Oscars. This company that supported independent filmmakers had done very well. It had won an Oscar for *Marty*, the best picture in 1955; *Around the World in 80 Days* in 1956; *The Apartment* in 1960; *West Side*

Story in 1961; *Tom Jones* in 1963; and subsequently *In the Heat of the Night* in 1967; *Midnight Cowboy* in 1969; *One Flew Over the Cuckoo's Nest* in 1975; *Rocky* in 1976, and *Annie Hall* in 1977. Some run for a company that depended on brilliant independent filmmakers!

Tom Jones got ten nominations from the Academy. Best Picture; Best Director for Tony; Best Screenplay - John Osborne; Best Actor - Albert Finney; Best Supporting Actor - Hugh Griffith; three best Supporting Actresses - Dame Edith Evans, Diane Cilento, Joyce Redman; and Best Art Direction. On Oscar night in 1964, Tony Richardson was in the Far East investigating the background of a book he was considering for his next film. I couldn't believe he chose not to be there, but he asked me to accept the Best Picture award on his behalf if he won. I was speechless. Studio executives don't usually get more than a thank you every now and then. I've had my share, and I'm always touched that someone remembers. But being asked to accept? I'm not so sure that it happens much. In fact, it did happen and after 1963, the Academy decided that only the winners could accept the actual award. I hope I didn't contribute to that decision, but there I was on Oscar night, in my aisle seat on the third row, in a state of total...what? A cocktail made up of excitement, anticipation, nervousness, anxiety and exultation. My belief in the film had carried us this far. Could it actually happen that this daring, arrogant, but nonetheless formidable film could go all the way?

When the awards were announced, none of the actors nominated won, but John Addison won for music; John Osborne won for screenplay; and Tony did for directing. Most often, if those two categories win, so does the film itself, but strange things happen at the Oscars. So when Frank Sinatra and Jack Lemmon came out to announce Best Picture, my heart was pounding. They said, "The Academy Award for Best Picture for 1963 goes to *Tom Jones*," and the next thing I knew I was up on the stage overlooking the vast tuxedoed audience with Tony Richardson's Oscar in my hands. I spoke for less than 30 seconds, saying that my heart was in my throat but I wanted to thank the Academy on behalf of Tony. Then I went back to my seat still clutching the gold statue. I remember

little else, but as I write this, my heart is again where it was when I heard the words announcing that it had won.

United Artists was so special because it had a soft spot, a reflection of an attitude that was part of the philosophy Arthur and Bob created. The easy way to describe it was "loyalty". From its inception in 1951, the company always gave back to the filmmakers that had contributed to its existence or successes in ways that often far outdid the initial raison d'être for loyalties. UA did that knowingly, and it was almost a given of how we operated. Whether it was Edward Small who financed the acquisition of the company from Chaplin and Pickford, or Otto Preminger or Stanley Kramer who made early successes, or Tony Richardson or the Mirisch Company, we often were prepared to subjugate our concerns or instincts about certain individual projects because of the contribution of these filmmakers made to the company's success. Eddie Small made dozens of movies, mostly low-budget programmers with an occasional high-profile film thrown in such as Billy Wilder's 1957 version of *Witness for the Prosecution,* among other classics like *The Wicked Dream of Paula Schultz, Captain Kidd and the Slave Girl,* and *The Curse of the Faceless Man.* I counted 76 movies that Eddie made for the company simply because he was there to help start it all. Now, that's loyalty.

We had other producers who, like Mr. Small, made mainly second features or low-budget pictures, usually action-oriented or westerns. They were made by producers like Aubrey Schenk and Howard Koch, who later became president of Paramount. Not many people know that Howard had directed *Hot Cars* and *Emergency Hospital* for UA in those early years. Or Jules Levy, Arthur Gardner, and Arnold Laven, three wonderful men who made quality second features for us or modest A movies with John Wayne or Burt Lancaster every now and then. These were producers who loved their craft, made honest films, had their egos under control, and were the backbone of the business. People who cared about what they did had a home at UA because they were there when we needed them. So in that spirit, we did a series of other films with Tony Richardson. One, his version of *Charge of the Light Brigade,*

was described by Judith Crist, then the critic of the *New York Herald Tribune*, as an "intellectually historic film of epic proportions". But we also had some major disappointments, sad to go into detail about and not really worth it, except for one instance which has always made me laugh every time I think about it – which is as seldom as possible.

In 1966, Tony made a film for us titled *Mademoiselle*. It starred Jeanne Moreau, the great French actress, and was shot in the boonies of southwest France near a town called Le Rat. It holds a special place in my heart because I visited the location with David Chasman, a dear friend who worked with me at UA initially as advertising director but eventually in production because of his taste, his knowledge of film, his sense of humor, his gambling abilities, his incredible memory, and a vast number of other reasons as well.

When we got to Le Rat, which wasn't easy since there was almost no way to get there, we were both booked into the local B&B. There was but one room with one bed, and it was ours. It was, I promise, truly a one-night stand. Anyway, Tony finished the film, and it was invited into the Cannes Film Festival. On the basis that it would help with the European release from the publicity that emanated, we agreed to the screening. Tony shot the film in an unusual way. It was about the erotic and erratic relationship between a French woman in a small town and an Italian lumberjack. Tony chose to shoot the film with an Italian-speaking Italian, and Jeanne Moreau (sometimes speaking in French, sometimes speaking in accented English to the camera). It was subtitled, confusing, and to quote the critic Roger Ebert, "a murky mess". I was most dubious about how the French audience would respond to this rather bizarrely constructed tale told in several languages, including theirs, being directed by a snooty Englishman (their definition).

We arrived at the theater and the traditional introduction of the filmmaker (the director or "auteur", as the French called them) took place with Tony standing up from his front seat in the loge, modestly waving to me with a somewhat shit-eating grin on his face. The lights dimmed, and Tony and I moved back to watch

the film for the first 15 minutes or so before going to have a drink. We surely needed one. It wasn't but a few moments before the French audience resented what it was watching and started making menacing sounds at the screen. The French audience is notorious for their rudeness. Shortly after the noise started to increase in intensity, I saw objects being thrown. I was frozen and didn't dare look at Tony. Then an object hit the screen – or was it two? – a tomato perhaps, or a dozen of them. Whatever it was, it was awful. I turned to look at Tony, not knowing what else to do. There he was, all 6'4" inches of him, with this gigantic smile on his face. I couldn't believe it. "What the hell are you smiling about?" I asked. "Oh, everything's fine. I suspected there might be a problem, so I took five valium before I left the hotel." Sure, that's why he was smiling; he was stoned. I wish I had been.

James Bond

"I just have to make a phone call."
- Cubby Broccoli

Movie franchises have come in many shapes and sizes, from *Andy Hardy* to *The Thin Man*, from *Star Trek* to *Star Wars*, from *The Pink Panther* to *Harry Potter*, from *Superman* to *Batman* to *Spiderman*, from *Friday the 13th* to *Saw*. None, however, have come close to the number of films and the total viewing audience of 007 James Bond.

Much has been written about Bond; some to exploit and capitalize on the success of the films, some of it purporting to be the "inside story", but usually based on the particular agenda of the author. Until now, no one has written in detail exactly what happened, how it happened, and why it happened for one simple reason: they weren't there. One fact, however, has been consistent from the interested parties: the James Bond movies would not have happened had it not been for this author's belief in their potential. It's as simple and as complicated as that.

As with almost every story in show business, there are no straight roads to any destination. There are multiple pit stops along the way with many characters who contribute and then disappear only to show up later, and others never to be heard from again.

The details of the James Bond movies, the initial deal made with United Artists, and the complex nature of the Broccoli/Saltzman early years have been researched by many writers, occasionally

even getting quotes from some of the principals. But nowhere has the story of James Bond been written in detail by anyone directly involved in all aspects of the story until here and now. All the principals have passed away, but the story is the stuff of movie legend. So to borrow a line from my friend, the great Joseph L. Mankiewicz, "Fasten your seat belts. It's going to be a bumpy ride."

In 1961 my first cousin, Nancy Moses, was married to a Wall Street broker named Semon Wolf. One day Semon asked me if I had ever read any of the Ian Fleming paperbacks about a British Secret Service agent named James Bond. I told him I had not. "It would make a great movie," he said. Now, when you're in the movie business, people make suggestions to you all the time. As I mentioned earlier, my grandfather always said everyone had two businesses - their own and the movies. How true that is! Most everyone talks movies, thinks movies and goes to movies. In this case it was Semon. Being a good listener, I read a couple of the Bond paperbacks and told Semon he was right. "What do I owe you?" I said. He quoted his price: "Buy me a dinner if it works."

To start the ball rolling, I called Doris Vidor in our Los Angeles office. UA did not own a studio since all our pictures were independent productions, but we had a small LA office on the Samuel Goldwyn lot at 1041 North Formosa Avenue in Hollywood, run by a classmate of Arthur Krim's from his days at Columbia law school, Bob Blumofe. Doris was there as a liaison with the Hollywood community, both business and social. She was Hollywood royalty, wise in the ways of everything important in Tinseltown. A daughter of Harry Warner (one of the Warner Bros.), she had been married to director/producer Mervyn LeRoy, and was mother to Warner LeRoy and Linda LeRoy Janklow. After divorcing Mervyn, Doris married the director Charles Vidor. Following his untimely passing, she came to work at UA. She was smart, witty, attractive and no- nonsense. On her wall was a signed picture from the great writer/director Billy Wilder, which I have never forgotten. On it Billy wrote, "To the wife of my friend, to the friend of my wife, to a love in my life." Pure Wilder.

I called Doris and asked her to check on the rights to the James Bond books whose author, Ian Fleming, was represented by MCA. Her response was quick. He was represented by Bob Fenn at MCA London, and they were not for sale. That's what she found out. I called Semon Wolf. No luck, no dinner, but thanks - it was a good idea.

Lew Wasserman, the chairman of MCA, was scheduled to have lunch with UA's top management, Arthur Krim, Bob Benjamin and Arnold Picker, and now as head of production I was joining the table at Vesuvio on West 48th Street. Same table, same waiter every day. It's where we talked to each other, exchanged information, and then we made decisions. Friends at competitive companies continually asked how United Artists ran so smoothly and seemingly without management problems or personnel crises. My answer was simple: we talked to each other every day, and made our decisions. We also answered our phone calls the same day, and we prepared a chain of command trained and ready to move up the executive ladder.

So Lew Wasserman was coming for lunch. He was a friend of the company; along with Abe Lastfogel of the William Morris Agency, he had helped United Artists establish itself as a new force in the business when Krim, Benjamin and their partners acquired the company. I had first met Mr. Wasserman many years before. In 1948, my parents and I had driven across the country to visit relatives in Los Angeles. Dad, who ran Loews Theaters, which also owned MGM, wanted me to visit the studio since he recognized and encouraged my love of the movies and the movie business. We made a stop in Las Vegas at the Sands Hotel, the "in" hotel for the industry.

My mother, Sylvia, loved to gamble, so we headed to the craps table. Mother got into the game and shortly after she started betting, a tall, taciturn gentleman with thick black-framed glasses stepped in and started to bet with chips that had three numbers on them, like $100 and $500. He looked at Dad with a smile and said, "Hi, Gene." Dad, smiling back, acknowledged, "Good to see you, Lew."

"Who's that?" I whispered.

"Lew Wasserman, head of MCA. He represents many of the acts and bands that play The State and The Capitol." (They were the

two Loews houses in Times Square that had live stage shows.) We watched them play a while. I'd never seen a craps table before and I was trying to follow all the betting. Mr. Wasserman had the dice and as he placed his bet, he put two $100 chips on the table covering a marking that showed 2 dice with four spots. He said to the croupier, "One for you and one for me."

"What's that?" I said to no one in particular.

"Shh," said Mom. "I'll tell you in a second." Lew rolled the dice and up came 2 fours. The croupier put seven $100 chips in front of Mr. Wasserman and slipped seven $100 chips in the top pocket of his own shirt. "Thank you, Mr. Wasserman." Oh my god, I thought. This man just gave the croupier $700!

Needless to say, I never forgot that moment. When I was in a position to work with Lew and told him that story, we connected in a way that lasted the entire length of our time together in the business.

Lew sat down with us for lunch. I couldn't hold back, so I went straight to the point.

"Lew, we should do a film with Mr. Hitchcock and I know just the project. One of the Ian Fleming books. You represent him too."

Lew laughed. "Not a bad idea," he said, "but Hitch thought of it already, and it can't be done. Fleming won't sell the rights."

I couldn't believe it. We might have had a chance to get Alfred Hitchcock to make a film for UA (he never did), and MCA couldn't get its own client to make a deal? And that's why Doris hadn't been able to find out the details. It wasn't that somebody owned them; it was that nobody could buy them. Lew filled in the only details he knew. MCA's London agent, Bob Fenn, had indicated that since *Casino Royale*, which had been bought by producer Gregory Ratoff some years earlier with no ties to any subsequent Bond books, Fleming had simply refused to consider any offers, even Mr. Hithcock's. It turned out Mr. Fleming didn't like movies. And so the lunch continued.

Just being with Lew was special. Mr. Wasserman and Arthur Krim were the two most extraordinary minds with whom I ever

dealt. Concise, dazzling in their ability to understand challenges and find answers, brilliant in the speed and depth of their intellect, and dedicated to the causes to which they were committed. As much as anything else, and just as important, they subrogated their egos all the while. They were interested only in the results; not the kudos or bullshit of a business that thrived on self-congratulation. What an education these men passed on, and what a model to learn from. Oh, and one more thing: their minds were so quick that they knew in a heartbeat where you were going miles before you got there.

So no Bond, no Hitchcock, but lots of Lew.

Months went by. The head of our London production office, Bud Ornstein, called with a strange request. "Harry Saltzman and Albert Broccoli are coming to New York and want to meet with the group - don't ask what it's about because they want to tell you themselves." Bud Ornstein had worked for UA for several years in the UK and did an excellent job. He also knew that I was very supportive of British film production and had already gotten several films greenlit. Bud was tall, elegant, spoke perfect Spanish, and was married to Mary Pickford's goddaughter. People liked him, and I did too. "Okay," I said. "I'll set up the meeting."

I knew Albert Broccoli's reputation and had seen most of his films. Cubby, as he was called by all who knew him, had produced films in London since the early fifties, mostly with his partner Irving Allen and mostly for Columbia Pictures, whose UK office was headed by Mike Frankovich, a smart, tough, knowledgeable studio executive and gin player extraordinaire. There was a regular gin game with a rotating group of major movie executives that was famous for its stakes and congeniality. It was big-stakes and big-time. Mike was a fixture, as was Ilya Lopert, who ran our UA continental production office in Paris. (When Ilya flew to London, he could usually find a gin game within 15 minutes of his arrival.) Anyway, Cubby was the real thing. His company with Irving Allen, Warwick Films, specialized in quality action pictures made at a reasonable cost; films such as *The Red Beret, Cockleshell Heroes,* and *Hell Below Zero.* He hired

talented directors such as Terence Young and Mark Robson, cameramen like Ted Moore, production designers such as Ken Adam, and screenwriter Richard Maibaum. Cubby's relationship with his partner Allen was edging toward professional divorce, but he figured he'd try one last shot at doing something together. Having read several of Fleming's books on Bond, he inquired about their availability. A meeting was set up with Bob Fenn, who advised them that CBS was interested in a TV series on Bond and that Fleming didn't like movies. Allen, who never liked the idea, got up and left. Clearly a Bond deal was out of the question for the partnership.

Canadian-born Harry Saltzman grew up in New York City and played around the world of show business for many years. From vaudeville, to French music hall, to the circus, to the NY theater, he was all over the map. During World War II he was in the psychological division of the OSS (Office of Strategic Services) and stayed in Europe when the war ended. He produced *Captain Gallant of the Foreign Legion* for TV in the late 50's, then joined in partnership with John Osborne, Tony Richardson and Oscar Lewenstein to form Woodfall Films. He stayed with them for several years and the company made three critical hits: *Look Back in Anger, The Entertainer,* and *Saturday Night and Sunday Morning.* It's hard to know just how much Harry contributed to these films, but he surely was a principal in the company. By coincidence, his then-lawyer Brian Lewis was also lawyer to Ian Fleming. Lewis told Harry that Fleming had recently decided to make a deal to protect the trust value of his books, since the one sale he'd made for *Casino Royale* was for only $6,000. A lunch was arranged and Fleming wanted to know how much Harry would pay. A deal was set at a $50,000 option for one of the books for six months, and if and when the pictures were made, up to an additional $100,000 per picture would be paid. Fleming's agent Fenn agreed, and Harry Saltzman had a six-month option on James Bond.

Harry may have tried to set the films up, but he certainly never came to United Artists, nor did I ever know that Harry had gotten this option. He either did nothing, or tried and got nowhere. With only 30 days left on the option, a writer friend of Harry's,

Wolf Mankowitz, suggested that Harry meet Cubby Broccoli, another friend of his. Cubby got movies made, and that's what Harry needed. The meeting was set up, and Cubby's enthusiasm and practical experience convinced Harry that with only 30 days left, a partnership was the way to go. A 50/50 deal was struck and EON Pictures was formed - "**E**verything **O**r **N**othing". Someone had a sense of humor.

Cubby's first call was to Mike Frankovich at Columbia. Mike would do almost anything for Cubby. They were friends, had a long business relationship, and gambled (and who knows what else) together.

Whether Mike even read the books I don't know. After all, they were not new to the marketplace, but the Columbia response was fast. "Cubby, if you insist, we will give you $300,000-400,000 to make a picture, but that's it. There's no real belief or support for the project. If you can get more elsewhere, fine, but let us know before you close any deal." Both Harry and Cubby felt the potential of the Bond books couldn't be maximized at that budget.

Cubby's next call was to UA's Bud Ornstein, who then called me and the meeting was set. I subsequently found out that Cubby was paying for Harry's trip to New York. Harry, never short on chutzpah, when finding out the Cubby was bringing his wife Dana on the trip to the Big Apple, insisted that Cubby pay for his wife Jackie as well. Maybe that was the first clue that this partnership was destined for eventual wreckage. But then it was early in the game. So Harry and Cubby and Harry's lawyer, Irving Moskowitz, would be attending. Norman Tyre, Cubby's counsel, couldn't make it in from Los Angeles.

Arthur Krim's office was the corner of the UA executive floor, large and square with windows on both sides of his catty-cornered desk. In meetings I always liked to sit on Arthur's left so I could tilt the back of my chair and put one of my long legs against the side of his desk. I used to do this a lot and this day was no different. Bob Benjamin sat opposite me and Arnold in the middle. We had arranged chairs for Cubby, Harry, and Irving, and introductions

were made all around. We sat back to listen, laughing, telling them Bud had refused to reveal anything, even at the potential loss of his job.

"We own the rights to James Bond," Harry said.

My chair came hurtling back to all four legs.

"You're kidding." They weren't. "How did you guys get them?" I wanted to know.

All they said was, "We got them."

I didn't even try to hide my excitement. This was a deal I felt we had to make right then and there. Since I was the only one at UA that had read the books, Harry, Cubby and I started to talk about why we liked them and what it would take to translate them to the screen. As we talked, it was clear we had a mutual creative vision. These books were not the run-of-the-mill adventure story. What gave them their special quality was basically two things of equal importance. One was the character of Bond himself - suave, sophisticated, stylish, witty and sexy. The second was the Fleming touch; the amazing variety of both location and villains. The first movie had to have a budget that guaranteed that the style could be supported. This was 1962, and costs were far different than now, needless to say. But if you look at the movies Cubby had been making for Columbia, they were, for the most part, well under $500,000. Cubby, Harry, and I agreed philosophically that major money had to be spent below the line (the physical cost of making a film). The other key factor was franchise potential, so the actor who played Bond had to commit to sequels as well.

My three bosses responded to our enthusiasm, and it was agreed that UA would approve a budget of $1.1 million for the first film. Made in the UK, it would be eligible for some contribution under the EADY plan, instituted by the British government to encourage production in Great Britain, lessening the UA risk. Harry, Cubby, and I agreed that $1.1 million could give the film the financial support to fulfill our creative vision. The rest of the deal wasn't difficult. We agreed to fair producers' fees and a 50-50 split of the profits, which was pretty much the standard UA formula, with one additional condition: the profits of the pictures would be

cross-collateralized in groups of two. In other words, if we made a second picture, it would be joined with the first in determining profit and loss. If there was profit on one of the pictures and loss on the second, the profit could be used to offset the loss, and vice versa. If both profited, so be it; and the same if they both lost.

Everything seemed to be moving along very well, so we began to talk about which book should be developed first. They suggested *Thunderball*, but having read the book I felt the story was going to be too expensive to shoot as the first picture. *Dr. No* lent itself better to the guidelines we set. The two agreed to go back and consider this, and we'd make a final decision. Everything seemed under control. We had agreed on a concept, agreed on a budget, and would shortly agree on the first title of what we hoped might be a successful series of films. We were all smiles.

"I just have to make a quick phone call," Cubby said. "I'll only be a minute." What the hell was this? And then Cubby said something that had been on my mind the entire meeting, but I didn't want to raise for fear there was a problem. That was Columbia Pictures. Cubby had made most of his films for them; how come they hadn't stepped up to the plate on this one? How could any company pass on James Bond? "Columbia," said Cubby. *Now* he says Columbia. I said it to myself, but I know my face showed exactly what I was thinking. Cubby saw it too. "David, don't worry. I've already talked to them and they said they had no real enthusiasm for the material. They don't get it, but I've been with them for years and I promised to call them one more time if there was interest elsewhere." I wanted to thank him for telling us now instead of at the beginning of the meeting. I felt and feared that he had used us to jack up Columbia's interest. Cubby clearly got the message. "I'm telling you not to worry. I'll be back in a couple of minutes."

What choice did we have? Harry looked embarrassed, Irving looked away, and Cubby left the room. It was a very long five minutes; the longest of my business career up to that time. Then the door to Arthur's office opened and Cubby said we had a deal. I did not know then who he called, or even if he had called anyone, or what indeed his strategy was. Subsequently, Cubby told me he had

tried to reach Mike Frankovich but couldn't get him, so he spoke to their Number Three man in New York, Abe Montague, head of U.S. distribution. Cubby told him the history and asked if he knew the projects. Montague said he had heard about the "Victor Fleming" projects (Victor Fleming was the director of *Gone With the Wind* and *The Wizard of Oz*), and he said the company would stand by their offer of a modest budget only to help out their friend Cubby, but would go no further. Cubby said he thanked him but it just wouldn't work. So UA had a deal for a James Bond movie; maybe a lot of them, in fact. Now all Harry and Cubby had to do was make the first one.

We shook hands and the deal was done. Papers may not have been signed between UA and the producers for a year or more, but in the 60's, those extraordinary years, that was the way we did it. The business affairs and legal departments at UA took its lead from the executives in charge. Ask any studio executive today how it works - no, I'll do it for you. You can't do a screen test on a performer without a signed deal. You can't make a deal for anything unless business affairs says it hasn't broken precedent. In our "hand-shake days" were there bad moments? Surely, but only to learn a sad lesson about an individual who couldn't be trusted. It was inconceivable that we could work any other way. We had agreed to make the first James Bond film, *Dr. No*. We agreed on a budget of approximately $1.1 million to do the film as Harry, Cubby, and I envisioned it. They were off to write a script, cast the lead and put it all together.

Cubby had been in the British film industry for years, and had worked with a group of highly competent people. Harry had limited experience, and then only in a more specialized area of the business; a few small British films of quality, but no major international appeal. Thus it was natural that in developing *Dr. No*, Cubby's connections were more appropriate. Richard Maibaum was approved as screenwriter, having worked with Cubby on several successful British action films. Because of his competence, and the knowledge that Cubby and Harry had that this project was

going to get greenlit, they immediately began to consider actors to play James Bond. We had no part in the search. When ready, they would show us their choice for our approval. The entire responsibility for the development and production of the film was in their hands.

The challenge was obvious. All they had to find was an actor who would carry out the role of Bond and agree to options for additional films, play a suave, sexy character that would explode off the screen and become the next Gable, Grant or Bogart, and - oh yes, he had to be English, irresistible, wear clothes beautifully, look good in a tight bathing suit, be able to run, jump, fight and drive cars very fast, seduce every women he meets - and since he was being given the chance of a lifetime, be very inexpensive to hire because after all, he was being given the chance of a lifetime.

Names started to filter back to us from London. Patrick McGoohan was mentioned. Then a bright young actor named Robert Shaw. Finally Harry called me from London to say he was coming to New York with some film and stills on their choice. His name was Sean Connery. He was a Scotsman. The clips Harry brought were from two films Connery had made for American companies, *Darby O'Gill and the Little People* for Disney and *Another Time, Another Place* for Paramount, both in small roles. I saw the clips. He was attractive. He had what I thought was an Irish accent in *Darby O'Gill*, and in the film with Lana Turner, he sounded more English. I was neither over- or underwhelmed. I asked Harry if he was the best he could find, and his answer was, "He's the richest man in the poor house."

"If he's the best you can find, then let's go with him."

It was as simple as that. The deal for Connery's services was made by Harry and Cubby with Richard Hatton, an agent I'd found in previous dealings to be most approachable and fair. At this time, however, UA had no involvement in the negotiation for the initial picture and subsequent options.

Next was the choice of director. Cubby and Harry made two suggestions: Guy Hamilton and Terence Young. Both were extremely competent. Young had worked with Cubby on several films, and

Hamilton had directed a film for us at UA in 1959, *The Devil's Disciple.* He had done an excellent job with the George Bernard Shaw adaptation and a star-studded cast including Burt Lancaster, Kirk Douglas and Laurence Olivier. He had also done a fine job with *The Best of Enemies,* a sardonic World War II story starring David Niven and the great Italian comedian Alberto Sordi. Hamilton was a fine director. Young's credits were more action-oriented, and I had met him on an occasion or two.Without personally knowing them, it would have seemed like it was a tossup. In fact, it was an easy choice for me. And the reason was Sean Connery. Sean was born and grew up just outside Edinburgh, Scotland. He lived in a humble household, never had made much money, and what he had, he never spent on clothes. He was not only *not* a clothes horse; he couldn't have cared less ... not exactly James Bond. On the other hand, the personal style of Hamilton and Young could not have been more opposite. Guy was a tall, quiet, deliberate man whose thoughtful demeanor was solid and professional. Terence Young was the exact opposite. As a matter of fact, had he been some years younger, *he* could have played James Bond. Years after I left UA, I produced a film directed by Terence. Terence dressed from Savile Row. Terence ate at Les Ambassadeurs, the poshest place in London. If he had money, he spent it. If he didn't have any, he spent it. If he saw a beautiful woman he went after her, but with class and style. And that's what Sean needed to become James Bond. He needed Terence Young, and that's who he got. Terence directed *Dr. No, From Russia With Love,* and *Thunderball.* Guy Hamilton directed *Goldfinger.*

The other key decision the producers made was hiring Ken Adam (now Sir Ken Adam) as the production designer for the film. He had worked with Cubby on *The Trials of Oscar Wilde,* originally titled *The Man with a Green Carnation.* Ken brought his genius to the Bond series. With the exception of *From Russia with Love,* which Ken's assistant Syd Cain did, he really was the eye that enabled the Bond films to translate into screen terms the visual lollipops, location and style, that were inherent in the Fleming books, one of the key ingredients that attracted us to the books

in the first place. Ken's brilliance helped create some of the most memorable films of his time. In addition to eight Bond films, he designed Stanley Kubrick's *Dr. Strangelove, Sleuth, Barry Lyndon, The Seven Percent Solution, Agnes of God, Chitty Chitty Bang Bang, The Last of Sheila, Crimes of the Heart, The Madness of King George,* and many others. An extraordinary talent, a total professional and a grand gentleman, a major contributor to the success of the Bond films - that's Sir Ken Adam.

In other words, a very good team was being assembled. On any trip I made to London, stopping at their office on South Audley Street was a must. Sharing a giant room with antique partners' desks in a magnificent old London townhouse around the corner from the Dorchester hotel, where I always stayed in my UA years, these two producers undertook the planning and production of *Dr. No.*

The start of production was nearing, but the final budget hadn't arrived for final approval. I kept asking Bud Ornstein when we would get it, and he kept pushing Cubby and Harry. Finally it arrived with the bottom line number just over $1.35 million, a quarter of a million dollars over what we had approved. In today's world that may not seem like a lot of money, but then it was a *very* big deal. And Arthur Krim was very tough on the numbers.

So here was this picture we had a deal to make for $1.1 million with a budget already in excess of $200,000 over, and the picture hadn't started shooting yet. A picture, let me remind you, that starred an unknown in a book that had been around a bunch of years, that interested not one of the majors except us. And I was supposed to go into Arthur Krim's office and tell him what? I knew what he'd say. He'd say, "Tell them to cut the budget." I had one problem with this. After talking to Harry and Cubby on the phone, they had convinced me that they simply couldn't give the picture the look, the style and the excitement we had all envisioned without the extra money, so I'd promised them to fight for it.

The playwright David Ives wrote a wonderful evening of short plays called *All In The Timing.* Well, never was a phrase more appropriate. Arthur Krim and Bob Benjamin were out of town. Thank goodness.

I walked out of my office through the room shared by our secretaries to see Uncle Arnold. As opposed to the domestic distribution arm of the company which was sloppy, unfocused and run with little discipline and less foresight or business acumen, the international department ran like clockwork; efficient, effective, and highly profitable. On a personal level, Arnold had no time for chit chat or small talk except within defined moments like our daily lunch. In addition he smoked cigars. A lot of men did then. Right there in his office. Arnold smoked and talked fast - I mean fast. His people did not fear him because he respected them and they knew it, but they also knew they had to live up to his expectations of performance. A cigar, machine-gun speed dialogue, real smarts, good looks; he was quite a package.

"I've got a problem on *Dr. No*," I said.

"Okay, tell me."

Since Arnold knew the history of the deal, it was easy. We had approved $1.1 million, but now it was over $1.3 million. "Arthur will insist on cutting the budget and I believe that would be a big mistake," I said.

"You believe in this, don't you?"

Of course I did, and I told him we needed this amount to make it right. He said, "You got the budget?"

"It's on my desk," I said.

"Let me see it."

I got up and went to my office, brought it back and laid it in front of him. He started reading the pages, turning them swiftly. He looked up and said, "Arthur and Bob are out of town, aren't they?" I said yes. "Well, I'm a partner here, and I've looked at the budget and I found a mistake in it. They added it wrong. It's actually just over $1.1 million. Tell Cubby and Harry it's approved."

Arnold knew there was no mistake in the addition. It was just his way of supporting my enthusiasm while giving them what they needed, knowing that as a partner in the company Arthur Krim would never question his decision to approve the increase.

Dr. No opened in London on October 5, 1962. Arnold decided that since it was a British film with a British hero, we should start

there. The film was well-received and other foreign openings followed. Germany and France in January of 1963, and so on.

On May 8, 1963, *Dr. No* opened at the Astor Theater on Broadway and the Murray Hill Theater on the East Side. *The New York Times* called it "a lively picture, ...a tinseled action thriller,..... pure escapism." Our feeling was it didn't really matter what the critics said. It was an audience -pleaser, and that was more than enough for a film at the cost of *Dr. No*. The only thing that was essential was that its box office justify another film ... and of course it did. *Dr. No* delivered well over $6 million in film rental worldwide. James Bond had passed his first test.

So what was next? We all agreed that *From Russia With Love* was the logical choice. It was a good story for the second in the series, and it could be made for a reasonable cost. The team went to work again and they did a brilliant job with a bigger budget - $2 million, no questions asked. Cast in the roles of the two villains were Robert Shaw, who had been considered for Bond, and Lotte Lenya, the grande dame of Bertold Brecht musical history. This time Guy Hamilton directed, but the style and tone had now been set.

On October 10, 1963, the film had its world premiere, in where else but London. One doesn't want to fool around too much with success. The picture was a hit. It doubled the numbers of *Dr. No*, doing well over $12.5 million in worldwide film rental. With distribution fees of 30% in the U.S. and 40% foreign, plus a 50-50 split of the profits defined as what's left after fees and negative costs are recouped, Bond was clearly headed for a big payoff. Considerably bigger than *Dr. No*, with "Bond, James Bond" being printed in papers around the world, we eagerly awaited the U.S. opening.

April 8, 1964. The Astor Theater. Here's what Bosley Crowther had to say this time:

"Secret agent 007 is very much with us and anyone who hasn't yet got to know him is urged to do so right away. Don't miss it."

Pretty exciting stuff for a young executive who went to the mat for something he believed in. But in the movie business success (or failure) is never examined in isolation, and there was a dark horizon on the company's balance sheet. A "little" film called *The*

Greatest Story Ever Told, the most expensive film we'd ever done, was destined to be our biggest disaster ever, even though we didn't know it yet. Bond was, under any circumstances, moving inexorably in the right direction.

From Russia With Love had a total film rental over $25 million, twice that of *Dr. No.* It was clear we had a very good start in building the franchise. It was not long after the opening of *From Russia With Love* that Irving Moskovitz and Norman Tyre, the producers' attorneys, suggested that their clients' deal be renegotiated. That in itself was not unusual, although any changes would usually be tied to a new deal with new pictures. Here, after only two films the producers were already pushing for a change. One of UA's strongest assets was the style with which they dealt with their filmmaking partners. In this case, Arthur agreed to a modest adjustment from the 50-50 partnership on the back end, as well as an increase in producing fees that satisfied the lawyers for the moment. However, it was clear that with any continuing success there would be continuing renegotiations. And there was one other thing that at the time was not apparent, at least to us. With the success of these first two films and the renegotiated producers' deal, how were Harry and Cubby handling Sean Connery? He was, after all, carrying the load, and had created, with his style and demeanor, a character with increasing worldwide box-office success.

Shortly after *From Russia With Love,* Richard Hatton, Sean's agent, called to ask if we had another film Sean could star in. He and Sean both felt that his career would be limited if he became known only as James Bond. I said I would try to accommodate the request. All I could find was a potboiler of a script, but with a director I felt was talented enough to deliver a good commercial film. The script was entitled *Woman of Straw.* The director, a Brit named Basil Dearden, had directed *Sapphire* and *The League of Gentlemen* (both well worth seeing). He and his producing partner Michael Ralph had signed Gina Lollobrigida to costar. We all liked the combination of Sean and Gina.

A problem arose on the billing because both of them wanted their names in first position in the ads. When the lawyers couldn't

agree, I personally got involved and found a mutually acceptable solution. We'd split the ads evenly, with half showing Sean in first position, and the other half with Gina. Everyone was satisfied. It seemed so unimportant at the time, but how you deal with egos is very important. The film did modest business and was totally ignored by cineastes. But solving the billing problem as I did led to solving a much bigger problem later - a problem that might have killed the Bond franchise if not resolved.

Next up was *Goldfinger*. Guy Hamilton directed and Ken Adam designed - a great team. The budget was now up to $3 million, and in those days $3 million could deliver a big action picture. And this time not only action, but Pussy Galore, Odd Job and Auric Goldfinger. It was one damn good movie.

Opening in over 150 theaters across the U.S., the film was a giant hit, delivering over $10 million in the U.S. in just the first ten weeks. Based on that, we decided to re-release a double feature of *Dr. No* and *From Russia With Love* prior to the next new Bond, *Thunderball*. With the best of the franchise bubbling up, another $8-10 million was picked up in film rental. *Goldfinger* was so good that, in what was probably an unprecedented move, it opened in the United Kingdom only 11 months after *From Russia With Love* on September 17, 1964, followed soon after by a Los Angeles opening on December 22 and the rest of the U.S. on January 9, 1965.

And it was big. Roger Ebert, in one of the most extraordinarily prescient reviews I've ever read, said "James Bond is the most durable of this century's movie heroes, and one likely to last into the next. Of all the James Bonds (sic. this was only the third) this is the best. It is not a great film. It is great entertainment."

Who knew? This book is being written in 2013 - twenty-three Bond movies after *Dr. No* - and *Skyfall* is the biggest one yet. Of course it cost slightly more than $3,000,000. Estimates have the newest Bond costing over $200 million.

Where to go after *Goldfinger*? *Thunderball* was the answer. The budget for *Thunderball* was far and away the most expensive to date, in excess of $5 million, but it was warranted. Terence Young came back and we began another chapter in Bond's history.

By now the marketing of Bond called for a change. We knew we would have a big hit on our hands, so this time we'd open the major overseas markets, as well as the U.S., for Christmas 1965. For the opening in New York's Times Square I suggested that we run the picture 24 hours a day, at least through the holiday season. To our knowledge this had never been done before for a first run major film, but the exhibitor agreed. Opening night I had a late dinner. The early shows had all been full. When I went by the theater after the midnight show and saw the lines waiting to get into the late-late shows, I knew the idea had worked. *Thunderball* was such an enormous hit that we knew it was time for *another* renegotiation with the producers. Once again, Arthur and Bob worked it out. It was only a matter of how the profits would be shared, how big the producers' fees would increase, and so on. Greedy, yes; but Bond was a big franchise and UA knew an accommodation was necessary.

It's time to now remind the reader of how the UA/producer relationship worked. Once approvals on any project were given, the production was on its own with no involvement from UA in any way. Occasionally I might visit a location as a courtesy, or be invited to see dailies, but basically the producers were on their own, including making all deals with cast and crew. We had approval of the basic deal with any stars and, in the case of Connery, we knew there was a clause covering his additional options, but we truly did not get involved with the negotiation of the details. We had approved Connery, and the producers had options they could exercise for subsequent films; that's all we cared about. Broccoli was experienced, reliable, and knew his business. During the course of actual filming we had no presence other than an auditor checking the financial cash flow. We had nobody on the set watching any of the day-to-day trials and tribulations that occur on any film. We simply awaited delivery. It may sound like an odd way to do business, but it was exactly the philosophy that attracted filmmakers to us, and it worked - most of the time.

In the case of the Bond pictures, there was little, if any, awareness that there was trouble brewing between Sean and the producers.

They never advised us of any problem and Richard Hatton, Sean's agent with whom I had solved the billing problem on *Woman of Straw*, never called to tell me of any difficulty.

Harry and Cubby's representatives during the deal renegotiation never indicated that there was a Connery problem. So when Harry and Cubby told us Connery had said that the last of the options was the last Bond he would do, we strongly suggested that they get him to agree to additional pictures. They said it would never happen. *You Only Live Twice* was the last one. Obviously this was a problem, and a *big* one.

United Artists relied on our producers to deal with problems on their films. In this case, Harry and Cubby simply said that Connery wanted out and wouldn't do another Bond. They didn't ask for our help and, clearly, losing Connery was hardly to their benefit; we accepted that they had made their best efforts to keep him and had failed. That's the way we worked.

Replacing Sean was not going to be easy. As in hiring Sean initially, it was essential to cast a performer who would agree to multiple options, and that would be hard to do if the actor was well established. So it was pretty much back to square one.

Everyone had ideas. Mine was John Newcombe, the Australian tennis player. He was handsome and had a great serve. I often wonder if he ever knew he might have been James Bond. But in the end, the two producers strongly recommended George Lazenby, another Australian (I knew nothing about his serve). All I knew was that he looked good, his experience as a male model gave him style, and if the producers felt he was the best shot, who were we to argue with the success they had created? They were the experts, self-appointed and otherwise. So Lazenby it was.

On Her Majesty's Secret Service opened to decent reviews, but most pointed out the obvious - that Lazenby was no Connery. So what else was new? I'm not sure if anyone could have survived being first out of the bullpen to replace Sean but, in any case, it surely wasn't going to be Lazenby. Business was considerably less than *You Only Live Twice*, and it was clear the franchise was in trouble.

Arthur called me in and asked if there was any way we could get Connery back for one more film, just one more. I called Cubby and Harry, and although they didn't disagree with our analysis, they didn't know what they could do since their relationship with Connery was essentially non-existent and non-speaking. Non-speaking? I had heard none of this, certainly not from the producers who might have thought it was something worth sharing with their partners! Getting no help from Harry and Cubby, I went back to Arthur and proposed that in exchange for doing one more film as Bond, UA should make a deal with Sean to deliver two pictures to us as producer and star of any scripts he wanted to make. We would waive all approvals on cast, director, and script and pre-approve in advance the budgets, with each picture to be no more than $1 million. This would give Sean the freedom to guide his career in any direction he wanted. In exchange, he would do one more Bond film. His fee would be $1 million and a piece of the profits.

Arthur agreed, and I flew to London to meet with Sean's agent, Richard Hatton. After hearing the proposal he responded with two changes. First, raise Sean's fee to $1.250 million. Second, a condition of Sean's return was he wouldn't have to talk to either of the producers. After I caught my breath, I said I'd have to run it by Arthur, Harry and Cubby, but that I would strongly recommend it. Then he added as an aside that if it was approved, Sean was going to donate his entire fee to The Scottish Educational Trust Fund. I must admit that I was just blown away by this little throwaway from Richard. And then he added that he much appreciated our getting involved and if the producers had dealt with Sean appropriately, none of these problems would have occurred. Basically he said they treated him like shit. They renegotiated their own deals with UA, but never addressed what Sean had brought to James Bond. He was simply, in their minds, an actor lucky to get such a break, and the hell with any reconsideration. He felt used and under-appreciated and he didn't like it one bit.

Sean only made one of the two films we offered, but his performance as a sadistic British police officer in *The Offence* was brilliant.

Directed by Sidney Lumet, who had previously directed Sean in *The Hill* for MGM, *The Offence* contributed in a big way to the extraordinary career Sean has sustained in his lifetime.

We met Sean's terms, he returned to star in *Diamonds Are Forever,* and the James Bond franchise was saved. Roger Moore, Timothy Dalton, Pierce Brosnan, Daniel Craig - and the rest is history.

Diamonds Are Forever opened in December 1971. The United States numbers doubled those of the Lazenby film and the foreign figures increased by over 25%. The Bond franchise was alive and well.

Some years later Sir Howard Stringer, Chairman of the Sony Corporation, honored my sister Jean Picker Firstenberg on her retirement as Director of the American Film Institute at a private dinner attended by a number of film luminaries, including Sean Connery. It was wonderful to catch up with him and share some of our memories of the Bond era. As Sir Howard went around the table introducing key people to speak about my sister, he came to me. "Now I'd like to introduce Jean's brother, David. The finest compliment I can give him is to say an old friend of mine, Sean Connery, told me that David was the only movie executive he ever liked." From across the table Sir Sean gave me a wink.

I think that a more personal evaluation of Cubby and Harry is appropriate here. Cubby was the easier of the two to understand. Having spent many years in the film business in Los Angeles prior to his move to London, he had acquired an understanding of the ways of the movie business, as well as having a high comfort level in dealing with the industry's, shall we say, idiosyncratic style of doing business. Personal contacts and relationships count for a lot in Hollywood, and Cubby had made many friends, worked with many companies, and had a personal style that fit in the ways of Hollywood. He was, in other words, accepted. He and his wife, Dana, socialized comfortably in a town where the line between business and extracurricular interests literally doesn't exist. It was movies all the time. Everything was about business, and if you had a place in it, you were accepted. If you didn't, it was hard to break in. Breakfast was business, lunch was business, dinner was

business, tennis was business, golf was business, gambling was business, wives were business, girlfriends were business.

Cubby was well-liked inside the business, and after he made his move to London he became a major player in the UK film business just as easily as he had in Los Angeles. He was also, in his own way, a generous man given to grand gestures. In 1969, working for the re-election campaign of John Lindsay for mayor of New York, I had hoped to raise some money from the film community. Lindsay was going to establish the first office to work with the film business coordinating production in New York City. On a personal level, I decided to help raise some funds for him. Movie stars and producers rarely gave much in those days, as opposed to executives such as Krim and Lew Wasserman who were big Democratic Party fundraisers. In fact Arnold Picker had been involved with Ed Muskie and Scoop Jackson's failed run for the Democratic Presidential nomination, and in one instance got a check for $15 (count it...$15) from Tony Curtis. Anyway, I got some reasonable gifts from a few New York producers who believed Lindsay would help the film business in New York. Cubby sent a check for $5,000. It was overly generous, but Cubby was being Cubby.

Harry Saltzman was a whole different story. He was an outsider to the business, and in meeting with him it was hard to feel totally comfortable. His limited experience made him awkward and he was often forced to rely on Cubby, whose experience was so much more grounded. It was hard for Harry to understand that a handshake deal at UA really was a deal. Fortunately Cubby and Irving Moskowitz, Harry's lawyer, assured him that was the way it worked.

Harry's strength was that he did believe in Bond and cared about the films, but he wanted to be treated like the equal partner he was. Since humor and style weren't his long suits, he sometimes felt, and perhaps appropriately, that he was an invited guest. There was, however, one aspect of his personality that touched me deeply, and that was his love for his wife Jacqui. His deep caring for her was apparent, and through the years I always felt for him as his days grew darker. Harry changed as the Bond films grew increasingly successful. He felt that he didn't need Cubby to be

successful, and began to produce films besides Bond. UA even financed several of these, including *Billion Dollar Brain* and *Battle of Britain*. As Bond's success grew Harry's ego grew as well, and he ventured into businesses he knew little about. He bought the Technicolor company, as well as DeJur, a French camera equipment operation, and several other small businesses. His focus was spread, his ego was growing and financial woes started to build up. The details of his buyout by UA in 1975 are not known to me, but the rumors about the incredible financial pressure he was under and his declining relationship with his partner were rampant. To survive he had to sell out, and I heard it wasn't pretty. After his buyout and the untimely passing of his beloved Jacqui, Harry's presence in the business declined and he passed away quietly and largely forgotten in 1994. When Cubby took over the Bond franchise, Harry's name slowly faded away. Now in the 21st century with the extraordinary revival of Bond in the hands of Cubby's daughter, Barbara, and his stepson Michael Wilson, Harry is no more than an asterisk. But he was much more than that. There are many people along the way that helped make James Bond into the most successful franchise in movie history, but if it hadn't been for Harry Saltzman, it wouldn't have happened at all.

In the years since Cubby's passing his daughter and stepson, who were part of his producing team over the last round of Bond films, have brilliantly reinvented the franchise. Little need be said other than the fact that *Casino Royale, Quantum of Solace,* and *Skyfall* have brought new, invigorated life to the Bond audience, thrilling new viewers worldwide. Looking back at the history of the franchise from Maurice Binder's dazzling title sequences, Monty Norman's famous James Bond theme made legendary by John Barry's orchestration, and all the artists and craftspeople who contributed to the history of Bond, I wish all of those who contributed, from my cousin's husband to the person who discovers James Bond for the first time, could look into a collective mirror and utter together, "The name is Bond. James Bond."

Midnight Cowboy

"It's a dark little book."
- John Schlesinger

Tony Richardson, Dick Lester, Clive Donner, Guy Hamilton, Ken Russell, Michael Winner, Terrence Young, Louis Gilbert, Basil Dearden, Ronald Neame, and even David Lean - all Brits - made pictures for us. In the 60's, London was home to a thriving film community, and there was one director whose films made me want to reach out and see if I could get him. The films were *Billy Liar* and *Darling*. The director was John Schlesinger.

Shortish, balding, chunky, Schlesinger was immediately impressive in both attitude and manner. His loves were film, theater and music, particularly opera. He was witty and direct. He knew that I was interested in having him do something for us, but when it came to my asking if there was any subject for which he had a passion, he seemed reluctant to be specific. I pushed and finally he said that he did. Along with producer Jerome Hellman, he had optioned a book but he doubted very much that it would interest a company like UA. He described it as "a dark little book."

I knew Jerry both as a former film agent and as the producer who had made *The World of Henry Orient* for us, a wonderful picture starring Peter Sellers, directed by George Roy Hill. It had been the first picture of the new UA to play the Radio City Music Hall, the number one theater in the United States at the time, and it

had done well. I remembered Jerry very well. Peter and his entourage had checked into the Regency Hotel on Park Avenue to start rehearsals and prep for the film. At 2:30 the next morning I was fast asleep and my phone rings. A somewhat embarrassed, apologetic Jerry Hellman says, "We've got a problem with Peter Sellers." At 2:30 a.m. I'd have preferred if he had handled the problem himself but, as my friend Charles Israel once said, "I had to get up to answer the phone anyway, so it was now my problem as well." "Peter Sellers just called. He and his group want to move out of the Regency immediately, or sooner if possible. You want to know why?" At 2:30 a.m. he's playing guessing games with me and I know it's not going to be humorous because, despite his talent as a producer, humor is not his long suit.

"Just tell me."

"It's poltergeists," he says. "There are poltergeists at the Regency."

I didn't know the official definition of the word but I knew it was something like ghosts or spectral figures, and I didn't much care. "What the hell, is he crazy?" Talk about a redundant question. "What do you want me to do?

"Well, I called the Waldorf and they have rooms."

Good, at last he was producing. "Fine, so move him."

"Well, it's a little more expensive and I felt I should check with you first."

"Thanks. I'll talk to you tomorrow."

It was *that* Jerry Hellman that was to produce this little dark book. You see what I mean when I say that every story you want to tell about a movie seems somehow connected to other stories about the movies?

"The title of the book," John said, "is *Midnight Cowboy*, and I'll send you a copy tomorrow." I told him I would read it on the plane on the way home, and I did. John was absolutely right about it being a dark little book. James Leo Herlihy's novel depicted a world of drugs, illicit sex, both straight and gay, and the dark side of a relationship between two of life's more pitiable losers. It didn't seem very commercial, but it hit some chord in me that said

if the costs were minimal, it was worth developing. Perhaps I was persuaded even more by the desire to have John Schlesinger do a picture for us. Either way, I was persuaded to take a small risk and develop a script.

Since John and Jerry knew the film would have to be made at a reasonable cost (if it was ever to be made at all) both sides agreed to very modest fees for producer and director, and a total cost of $1.1 million for the entire film. A writer named Jack Gelber, whose off-Broadway plays had depicted the seamy life of addiction, poverty, petty and not-so-petty thievery that had haunted the city was hired to write the screenplay. It was added to the list of scripts in development; just another title.

Time passed and I heard nothing from Jerry or John. Finally, I called and Jerry told me he couldn't or wouldn't send me the Gelber script for one simple reason: it was no good. Neither he nor John felt it was in any way cinematic, and they insisted on saving me the disappointment of reading it. They were probably afraid I'd be so disheartened that I'd give up any further interest in developing the picture. Shit happens, I thought, with not a little disappointment.

"But," said Jerry, "we have a wonderful writer who wants to do it starting over from scratch. Waldo Salt will do it for short money."

I probably would have passed on most any other idea since my enthusiasm for John had already cost the company enough, but Waldo Salt was another story. He *was* a very, very good writer, and had gone through troubles during the House Un-American Activities days when many professionals were banned from the entertainment business for Communist affiliations, real or imagined. There was a group of writers called The Unfriendly Ten and a cliche in the business was that if you hired one of the Unfriendly Ten you'd get a great script. Billy Wilder, the Oscar Wilde of Hollywood wits, had once been heard to say about The Unfriendly Ten: two were actually very good writers, the other eight were just unfriendly. Anyway, Waldo Salt was one of the Ten - hopefully one of the two that were talented.

Months go by, and Jerry called to say he's sending over the Salt screenplay. I read it. It was extraordinary. A tough, torching

script; everything the Gelber script was not. That was the good news. Jerry was delighted by my reaction and said he wanted to see me as soon as possible to talk about the budget. That sounded to me like the bad news, and it was.

The $1.1 million number was now history. Jerry's new budget was $2.2 million. Sure, a lot of time had gone by, but to me it was still a dark little picture; just one that had a terrific script. There are those filmmakers who are meticulous in budgeting and execution, there are those who would like to be but don't know how, and there are those who just don't give a shit. Caveat emptor. You have to know who to trust and who not to, especially if you are giving away creative control (see the chapter on George Stevens). I have been fooled at times, but forewarned is forearmed. As an example, after doing several pictures with Sergio Leone, the Italian director of the early Clint Eastwood westerns, *A Fistful of Dollars* and *For A Few Dollars More*, it should have been clear to anyone making a film with Sergio that they should have completion bond protection, meaning that a financial company is being paid to guarantee the cost of the entire movie. They do it by collecting a large fee, having a hefty cushion in the budget itself, and having the right to take over the picture if necessary. Sergio actually put one insurance company into bankruptcy. In another case when I was at Columbia, a completion bond company took over *The Adventures of Baron Munchausen*, Terry Gilliam's film, weeks before filming because during preparation alone it was already millions - I repeat, *millions* - over budget. Both Leone and Gilliam were highly-skilled, caring, talented filmmakers. You just had to know who you were in business with.

At $1.1 million, I figured with John, *Midnight Cowboy* might go to $1.5 million. But at $2.2 million, who knew how far over it would go? Since the budget had increased, Jerry told me he and John felt they should double their fees (I guess the former agent in Jerry was coming out). I was irritated, to say the least. I had supported a new script even though their first one failed, and now because the script was good, they wanted to double the budget. And now because it was more expensive, higher fees were justified? What

was I missing here? They should be *reducing* their fees. It wasn't pretty.

Some years before, we had made a deal with Charlie Feldman, one of the great Hollywood agents in the 40's and 50's, to produce a movie of Mary McCarthy's big, best-selling novel *The Group*, a story of seven or eight young women struggling to make it in the New York City. We mutually decided to use some up-and-coming actresses in the film, and in giving them an opportunity to play a major role, we planned to get some additional options (rights to use them in additional pictures in the future at a slightly higher but fixed fee) as part of their deal. The legal department reported to me that in doing so, Charlie, I guess as an ex-agent, was assigning those options to himself and not sharing them with us as the financier and distributor of his film. This was totally unacceptable, and I advised the legal department to advise Charlie's lawyer that the options were to be shared; end of conversation. The lawyer's response was still "Charlie says they're his." Our lawyer, Ralph Kamen, came in to my office to report this, and I blew my stack. "Get Charlie on the phone!" It was a short call. Charlie said something, I don't remember what, but I didn't like what I heard, so I yelled "The options are for sharing or forget the picture!" and before he could answer I slammed the phone down so hard I broke the handle. I was totally embarrassed. I didn't know what to do. I had never yelled like that before and certainly never hung up the phone in anger, no less broken it, and in front of a very nice man who was simply delivering a message. Looking back on it, I realized that it was undoubtedly because Charlie was a friend. I was so hurt that he would try to take a business advantage that I just blew it. A couple of minutes later my secretary Peggy buzzed and said, "Charlie's on the phone."

"Okay, we'll share the options," he said.

"Charlie, you're the only man in the world I'm grateful to for giving me something I've already got," was my reply.

Maybe that's why I was so angry with Jerry. I had developed *Midnight Cowboy* with him, stuck with him through another writer, had it pay off with a great script, and now he was fucking with me.

I was supposed to go to my bosses and tell them this risky, eccentric film that was supposed to be $1.1 million, probably would have been $1.5 million, was now $2.2 million, and probably would go over $2.5 million to who knows what? I was deeply upset. I knew Arthur Krim was not yet in, and I was thankful for it. He would have had no patience for the problem and we might have blown the movie. I went to see Bob Benjamin. There was an entrance to his office that I could use without going past his secretary. I opened it, looked in and he was alone, smoking his pipe. (Those were the days.) I leaned against the wall. Bob looked at me and asked what was wrong. He had more empathy than Arthur, Arnold, and the whole company combined.

"What's wrong?"

"It's *Midnight Cowboy*."

"Tell me."

So I sat down and told him the whole story. He hadn't read the script – he only read them occasionally – but he was a great listener. I was upset and he saw it. He didn't interrupt me but when I finished, he looked at me and said, "David, it's only a movie. It's only a movie." He was right, but he was also wrong. To me, it was so much more. He went on to say, "Well, see if you can get them to agree to defer the request for a higher salary, make this adjustment, modify that condition…make it work. I know how badly you want to make it work."

And so I called Jerry back, laid out our position, and we made it work. They deferred their requested increase, we modified the adjustments here and there, we approved the budget at $2.2 million, and *Midnight Cowboy* was green-lit.

Marion Dougherty was hired as casting director. She had cast many New York TV shows and had just started doing features. She knew the New York acting scene better than anyone. And she knew Dustin Hoffman's work from small stage roles, TV series like *Naked City*, and one film, *The Tiger Makes Out*. Marion believed he had great potential as a character-driven star, even before Mike Nichols cast him in *The Graduate*. Shortly after completing that film, Dustin was cast in the role of Ratzo Rizzo, but Universal's casting director

Monique James would not let their contractee Michael Sarazin play the role of Joe Buck because she thought it would kill his career. Talk about bad advice. Jon Voight got the role. The role might have made Sarazin's career. Her refusal to let Sarazin co-star with Dustin Hoffman in *Midnight Cowboy* affected two careers: Sarazin and Voight. I certainly would have approved any actor John wanted to cast as Joe Buck because I trusted him as a film-maker. Clearly, my trust turned out to be well-placed for us all.

I didn't visit the Texas or Florida locations, but when they got to New York I went by the exterior of the then-Gotham, now the Peninsula Hotel just off Fifth Avenue, and watched Jon Voight get thrown down the steps. That was it; that was all I saw of production.

Schlesinger's vision for the film led him to demand extra shooting time to get the cutting options of multiple scene takes; and these extra days led to serious budget overruns. I was concerned, but also believed in John's vision, and hoped the extra money was being well-spent.

John Barry, the English composer who had done the James Bond films for us, among others, was hired to do the score. Many months after the completion of shooting with the budget already heading over $3 million, and some pleading on my part to stem the flow of money, John and Jerry said they were ready to show me the film. They said bring anybody else or just bring yourself.

I'd never done it before, but I decided to invite everyone in key positions in New York to come to this very first screening of the movie. Looking back, I have no idea why I did what I did; maybe it was instinct. Usually I saw the picture alone or with just a few of the key people like Arthur, Bob or Arnold. Usually, I left the distribution (sales) people out of it – I didn't trust their reaction to anything short of obvious commercial material like *The Great Escape* or *The Pink Panther*. The marketing people were more sensitive, but each film is a different case, and *Midnight Cowboy* was a different case altogether. Nonetheless, I just decided to ask everyone. The bosses - Krim, Benjamin, Arnold Picker - as well as marketing, US sales, international sales, the whole bunch, probably forty people. The screening was on 54th Street between 11th and 12th Avenues at 10:30 a.m. Before the film, John arrived and told

me that John Barry's score had been laid in with the exception of the main title theme, and they had put in a pre-recorded song that would work for *this* screening.

Because of my background, I'm always aware of the physical nature of the room in which I see a movie. I had been in this odd screening room several times before, and I didn't like it. It had soft green walls, and the screen was covered with a green lit curtain that as the lights dimmed, didn't rise up and divide or separate from the center. This curtain exited in its entire length from left to right, and I know I thought as it started its odd movement that it seemed an appropriate presentation for this odd movie that I was about to see with forty other guests, none of whom had anything to go on except some production stills.

So began the first screening ever of *Midnight Cowboy*. John Schlesinger was sitting right behind Arnold, and I was a row further back (always on an aisle). One hundred and thirteen minutes later it ended. The curtain slid back across the screen as Harry Nielsen's singing voice faded into the far distance. Looking back I can say, *was there ever such a moment?* The silence was absolute. It was so quiet you could hear it. And then my beloved Arnold, the tough guy, one of the owners of the company that had permitted me to take a risk on this dark little book, turned to John and said in a voice that could be heard by everyone in the room – and perhaps I romanticize as I write this: "John, it's a masterpiece." And like letting the air out of a giant balloon, the room exploded.

A few of us went to lunch. I asked John about the Harry Nielsen song, and why we just didn't use that? Jerry and John said they were so over-budget, blah blah blah. I agreed that we should just buy the song and use it. No one could envision the film without it. That's how it became the film's theme.

The challenge in marketing the movie was obvious. There was no way the MPAA rating Board would give the film an R, thus permitting it to be released in all the usual outlets with all the usual ads in all the usual papers. There just wasn't anything usual about the film. So it was decided we would rate the film X ourselves and take whatever commercial consequences would result. I don't

know what John expected, but what he got from United Artists was total unequivocal support for the preservation of the film's integrity. John asked me one more thing unexpectedly and I was surprised when he asked. Never before had any filmmaker asked that their film not be released in South Africa until the end of apartheid. Foreign markets all had challenges whether it was censorship or political or cultural matters, and it was a battlefield on which we often had to make compromises. In this case, John asked us to make an exception and when I put it to Arnold as head of all things international, he agreed and John was very grateful. So we had an X rating, limited theatrical distribution, limited advertising outlets and a marvelous movie. It all worked. The film got reviews, did business everywhere and was nominated for many Oscars. Jerry Hellman, in accepting the Best Picture award with one of the shortest speeches on record, thanked the Academy and he thanked me.

Shortly after the Oscars, the MPAA (Motion Picture Association of America) re-rated the movie. One day it was an X. The next day it was an R. Wonders never cease.

As always, or most always, there are follow-ups with our filmmakers. John clearly wanted to continue the UA relationship, and so did I. When the dust settled, we had a chat. He looked me right in the eye and said he wanted to make a movie about the assassination of Trotsky. I know I stared at him. I'm not sure if my jaw dropped. I could just see some actor with an axe in his head slumped over his desk in the last scene of the movie in a theater with nobody sitting in it. Or something like that. He saw my face and said, "Okay, forget that. I want to do the Nathaniel West book about Hollywood called *The Day of the Locust.*" A movie about Hollywood – oh boy, not my favorite idea - and I'd read the book and didn't like it. So that's what I told him. "I read the book, and don't like it." UA had made an interesting film in the 1950's with Robert Aldrich called *The Big Knife.* Nobody had gone to see it. MGM had made *The Bad and the Beautiful* – a studio-styled drama and again, not so good. I wasn't a fan of the idea, but I felt I owed

it to John to say that if that's what he wanted to do next, I thanked him for coming to us first, but check with other places to see if they wanted to do it. He looked at me, thanked me and said he'd let me know. Several days later, he called and said he was sending over a script and that if I would do it, he would make it his next picture. It arrived, and I read it. It was *Sunday Bloody Sunday* written by Penelope Gilliatt. I don't know if my reaction to the script was affected by the fact that it wasn't the assassination of Trotsky or *The Day of the Locust* (which John made for Paramount a few years later), though I like to think not. It was provocative, brave, and again, broke another barrier in filmmaking. As a gay man, John was the perfect director to make this ground-breaking film. Two men actually kissed on the screen in 1971. It was about time. We made *Sunday Bloody Sunday* with Glenda Jackson, Peter Finch, and Murray Head. It was brilliant, daring, successful and made us proud that John had insisted on doing his next film with the company who had believe in him and trusted him so much. My friendship with him and his partner Michael Childers lasted until the day he died. He was an extraordinary man.

A Hard Day's Night

"Congratulations to you ."
- John Lennon to the Author

The cliche goes, "It's better to be lucky than smart." In the case of the Beatles, United Artists was both. Would the Beatles have made movies if UA had not signed them before anyone had ever heard of them? Of course, but UA did sign them. Would they have made *A Hard Day's Night* ? No way! How all this happened is the stuff of legend, often constructed, deconstructed and reconstructed depending on the agenda of the constructionist. So here is the actual, factual, unassailable emis (or "truth" as any Jewish fan of the Beatles can attest to).

It all began when Noel Rogers, an executive at United Artists Records and Music Publishing in London, told his boss John Spaulding that Brian Epstein, manager of a rock group called the Beatles in Liverpool, was interested in making a low-budget film featuring the group. Although they were known in their home town, they had little national following, and even less international. Spaulding called his boss Mike Stewart in New York. I had brought Mike in to oversee a reorganization of our overall music operation. The raison d'être for the company was to capitalize on soundtracks and publishing rights for our films, which in the company's earlier days had been sold on an individual picture basis in order to reduce the negative costs of those pictures. Talk about being penny wise

and pound foolish. Rights are everything, and the value that I built up in those years were worth hundreds of millions of dollars.

Mike came to me for an okay on this little deal. Since the group had no film producer attached, only a desire to make a film, it was easy. Soundtrack rights, shared publishing - why not? The deal was negotiated and put on a list of things that might have a future.

Then it happened. The extraordinary night when the Queen of England applauded in time to the rock group from Liverpool. The Beatles became THE BEATLES. And United Artists had them.

Now that we had them, we had to do something about it. The deal called for a film in the £50,000-60,000 budget area, but that wasn't the issue. Who were the right people to make a movie with The Beatles; that was the key decision. After meeting with Brian Epstein for the first time in London, and liking him, it was clear he was going to leave it up to us to recommend who would make a good fit.

This was the beginning of the history of the Beatles and United Artists, a story that had a wonderful beginning and middle, and one of the most shockingly disappointing endings of my life in the movies. It was, basically, all my fault. To this day I am filled with pride at what was created, and devastated how it all ended, devastated and personally ashamed and embarrassed.

If you have never seen a short film entitled *Running, Jumping, Standing Still,* stop reading this right now, go online and watch it. Starring Eric Sykes, Spike Milligan, and a very young Peter Sellers, it showcased the talent of its director, Richard Lester, in an eye-popping few minutes. The Beatles admired the film and had said they wanted to work with Richard. From the moment I saw it I wanted UA to work with him as well, and soon we had the opportunity to do it.

Walter Shenson, an ex-pat American producer living in London, came to us with a sequel to a successful small comedy, *The Mouse That Roared* entitled *The Mouse on the Moon,* and Dick Lester was the director. There was nothing stylishly comparable to *Running, Jumping, Standing Still,* but it put us in business with a talent for whom I had a real enthusiasm. The UA lawyers negotiated with

Shenson's lawyer, Harold Berkowitz, an A-level Beverly Hills attorney, a partner in a firm we had negotiated with dozens of times. The *Mouse* deal was straightforward and predictable. Shenson then negotiated his deal with Lester to direct and they began work on the film, giving all the standard approvals on script, cast, budget and so on. Nice and easy. The film was funny, stylish, delicious. Well-produced, well-directed, well-acted by a group of comic actors led by Margaret Rutherford, Terry Thomas, Ron Moody and Michael Crawford. It was well-reviewed and well-received. All was well with the world.

Now it was Beatles time and, to me, there was only one talent who might know best how to translate this group to the screen. That talent was Dick Lester. Not the talent of *The Mouse on the Moon*; the talent of *Running, Jumping, Standing Still*.

Here's where I made a mistake, the one that still gives me nightmares. I took the easy way. Any film we would do with the Beatles would need a producer, as well as a director. Brian Epstein wasn't a movie producer, he was the boys' manager and he had no ambitions to "produce". He left it up to me to make that decision. The film needed a producer and Walter Shenson was a producer who had worked with Dick, so why not Shenson? I spoke with Walter and Dick, and then turned it over to our legal department to negotiate the deal. They did, and I didn't bother to check the details. The fact is, the way we worked our negotiations was pretty standard. If we had made a deal with a producer before, we usually just rubber-stamped any subsequent arrangements unless there was something unique in the project. The producer usually made the deal with the director we approved, but if it was similar to previous deals the legal department just ran with the ball. There were far too many movies and deals being negotiated at one time to check the details of every one; if there was precedent, that was sufficient.

That's what happened here. The legal department made the deal with Shenson, and he made the deal with Lester. It was all standard stuff. My mistake was that I never told our lawyers that Lester was the key. I didn't give a shit about Shenson, but since he had worked with Lester before, and there was precedent all up and down the line, it

was easy to rubber-stamp the whole thing. That was mistake number one, and it was mine. Mistake number two compounded the felony in a way that still upsets me, and this happened because the legal department agreed to something so unprecedented for UA that it never should have been approved. The lawyers never mentioned it and, needless to say, the top executives of the company never read contracts. They relied on the legal department to point out any unusual aspects of a deal for approval, but no one pointed out to any of us what had occurred in this deal and, in fact, I didn't find out about it until many, many years later when I picked up the trades and read that Walter Shenson WHO NOW CONTROLS THE DISTRIBUTION RIGHTS to *A Hard Day's Night* has made a deal with Harvey Weinstein and Miramax to rerelease the film theatrically. WHAT??!! How did anyone at United Artists grant these rights to Shenson? I felt like picking up the Intercom phone at the UA office and having Herb Schottenfeld and the whole UA legal department come to my office immediately. "What the hell did you do?" I would say in a totally outraged but controlled tone of voice. "Who authorized such a preposterous grant? No one, not anyone on this floor. Who? Shenson was lucky enough just to produce it, no less get any such rights. How could this have happened? When I find out who did it, they're fired. Property rights, distribution rights, in perpetuity, the company's lifeblood. How did this happen?"

Back to "then"...

All I wanted to do was get a Beatles movie made. We had a three-picture deal and already their schedule was going to be a problem. In meeting with Dick, I made it clear I wanted to get a film made as quickly as possible; the specifics of the content were secondary. I would rely on him and his chosen writer, Alun Owen, to create the vehicle. We had a Beatles soundtrack, we had half the publishing, and that was justification for the film all by itself.

Richard and Alun Owen came up with a script called *A Hard Day's Night – A Day in the Life of the Beatles*, a title the Beatles came up with themselves. George Martin and the boys were creating the music and the soundtrack. All was right with the world as far as I

was concerned. I'm not even sure I remember reading the script. I just wanted the movie, and it was in the hands of a filmmaker I trusted. It wasn't £50,000 pounds anymore; it was in the $500,000-$600,000 area, but so what? It was the right price, it was the right director, it was the right group, it was the right music, it was the right time. It just turned out to be the wrong deal.

As always with United Artists, the picture went into preproduction, production, post and final cut without any involvement from us. We didn't even hear the soundtrack. George Martin and the group created it, and Dick and his team matched the story, picture and music all on their own, without a decision of any kind from United Artists. We had been fortunate enough to sign them up. All I heard was that everything went well. I saw a cut of the film in London and was sure that we had a hit, although the film was - how shall I say - highly stylized.

Word came that the finished picture was ready for screening. I was about to leave for Los Angeles with my bosses to meet with some of our major producers on business, the usual jaunt: The Beverly Hills Hotel, Chasen's restaurant, Swifty Lazar, the whole nine yards. The London office shipped the print of *A Hard Day's Night* to Los Angeles for me to screen there. I was excited about seeing the finished offbeat black and white little music film, but the decision where to screen it was suddenly taken out of my hands and led to what had to be the most extraordinarily bizarre first screening of any movie in my career.

The subject of the showing came up with Arthur, Bob and Arnold when by sheer happenstance Harold Mirisch was sitting in our office. The oldest of three Milwaukee-born Mirisch boys, he had been an exhibitor in New York working for RKO Theaters. He ran them similarly to what my father did at Loews Theaters. They were the two major New York chains, had the best locations, ran the product of all the majors divided between them and really ruled the roost. Harold had moved to Los Angeles, and with Marvin and Walter started producing films. He had a home just behind the Beverly Hills Hotel and had organized a dinner at his house in honor of the visiting UA honchos.

You've got it. Harold heard me say to my associate that the print of *A Hard Day's Night*, the new Beatles movie, had arrived and that I was planning to screen it the next day. So he said the unthinkable words, "Let's screen it at my house after dinner tomorrow night."

"Not a good idea," was my response.

"Oh, come on, it'll be great. *Everybody* would love to see the new Beatles movie."

Let me describe in a little more detail who "everyone" would be. "Everyone" was the close cadre of the Mirisch/UA filmmakers; Billy Wilder and his stunning, witty wife Audrey; Billy, the writer and director of such brilliant films as *Double Indemnity, Sunset Boulevard, The Lost Weekend, Some Like It Hot, The Apartment,* etc.; I.A.L. Diamond (known as Izzy, or Izz), Billy's current writing partner, who once spoke loud enough for me to actually hear what he said, and once smiled, though not on the same day. He once looked at me straight in the eye (it must have been an accident because mostly, he stared at the floor); Blake Edwards (the director of *Breakfast at Tiffany's* and *The Pink Panther*); John Sturges who had directed *Bad Day at Black Rock, The Magnificent Seven* and *The Great Escape;* Irving and Mary Lazar, the great agent and his fabulous wife, and of course the brothers, Marvin and his wife Florence; Walter and his wife Pat (neither of whom were a million laughs) and Harold's son Robert, wife Wendy and her sister Toni Howard. Oh yes, and his Business Affairs executive Ray Kurtzman and his wife. That's what Harold meant by "everyone." I'm sure Harold meant it when he said that everyone would love to see the new Beatles movie. I'm sure they would, I thought. But I knew one thing for sure; not one person in that group, let alone in Los Angeles, had seen *Running, Jumping, Standing Still.* They would be in uncharted territory.

The way it worked in Harold's house was similar to most of the private movie palaces in town. There was either a modest projection room with about six or eight seats where the movie was screened, or more often than not as in Harold's house, at one end of the living room, a screen would slide down, and at the other end, perhaps 30 or 40 feet away behind a wall, there was a projection booth I personally hated these types of screenings, even

though I understood the courtesies extended in a company town. As my father's son, I believed in great seats, great projection, and that intimate relationship between viewer and image that only takes place in the darkness of a theater.

I began to protest that this was not a good idea but Arthur, who was oblivious to the decision that had been made on the style of film I had okayed, seemed fine with the idea. "We're all friends," he said. "It shouldn't be a problem." Well, no, no problem if it was Burt Lancaster and Kirk Douglas in *The Way West*, or Jack Lemmon in *How To Murder Your Wife*, but in the style of *Running, Jumping, Standing Still*, I wasn't so sure. So with a look at Arnold who saw my apprehension but did little about it, it was agreed. The first screening of *A Hard Day's Night* would be at Harold Mirisch's house, Beverly Hills, 90210, in front of an audience who would be seated on bridge chairs in the enormous living room of his house after a dinner with wine catered by Chasen's. How's that for the plot of a disaster movie?

Wednesday night, 7:30 p.m., drinks are served. I could barely talk, no less sit. Arnold, who let's say is more sensitive to me than anyone else in the room, is telling me it's going to be fine, even if it's isn't – whatever that means. I know one thing – I'm not ever going to tell Dick Lester that this is where UA had the first screening of his movie.

I remember nothing about the dinner. I could barely sit in my chair. Bob Benjamin, the sweet, dear man, saw my discomfort and smoking his pipe as always, put his arm over my shoulder and told me everything would be fine. I didn't believe it for a second. This group was the cream of Hollywood, and I had no idea how they would respond to a Dick Lester film. Dinner finished, and coffee and dessert was served. The Chasen's staff took down the tables, making more room for the audience to spread out in their bridge chairs. The living room lights dimmed, and on the screen came *A Hard Day's Night*.

On the good side, movie people are almost always respectful of what they are seeing. They may not like it but in my experience, they are seldom rude. They respect the craft, the work and the

effort, if not always the result. I was sitting next to Bob Benjamin, pipe smoke and all. (That's why I remember sitting next to him.) Others were scattered in no great pattern.

A Hard Day's Night only runs about 85 minutes, which is very short for Hollywood standard 'A' films, and it moves quickly. In that day its unique style was as far away, in storytelling sensibility and tradition, as a major studio film could be.

The movie ended in what seemed to me like either 20 minutes or 3 hours and 20 minutes. I only knew one thing – that Dick Lester had delivered everything I could have hoped for and more. The lights came up and there was total silence. No one said anything. They didn't know what to say. Or they did know and didn't want to say it. Bob Benjamin leaned over to me and after a few seconds said, "We're going to make a lot of money, aren't we?" I wasn't sure if it was a real question or not, but the answer was "yes". We had the soundtrack on our record label, and we owned half of the publishing worldwide. Finally the room opened up with a little conversation. How original it was, how unusual, and so on, but it was clear to me that I was getting words with no real meaning: expressions of appropriateness, but little depth. They had seen the unknown and had not known how to respond to it, and the culture that this picture would affect for generations had not yet had a chance to penetrate the sensibility at the Mirisch home. All I knew was that Dick Lester had done what I'd hoped he would, and soon the world would discover it.

Did they ever! The music, movie and the artists will last as long as the history of the planet. I don't know how many times writers, essayists, people from everyday life talk about the influence of *A Hard Day's Night* on their lives, or on the cultural life of our society. What an extraordinary impact a movie can make, and how thrilling to be part of it.

The picture's UK premiere was July 6, 1964, and it did well at the box office, grossing more than $13 million worldwide. Here's an often overlooked fact - in 1965 it picked up two Academy Awards nominations: one for the Alun Owen's script and one for George Martin's musical direction. The album won a Grammy for Best

Performance by a Vocal Group, publishing rights were enormous, and UA had the Beatles. Not bad.

So what next? Well, we had a three-picture deal and Brian and the boys wanted to honor it. There were only two problems. One was schedule, and two, was what to make. Dick had no great idea, but Brian gave us six or seven weeks where they could make themselves available. Dick got screenwriters Charles Wood and Marc Behm to come up with a madcap comedy chase script titled *Help!* so they headed to the Bahamas to shoot. Arthur Krim and I flew down to attend a dinner hosted for them by the Governor General of the Islands, and that night, for the first time, I had a conversation with John Lennon. "Congratulations," I said to John. "Congratulations to you too," he answered, and those were the only words we ever spoke to each other.

Help! was shot on a short schedule in the Bahamas, during March and April 1965, opening in the UK just three months later on July 29, 1965. It was a hit - well reviewed and a box office success earning more than $12 million. Dick Lester, the Beatles and I all knew that *Help!* was an obligation fulfilled by Brian and the boys out of loyalty to us and their contract, but their schedule would probably never permit a third feature. They were simply too successful to take time out of their enormously complex and demanding concert and recording schedules to make a third film, no less actually find one. The second one was difficult enough. Then along came Al Brodax, King Features, and *The Yellow Submarine.*

Al Brodax, a decorated veteran of World War II, started his show business career at The William Morris Agency and subsequently joined King Features Syndicate where he headed their TV and Motion Picture Division, creating cartoon series for such characters as Popeye, Krazy Kat, Beetle Bailey and others. Early on he sensed that the Beatles were the next big thing and he convinced Brian Epstein and the boys to agree to a Saturday morning television cartoon series (a right that they reserved in their contract with UA). I had known about it and accepted it, despite worrying that it might in some way dilute their film audience, but the series was produced and in no way affected the success of their features. Who knows, maybe it helped.

Brodax's agent, Nat Lefkowitz, told Arthur Krim that his client might be interested in a feature version of the Beatles cartoon, so Krim and Lefkowitz put Brodax and Picker together. We hit it off and despite real concerns about an animated feature, a genre totally and almost exclusively (in those years) in the hands of The Walt Disney Company, Brodax and I agreed that the only way for UA to realistically get their third movie was if Brodax and King Features *drew* it. In the capable creative hands of Al and his people, already trusted by the Beatles and Epstein via the cartoon series, *The Yellow Submarine* came to life. And brilliantly, I might add. Under Brodax's guidance, the creative look that so distinguishes the film was drawn by the German artist Heinz Edelmann. It's as brave and unusual as the Beatles' music.

Then in the middle of production on August 27, 1967, Brian Epstein died. The shock affected us all. I could only imagine the impact on the boys. Many people found Brian difficult, but despite all the pressure of money, schedules and artistic creativity that surround handling the most successful group in recording history, he always dealt with UA and me openly, truthfully, and with class. His loss was devastating.

Nonetheless, the picture was completed and the good news was that it worked. It worked creatively, winning the New York Film Critics Circle Award for Best Full-Length Animated Feature, as well as a Grammy nomination for Best Original Score, and it worked financially. An animated film, even one with the Beatles, was not UA's cup of tea, but the audiences loved it. So did the critics:

"The film may be the first burst in a whole new eruption of spontaneous glee. Joyful absurdity. *Yellow Submarine* outdoes Disney." - *Look Magazine*

"It is sheer delight in its concept and execution. The animation is superb...pop and psychedelic." - Judith Crist, *New York Magazine*.

"I doubt that the Beatles can top their *Yellow Submarine*." - *NY Daily News*

"*Yellow Submarine* is the best manifestation of the Beatles yet in film. A classic."- *Daily Express*

"Nothing in feature animation has matched the endless inventiveness of *Yellow Submarine*." - *Newsweek*

You may notice in this book a photo of me with four friends. It has unlocked many a door.

A few years ago at a charity event, I had a chance to spend a few minutes with Paul McCartney. His face lit up when I re-introduced myself, and we both shared a moment remembering those times years before.

It was thrilling for United Artists to be a key participant in the historic, iconic, culture-shaping, early life of the Beatles.

The Ones That Got Away

"You could have had Star Wars"
- George Lucas

Many years ago in response to some reporter who was asking me to comment on a quote from a studio executive who was claiming to have the answer to how he (and it was a he) was able to clearly identify projects that would turn into box office successes, I said something like the following:

"If I had made all the projects I turned down, and turned down all the projects I had made, I probably would have had the same number of hits and flops."

I was being slightly facetious, but nonetheless it was close enough to the truth to have hit a chord that led to its being remembered. Rob Reiner said it would be engraved on my headstone. Peter Bart wrote that it's right up there with Bill Goldman's "Nobody knows anything." Mr. Goldman is the screenwriter of such films as *Butch Cassidy and the Sundance Kid* and *The Princess Bride,* among many others. He is also the author of the best book ever written about the movie business. If you haven't read *Adventures in the Screen Trade* stop reading this book now, read the Goldman book, then come back to this. When he said "nobody knows anything" it was, and remains the wisest thing ever said about our business.

The truth is that my quote genuinely reflects the perilous nature of taking oneself too seriously, and clearly the history of

Hollywood decision-making is replete with people taking credit for things they may indeed have had little responsibility for (a lot more of that in the Paramount chapter), and distancing themselves from any disaster, especially if that disaster can be pointed at someone else.

So let's take a look at the ones that got away, the ones that I wish I'd been either smart enough or lucky enough to say yes to, or the ones I just couldn't get approved. If you think they don't hurt for more than just a minute you've got, as they say, another think coming.

We'll get started on an easy one: *The Graduate.* Larry Turman, a producer I respected, sent me the book with Mike Nichols attached to direct as his first feature. I read the book and didn't get it. I didn't see the humor, the satire or the potential impact. It wasn't complicated; I just didn't get it, and none of the studios did either. Larry was able to get Joseph E. Levine's Embassy Pictures to put up the money and, ironically, I was able to secure the international distribution rights for United Artists after seeing the film, paying more for them than the entire film would have cost if we had financed it from scratch and had the whole world. *The Graduate* became a classic, but not for United Artists.

The next three — *Bonnie and Clyde, Planet of the Apes,* and *American Graffiti* — were much more painful.

David Newman and Bob Benton had optioned their original screenplay for *Bonnie and Clyde* to two independent producers, but retaining for themselves approval of the director. When I read the script I wanted it for United Artists and saw in it the opportunity to do something unusual with a classic American gangster story. I had an idea to find a non-American director to give the material a freshness that would separate it from other gangster movies. François Truffaut, the brilliant French director, was my choice. There were conversations, but nothing materialized. I should note that in the years subsequent to that UA was privileged to make four movies with François: *Baisers Volés* (Stolen Kisses), *La Mariée etait en Noir (The Bride Wore Black), La Sirène du Mississippi (The Mermaid of Mississippi),* and *Enfant Sauvage (Wild*

Child). Nonetheless, the two independent producers had no luck setting up the project.

As head of production, one of my daily rituals was reading the title registration bulletin from the Motion Picture Association of America, where studios and companies could protect their new titles from usage by others. It was a good way to keep up with what projects the competition and independent producers were working on. One day there it was, *Bonnie and Clyde*, registered by Tatira Productions. "Who the hell is that?" I asked myself and found out it was Warren Beatty. So I called Mr. Beatty. He was thrilled that I was interested and he referred me to Abe Lastfogel, his agent, who ran the William Morris Agency. Abe, a good friend of the company, had always supported our philosophy and we were in business with many of his key clients. The Morris office in those days still reflected the old ways of doing business. They were tough but they were fair, and all of their key agents were a pleasure to do business with, such as the late Stan Kamen, Joe Schoenfeld, and many others, including Lenny Hirshan, Clint Eastwood's agent. Eighty-two years old, and still representing Clint today.

Abe himself was special. I laugh every time I think about him because he was tough, he was very short and he loved to play golf, very often at lunchtime. The agency had their table at the Hillcrest Country Club only a few minutes from the office. A pastrami sandwich, a kosher hot dog, and a 9 hole run around the golf course in less than an hour. Abe did not walk; he ran. I'm 6'3", considerably younger, and I had to run to keep up with him.

"Listen, kid," he said to me one day, "do you bathe or shower?"

"Shower."

"I bathe, and I turn myself sideways in the tub – not lengthwise, sideways – and I put my two legs up straight against the wall and I pat myself hard on my stomach with both hands 100 times. That's what I do. It's healthy. You should try it."

I looked at him in amazement. The image he projected was so humorous I could hardly keep a straight face. A naked Abe, 5'2", legs up, stomach patting … I'm longer than the tub, and he wants me to try it. Anyway, Abe is Warren's guy and that's who we have

to deal with. Here was the problem: I had to go to Spain to solve an issue on *A Funny Thing Happened On The Way To The Forum,* so I asked Arthur Krim if he would deal with Abe on this one. They'd had a long and positive relationship over the years, much longer than mine, and they were friends. I really pushed Arthur to make the deal and make it quickly, and he supported my enthusiasm. I thought we'd be in good shape. What I forgot to consider was one thing. Arthur was the same height as Abe, maybe an inch or two taller, and though they were friends, both were tough negotiators. It became a pissing match over a $150,000 difference in the budget of the film. Abe wouldn't budge, Arthur wouldn't budge, and in no time – a day or so – Abe set up the movie at Warner Bros. It broke my heart to lose the film.

Two interesting things happened as a result of the Warner Bros. deal. Warren Beatty had serious reservations about the way Warners was suggesting to distribute the film in both the United States and abroad, and he came to see Arnold Picker and myself for some added insight. There are few people smarter about our business than Warren, and the friendship that began then has remained to this day. He knew how much I wanted the movie for UA and over the years, from *Heaven Can Wait* (my time at Paramount) to the mess of *Ishtar* (my time at Columbia), he has always been open and ready to talk. Warren's life has been a Hollywood drama from the beginning. Every movie he has made, every woman with whom he has been, every decision he has made in his life has been chronicled and become part of the Hollywood vernacular. When we met for the first time on *Bonnie and Clyde,* we found that we loved talking about movies and talking about this project. We never hung out, never talked women; we just connected as two men who loved what we did, and the long-distance relationship has survived to this day and has been special to both of us.

On to Arthur P. Jacobs, a first-class Hollywood publicist who successfully made the transition to producing. He was one smooth, smart guy. I was in Las Vegas on some business, and Arthur asked me if he could show me some drawings for a project he was hoping to get financed. He walked in with half a dozen large, beautifully

illustrated scenes of people whose faces look ape-like. The project, titled *Planet of the Apes*, was based on the Pierre Boulle novel with a screenplay by Michael Wilson and Rod Serling. It was quality stuff. I am not a sci-fi enthusiast by any stretch, but somehow this seemed to me like it would have great possibilities. It was also expensive, so I asked Arthur if he would bring the presentation to New York to show Krim and Benjamin. He agreed, and shortly thereafter the date was set. It looked like it couldn't miss to me. He and I were both excited.

There's no point in dwelling on the meeting. We showed the artwork to my bosses. They told Arthur they'd get back to him that day, but I wasn't happy with my perception of their response. When Jacobs took his pictures and left, it took no time for them to confirm my feeling. Bob's quote was simple: "Who wants to see a movie with people dressed as gorillas?" How do you answer that one? "Everyone?" "Almost everyone?" I couldn't persuade them. It was a very expensive roll of the dice and they didn't get it, and I had to live with it.

It wasn't long after that Sam Gelfman who worked with me at the company suggested we buy the rights to a series of the books written by J.R.Tolkien called *The Lord of the Rings*. I didn't relate to them, but based on Sam's enthusiasm, I okayed the deal. Some years after I left the company, they made an unfortunate animated film with Ralph Bakshi that I never saw and subsequently the book rights were passed on to Peter Jackson. The rest is history. I never saw that potential in the material, but Sam did.

A few years later, Arthur Jacobs called again and came to see me with a musical version of the book *Tom Sawyer* and said he had *Reader's Digest* interested in investing. It led to one of the most amusing meetings of my career.

The *Reader's Digest* empire was based in Pleasantville, New York, run by DeWitt Wallace and his wife Lila Acheson Wallace. To close a deal for their investment, they requested a meeting with me, and so Arthur and I were invited to their offices for lunch. Mr. Wallace was a conservative icon who demanded love of God and country from all his *Reader's Digest* employees. Their cars in the parking lot

were constantly checked to make sure of the proper placement of the American flag on their bumpers and so on. Lunch was in the executive dining room. Our goal was simple: to get Mr. Wallace to sign off on a multi-million dollar investment in a musical version of *Tom Sawyer*. By doing that, we'd not only have their financial support but clearly they would use their magazine pages to ensure that their readership would show up in droves to see this great American classic on the silver screen.

That's what I was thinking when I walked into the prim, proper and oh-so-dainty dining room of *The Reader's Digest*. The waitresses wore black dresses with white lacy aprons and, I swear it, black patent leather Mary Janes on their feet. Small talk ensued and in walked Mr. Dewitt Wallace – tall, confident, Protestant, the master of all he surveyed. I was hoping they hadn't checked my car for the American flag. We sat, there was some small talk along with our soup, then Mr. Wallace looked up to address us all.

"Mr. Picker," he says, "I have to tell you I don't go to the movies."

And he stopped. To this day I don't know how I came to say what I did, but I said it, and it was an outright lie.

"That's okay, Mr. Wallace," I said. "I don't read your magazine."

We got the money. The movie flopped. I would have traded it for *Planet of the Apes* any day.

In 1971, I saw *THX 113*. George Lucas was a young director who interested me, and so we met and agreed he would develop a film for UA. The project was entitled *American Graffiti*. George and Gloria Katz and Willard Hyuck wrote the script. When it was delivered, it was budgeted at under $750,000, and in my opinion was worth the risk. Most of the time my approval to go forward was enough for a green-light, but for some reason that I can't remember, Arthur Krim asked if he could read it. He read it that night and told me he didn't think we should make the film.

"Why not?" I asked him.

"Because it's not about anything."

So we argued. I tried to explain that it *was* about something. It was about kids and a special moment in their lives and so on and so on, but I couldn't persuade him, and here was my problem. I

could generally get anything I wanted made. Arthur rarely put his foot down and when he did, he got very stubborn. After all, it was his company. When I look back now, we took real chances and it was because I was supported in what I wanted to do, going back to *Tom Jones* and *Midnight Cowboy* and *James Bond*. So how could I go to the mat for the occasional time when Arthur didn't get it? I wished I'd pushed harder – maybe I should have, but I didn't. UA put *American Graffiti* in turnaround, and Universal picked it up. And you know how that story ended.

While we were developing it, George had sent me a short outline of a science fiction film. It was much too soon for us to contemplate anything before we made *American Graffiti*, and so it just sat there and then went away, along with our relationship with George. Every time I see him, he delights in smiling and saying "You could have had *Star Wars*"..... because that was the title of that little outline.

How true. We could have had *Star Wars, Planet of the Apes, Bonnie and Clyde*, and *The Graduate*. We could have had them all.

An Officer and a Gentleman

"You have my word."
- Jerry Weintraub

Talk about a Hollywood story. Here's what it took for *An Officer And A Gentleman* to arrive at your neighborhood multiplex and become a big box-office success. A long-forgotten agent sent me a script written by Douglas Ogden Stewart entitled *An Officer And A Gentleman*. He told me it was owned by Jerry Weintraub, a well-established producer and friend of mine who had an exclusive deal at Universal. Rumor had it Universal wasn't interested.

I was running Production at Lorimar at the time and was looking for commercial projects; not fancy arthouse indie stuff, but big box-office stuff. The company was owned by Lee Rich and Merv Adelson, a truly odd combination. Lee's very successful career had mostly been in television. He was smart, easy to work with, and low-key up to a point. Merv was relatively new to the business - bright, aggressive, opinionated, enjoyed the company of the Las Vegas crowd. He had a private jet, a lovely wife, and he was smart, but inexperienced in big-time movies. I was there to bring them into the film business.

Several days later, Jerry called back to say Universal had passed.

"We'll be happy to do it with you," was my response.

"I'm exclusive to Universal," he said, "and Paramount's already called wanting to make a deal, but I told them you had called me first."

Now that was a big deal. A major producer who could have played a studio against an independent did the honorable thing. Although Jerry and I knew each other, we'd never done business. He was simply honoring a conversation.

"It's yours for what I have in it to date," he said.

I agreed, and the deal was done. Lorimar now owned *An Officer and a Gentleman.*

I called Marty Elfand, a former agent turned producer, a three handicap golfer, and a pal, to tell him that he was now the producer of *An Officer and a Gentleman.* I knew Taylor Hackford was interested in directing, so I brought them both on board.

Merv and Lee liked the script, but Merv asked me if the U.S. Defense Department would assist in the making of the film. The military had an office for coordinating cooperation on film productions that they believed would send the "right message" to moviegoers worldwide. I already knew the answer to the question because Weintraub had told me they had turned the film down. Knowing that Marty Elfand had found a way to do it without the support of the U.S. Air Force, shooting in both Washington state and Alabama, I was prepared to go forward that way and told Merv so.

"I don't want to do this film if the government won't cooperate. That's my position and that's that. If I had known that going in, I wouldn't have bought the script," said Merv.

I tried every argument I could muster and Lee chimed in as well, but Merv wouldn't budge. There was on the surface no sound reason for his position. Movies on the military had often been made without government cooperation. Nonetheless, Adelson was adamant. I called Marty to tell him two things; first, that we weren't going to do the movie, and second, to call anyone in production at Paramount, from Eisner down and tell them he might, just might be able to get Picker and Lorimar to give up the project. Knowing of their interest through Weintraub, my instinct was they might step up and if it was hard to get, and they really wanted it, they'd agree to pay more.

"Marty, tell them you're the producer, Taylor's the director, and let's see if they bite."

Bite they did. And good for them. They smelled what I did—a big fat potential winner.

It didn't take long. The deal was easy - a lot of cash, but more important 7.5% of the gross, just as if Lorimar was Steve McQueen or Clint Eastwood. And, oh yes, Executive Producer credits for Merv Adelson and Lee Rich.

The movie's success paid off big for Marty, for Taylor, for Lorimar, and for Paramount. And I had the pleasure of making all my friends rich. The only thing I didn't have was a piece of the action.

The Greatest Story Ever Told

"Surely he must be the
Son of God"
- John Wayne

It wasn't until recently that I realized what led me to a decision that almost bankrupted United Artists. The roots of this calamitous event go back to 1939, when I saw what I still believe is one of the greatest movies ever made, *Gunga Din*, directed by George Stevens. I have seen that film more than any other in my life. *Gunga Din* has everything that makes movies fabulous: a great story, the great Cary Grant, Douglas Fairbanks Jr., and Victor McLaglen, men's men and women's men, and villains to hiss at - Eduardo Cianelli and Abner Biberman (in black face, believe it or not, but that was 1938-39). Then there is the ultimate hero - the downtrodden, bullied and beaten Sam Jaffe (also in black face) as Gunga Din, the water carrier whose action saves them all. His image at the film's end is superimposed over the night-lit tents, a tribute to his heroism, valor, courage and sacrifice. "You're a better man than I am, Gunga Din." I defy you not to cry. This may have been the reason I joined Krim and Benjamin in agreeing to finance *The Greatest Story Ever Told*, the story of Jesus as played by Max Von Sydow and filled with half the character actors in Hollywood to be made by that great American director, George Stevens. They just did not come any better. The man had made *Swing Time, The More The Merrier,*

Woman Of the Year, Gunga Din, Penny Serenade, Giant, A Place in the Sun, Shane, and *The Diary of Anne Frank.* How could a company not want to work with George Stevens?

On a fateful day in 1963, Charlie Feldman, a great agent and friend, called Krim and said he believed that Twentieth Century Fox, who had a deal with Stevens to finance his film version of Fulton Orsler's best seller on the life of Christ, were prepared to let it go. They felt it didn't fit with their new production plans and were adjusting their schedule to give it up if Mr. Stevens could find another studio. So we flew out to meet the Master. And he was mesmerizing. His plans were grandiose and expensive. Conceptually he was going to break with tradition and film the biblical epic in America, so that there would be a startling but exciting visual differentiation from all previous bible epics. The reds and browns of the Southwest would be the background against which this version would play. Not only would he shoot in 70mm, but the sound track would be technically head and shoulders above any that ever been conceived by the techie boys at the Goldwyn Studio Sound Department. And the cast? Every name he could attract would want to be part of this. He was brilliant. I understood about thirty percent of what he was talking about technically, but then I was youngest participant by far in the decision and I didn't have the nerve to say to my superiors, "Technically, do you know what the fuck he's talking about?" They didn't say anything either. Maybe they didn't know any more than I did, but I know that we sure were all excited. What a coup! This project couldn't miss. The man who made *Gunga Din* was going to make a movie about Jesus Christ for United Artists.

A deal was struck and we took over the project. George had given us a complete budget of $9 million - at that time the most expensive picture we had ever financed - and we flew back to New York, all smiles.

The Greatest Story Ever Told began our greatest battle ever fought. George Stevens turned out to be a very deliberate man. No decision was made quickly, and most often no decision was made at all. Since

we gave control to our producers, once a budget was approved we were kept up to date by production reports that indicate the number of pages shot daily, the number of feet of film shot, and weekly budget summaries. Two weeks before shooting began in Arizona, we were already over budget. Arthur asked me to go out and visit George and see what if anything could be done about moving things along and bringing down the cost. George, always polite and informative, explained the difficulty of shooing an epic of this size, but said he would see what he could do. You understand that I'm 32 years old talking to the man who made, need I say it again, *Gunga Din, Shane, A Place in the Sun,* and *Giant,* and he is telling me he understands our concern and that he will try to address it as quickly as possible. (Right!)

I'm sure you get the idea. Shooting started, and we were looking at a $10.5 million budget. The production reports started to show slower work partnered with more budget overruns.

It was clear that George knew something that United Artist had not yet come to realize: *there wasn't a lot we could do.* On most films, there is often a way to solve budget problems with professional answers provided by filmmakers who want to help or, in a worst-case scenario, could be threatened with takeover or legal action, etc. With the *Greatest Story Ever Told,* George had us by the scrolls. There was nothing we could do. We couldn't take it over, we couldn't shut it down. Could we try crying? No, we couldn't; we were fucked.

I'm getting daily production reports because of all the problems and a report came in that nothing was shot this particular day. Nothing!!! I called the production manager.

"What the hell's going on?"

"He's rehearsing," was the answer.

"REHEARSING? For whole day? Are you crazy"

"That's what he's doing."

"Rehearsing? Rehearsing what?" (*Gunga Din* was not going through my head anymore.)

"A tracking shot."

"A tracking shot? What are you talking about, he's rehearsing a tracking shot? What shot?"

"The one where the sun rises over the sleeping disciples."

"Excuse me?"

"You heard me."

"I'm coming out."

First, I went to my bosses with the bad news that Mr. Stevens, who was already heading towards a $14 million movie, was rehearsing a tracking shot of sleeping disciples on some rocks for three days without the cameras turning. I was on my way to Arizona to see what I could do.

"David, don't you understand the importance of this shot?" said George. So here's what I was able to do. Nothing.

He rehearsed for three days and then got his shot. It was gorgeous. It lasted twenty seconds, as I recall.

I called Arthur and asked him if he had any ideas. This is what he said: "Tell George that if he doesn't bring the film under control, he could bankrupt our company." Great.

"George, Arthur said to tell you we need your help. If you can't get the show under control, you could bankrupt our company."

"David, I understand. Let me see what I can do."

Several things were going through my mind. One of the most exciting was - that whatever the cost - George was making a great movie, and in the end financially we'd be okay. The other thing was that several other of our films were showing real power. James Bond looked like a franchise, and then there were these kids from Liverpool that sang and looked like they were going to be hot, and their first movie was on the way.

The picture eventually finished shooting. The total cost was $20 million, and that's a lot of money. Just to give you a sense of comparative costs in those years: *Dr. No* cost $1.3 million; *A Hard Day's Night*, $400,000; *Never on Sunday*, $140,000; *Lilies of the Field*, for which Sidney Poitier won his Oscar, $250,000; and 10 years later working with Bob Fosse on *Lenny*, we shot 18 - count them, 18 - six-day weeks with six weeks' rehearsal, used just under one million feet of film, paid Dustin Hoffman $750,000, and the movie cost $3.5 million.

George cut the movie together and invited us to see it. For reasons I forget, Arthur couldn't make it, but Bob and Arnold did.

We were delighted; worried because of the cost to be sure, but we figured we had a winner, as did our sales and marketing executives.

The picture was scheduled to open on a reserved seat basis at The Warner Theater in Times Square. Because of the delays in shooting and a very complex post production, we had to open in New York with a big advertising campaign but no screenings, since George was only going to deliver the print two days before the premiere. There was a test screening scheduled and Arthur, who had not seen the film with us in Los Angeles, went to the morning run-through. Arnold, Bob and I waited anxiously for his return to bolster our belief that we had weathered the storm.

Arthur didn't walk, he shuffled hunched over somewhat, so as he returned from the screening his physical presence gave off no clue to his reaction.

"It's a disaster." That's what he said. "It's a disaster."

I have to tell you it had never crossed my mind. I believe the three of us had convinced ourselves it was good because it just *had* to be good, for the good of the company. We were in a state of shock. A $20 million disaster. There was never finger-pointing with this family of men. The hits were all ours, as well as the flops. So there was no guilt; just shock.

There was a preview that night before an invited audience, mostly people in the company, their friends and so on; an audience that normally would bend over backwards to be positive. And they were, almost to the end of Part One. The movie, 70mm, reserved seat, over 3 ½ hours long, had an intermission. The last scene in Part One is Max Von Sydow as Jesus riding a mule into the city being greeted by the local citizenry waving their palm fronds. On the roof, a group of Roman centurions led by John Wayne are watching the activities below. Wayne speaks as only John Wayne could and, as I remember, it was his only line in the film. Wayne looks down and drawls, "Surely that must be the Son of God." The audience howled with laughter. They didn't titter, they didn't chuckle, they howled.

There went $20 million dollars down the drain. All because of *Gunga Din.* I guess John Wayne was just in the wrong movie.

Hawaii

*"Scene 16: The ship enters
Lahaina Harbor."
From the screenplay by
Dalton Trumbo and Daniel Taradash*

The script read simply, "Scene: The ship enters Lahaina Harbor." The movie, *Hawaii,* based on James Michener's enormous bestseller, with a screenplay by Dalton Trumbo and Daniel Taradash, was being directed by George Roy Hill. In 1964 George had directed a delightful film for United Artists called *The World of Henry Orient* starring Peter Sellers and cast by Marion Dougherty. It was the first film under the new UA to play the prestigious Radio City Music Hall. Little did we know then that this combination of director and casting director would cost us big-time. Years after *Hawaii,* George directed such fabulous movies as *Butch Cassidy and the Sundance Kid* and *The Sting.* He was a talented man.

Michener's thousand pages covered the entire history of the magical islands, from when they first appeared above water from the ocean depths near the beginning of time to the present day, from their first native habitants who had paddled across a vast sea to form a new civilization to the monopolistic grandees who owned all the pineapples and Mai Tais grown and stirred in that part of the Pacific. From peace to war, from fathers to sons in all generations, this epic book was to be one very long, gigantic, commercial spectacle of a

movie, given into the hands of Mr. Hill and his producer Walter Mirisch, whose only major talent was to have been born a baby brother to the brilliant Harold Mirisch. United Artists had greenlit its most expensive production ever. We should have known better.

The film had been shooting for some weeks, and was already behind schedule and over budget. Part one, the early establishment of the foreigners into the native islands, starred Julie Andrews and Max von Sydow and a cast of thousands. There were more than a few major roles for the original Hawaiians, and Ms. Dougherty had cast them brilliantly, mostly from Samoa. The performers were exciting visually, had real acting skill, and were totally professional. They weren't the problem; George was. He was demanding—okay. He was meticulous, up to a point—okay. He was also totally uninterested, incapable, or perhaps just over his head in guiding the project financially within the framework he'd agreed to when the schedule and budget had been approved.

So, here's where we get to "The ship enters Lahaina Harbor." Simple enough. The sailing ship with the new settlers from America arrives and is joyously welcomed by the native population. Canoes are paddled out, natives clamber aboard bearing gifts, food, and flowers. Even with proper preparation, shooting on water is not the easiest challenge a filmmaker has to manage. It was scheduled for several days. As each day passed and Mr. Hill was unsatisfied or unable to get what he wanted, he got not only more frustrated; it got way, way more expensive. He would not compromise. It looked like this one sentence was headed for a three-week disaster. Complaints to the producer, Walter Mirisch, fell on his incompetent ears like the petals of the leis that were strewn all over the set. With the picture nowhere near completion, there was one option left: Goodbye, Mr. Hill. Hello to a new director. Firing a director off a film is not only a sad and unfortunate option, it also requires time for the new director to get familiar with the material, with the crew, with the film already shot, and so on. It's an option of last recourse, but in this case it had to be done.

By rule of the Director's Guild of America, no director could be hired to replace another until the original is notified that he or

she is off the movie. Of course, this is an almost impossible rule to follow, since from the financing and the producing position you've got to know how you're able to proceed. So, understandably, many "what if" conversations take place. In this case, the "what if" was with Arthur Hiller, a solid professional. He was likable, available, interested, and prepared to take over immediately and continue shooting while catching up on the job. Everyone knew the picture was in trouble. Everyone knew that something had to be done. No one knew what United Artists was actually going to do, but the fact that David Picker was coming to the location on Oahu about 40 minutes outside Honolulu caused serious speculation.

I'd known Marion Dougherty from her casting work in New York. I knew her to be a good person, and I knew her to be professional. What I didn't know was that she and George had been friends for some time—I mean close, very close. George was married, had a large family, and I knew him and liked him, but I knew nothing about his personal relationship with Marion. Marion was also married, but her relationship with George remained constant to the day he died. It was real and caring and devoted.

I flew to Hawaii. Arthur Hiller waited in Los Angeles for my phone call to hop on a plane and take over. On arriving I went to the production office and was brought up to date on the latest numbers. It all translated into major trouble. George had to go. I'd been told that the great John Ford, director of *Stagecoach*, lived on his boat at a marina nearby and had asked if I could come by and say hello. I was thrilled and stunned. To just meet John Ford was worth the trip, and the hell with *Hawaii*. At the same time, I was curious about why he wanted to say hello. He didn't know me—he was so badly sighted I understood he stayed most of the time in a dark room below deck—but I could not wait to meet the great filmmaker. He had directed a film for us at UA some years before, *The Horse Soldiers*, produced by the Mirisch Company, and it was hardly vintage Ford. It turned out that Mr. Ford had a message for me. He wanted me to know that he had met Mr. Hill and he was very impressed with him, and hoped that whatever problem we had could be solved between the two of us. I was stunned

and surprised, but it was clear that the word was out, and in Mr. Ford, Mr. Hill had some messenger. I obviously thanked him for his input. The only other time I saw him was the night of the first American Film Institute Tribute in 1973, when the then-dying giant was honored by the industry who loved and respected him so much. The evening was attended by the President of the United States, Richard M. Nixon. Even he could not sully the dazzling tribute to one of the industry's great artists.

Back at the production office, I was told of a company luau scheduled for that night long before my trip was planned. I thought to myself, "Some going away party for George." When everyone had left the brief meeting, Mr. Mirisch said, "We've got a problem." It was never *"I've* got a problem", because he could never solve one. He was right, we did have a problem. After everyone left the room he said, "I don't think we can fire George." I was speechless. "Marion Dougherty has gone to all the Samoan actors and got them to agree that if George leaves the film, none of them will continue to work on the movie. They'll all go back to Samoa, and we'll have to reshoot the entire film to date." The only thing I could think of was, "Brilliant; checkmate. She saved her friend's ass." So, Arthur Hiller stayed in Los Angeles. The luau, which I had thought might be a farewell and thank-you to George, was a welcome back to George. I had to smile at the guile, if not the gall of it all. (Thank you, Stephen Sondheim.)

There was only one way to deal with the budget. We cut out an entire section of the script. The film was still over budget and not very good. George went on to make great films and he and Marion continued their lives, separate and together, until the day he died. Marion later joined me as a partner in my company, and we, too, remained friends until she died last year.

Aloha.

Leonard Part 6

"We've saved the picture, man."
- Bill Cosby to the author

How does such a disaster happen? I've been involved in enough of them to know that at some point a simple "no" or "it's not good enough" would have been an honest assessment. But sadly it's not always as easy as that. George Stevens was a great director, and I was part of the management team that said let's take over *The Greatest Story Ever Told* from our rival company, Fox. Why didn't we know what was going to happen? Every sign said *Heaven's Gate* was a scary project. When Michael Cimino said to UA's top brass, "If you don't approve Isabelle Huppert as the co-star, I'll take it to Warner Bros., who wants it," all UA had to say was "Go ahead and take it." Did Disney have to make *John Carter*? Or Warner Bros.'s giant spectacle *Battleship Earth*? Or Disney's *Mars Needs Moms*?

At Columbia, Bill Cosby was seen as a safe bet. A giant TV star, a partner of the parent Coca-Cola in a Philadelphia bottling company, he promised to promote his own dream movie. He had written it, was starring in it, producing it, so how could he do anything but support and deliver his audience? Well, welcome to the wonderful world of Bill Cosby.

The picture was shooting when I joined Columbia as head of production. The great man had been high on Paul Weiland, the young British director suggested by the studio. Cosby was

producing, casting, masterminding the entire show, supportive of the director while despising the line producer, Alan Marshall, calling him a racist. Marshall wasn't a racist; he pissed over everybody regardless of race, color, creed, or sex. It was his style. Every major decision was Cosby's. There was only one major problem: Cosby's script was terrible and, never should have been greenlit.

When I saw Mr. Cosby's cut it looked hopeless. It wasn't funny, the performances were dreadful, and all the megalomaniacal creative control Mr. Cosby had been given delivered little of value. Cosby and I decided to try recutting the picture and then perhaps add narration, subtitles, anything that would give it some style, some humor, some anything. We worked for several weeks with a new editor, and finally agreed that we had done all we could. At the end of two weeks in the cutting room, our star put his arms around me and thanked me by saying, "We've saved the picture, man." Well, at the very least we tried.

Mr. Cosby promised to market *Leonard Part 6* to his audience - not an unreasonable commitment since he had been paid well over $5.5 million for his involvement. Nonetheless, some weeks before the opening date he felt an obligation to his fans to announce on Larry King's national TV show that he didn't know if *Leonard Part 6* was good enough. "It's not my picture," he said, thus guaranteeing that whoever might have considered buying a ticket because it was a Cosby film should just forget about it.

At no time did this gentleman offer to repay the $5.5 million he was paid but, hey, I'm sure in his head (surely not his heart - wherever that might reside) he was entitled to every nickel, since clearly none of what went wrong on *Leonard Part 6* was his fault. I wanted to sue the bastard for his fee and for submarining whatever little (how about "no") chance the film ever had.

Upon hearing my *Leonard Part 6* lament, Herb Gardner said it best. "It has been medically proven that Bill Cosby is full of shit." And here endeth the lesson for the day.

Leap of Faith

"I'd like to fire the director"
- Author to John Goldwyn,
President, Paramount

The plane touched down in Dallas, Texas, as I finished reading the script for the fourth time. Two days earlier, I was sitting quietly in my Los Angeles office working on several projects when the phone rang and the trouble began. Why did I say yes? I damn well knew why – because they asked. Brandon Tartikoff, the president of Paramount, and his head of production John Goldwyn had a movie with a problem, it's title, *Leap of Faith*. Its star was Steve Martin. Asking me to help was logical since I was instrumental in starting Steve's film career and clearly had a good relationship with him. Whether the suggestion of my coming on board came from him, I never knew, but Brandon and John asked me to take over the producing of the film. The first day of shooting was 72 hours away.

Why did I go? Okay, I was helping friends, I was being well paid, but with each reading of the script, the more I sensed trouble. Not because the script was bad; I just didn't understand why it was being made at all, no less scheduled for release on December 18, 1992, as Paramount's Christmas movie.

My own career has been filled with errors of judgment about box office potential, casting, directorial choices and marketing campaigns, yet somehow this one seemed an easy call. Why would any

company green-light a picture about a traveling religious con artist who could convince suggestible small-town America that he could perform miracles in the name of God? The subject matter alone was enough to stack all the odds against its success. Sophisticated audiences wouldn't be interested, true believers would be offended, and the audience for Steve Martin movies wouldn't come because it wasn't funny. In addition, Steve had never done business in the international marketplace, and the subject matter would have no international interest or understanding. So what was left? Nothing. But I guessed helping friends was reason enough.

There had been two producers. One had either just fled or been fired, I never really found out. The other was a very nice Michael Manheim whose wife, Janus Cerrone, had written the script. Michael had no real experience on a big major studio film, but he was there and had to be dealt with. He was neither the problem nor the solution. The problem was not only the project itself but the choice of director, Richard Pearce. His total experience had been independent low-budget films, and he had done some very good ones, but they were entirely different from what he now faced. Absent any producing supervision, he, along with his experienced and brilliant production designer Patricia von Brandenstein, had taken over the film. The production manager, a pro named Ralph Singleton, didn't have the position nor the authority to intervene, nor were they interested in his opinion. The film was all set to go, all the locations chosen and the construction of all the major sets underway. The cameraman Geoffrey Murphy had worked with Pearce on several of his small films and had a very good relationship with him. That was the situation *behind* the camera.

In front of the camera was Steve Martin. I have never worked with a performer more prepared, professional, and generous. In the course of three movies, not only was a good time had by all, but a thoroughly professional one as well. Steve was always on time, always open to suggestion, and always considerate of not only his other cast members but also the crew. He was smart – intellectually smart, awareness smart, professionally smart. As a

stand-up comedian, as a magician, as a banjo artist, as a lover of the history and content of art, his sensitivity to the world around him was acute and knowing. Then there was the rest of the cast. The men in supporting roles were Liam Neeson, Phillip Seymour Hoffman, and Meatloaf. All pros and all gracious actors. The women were Debra Winger and Lolita Davidovich. Talented, yes - but I wouldn't wish them on any production. Any producer might find trouble with these two smart, selfish, and demanding actresses. They were clearly going to be a producer's nightmare; no less for a director without any experience in handling talent of this nature.

As I went over the schedule with the production manager, it was clear that the location decisions had been made by the director and designer without any concern about budget.

On any production, a company move is expensive. The director had already insisted on two moves. In the big final scene, two thousand extras would be needed to fill a revival tent. The location they picked was miles and miles from any town of more than 100 people. That meant that every extra hired would have a very long drive each day they were needed, and the stars would also have to be driven for miles since there were only a few small motels nearby. It was a production nightmare, as well as a financial burden beyond the boundaries of necessity. There was not a reason in the world the film couldn't have been shot on the outskirts of any city. When I got there, construction of the site, the tent and so on, was underway; that ship had sailed.

Shooting began Monday morning. It didn't take long to sense trouble ahead. Every director has his own unique style. Pearce's was interesting. Other than a conversation with his director of photography and friend, Geoff Murphy, he barely spoke to anybody. To the actors, almost nothing. To the crew, little; and he certainly had no reason to talk to me. I had just gotten there and had nothing to offer as far as he was concerned. So I watched. I timed what Geoff and Dick were doing. I timed how long it took to set up a shot, the number of takes, how long between set-ups, and then how long to decide on the next one. And I wrote it all down for

three days. The first two days did not have any particularly difficult set-ups, but it still took two to two and a half hours between them.

Then we got to the third day. For those first two days, I'd watched the director talk only to his cameraman. On the third day the scene was the counter of a diner with 12 customers, including Steve. This is not an easy set-up. As Mr. Pearce started to work around the diner trying to integrate all the players into the action with Murphy, Steve started staring in my direction, as if to say, "What the hell's going on around here?" Since I was always in the background, Steve and I hadn't had a chance to talk about anything in detail. It was a terrible day's work, and when it was over I went to Mr. Pearce and asked to have a chat. He agreed and I went over the first three days: how long it took for each set-up, how long he and Murphy would go away to talk between set-ups, and how long it took for the camera to be moved again. The average was two and a half hours in the easy-to-shoot scenes, and in the diner we hadn't completed even half of the scheduled work. In my estimation, as well as that of the production manager, after three days of shooting, we were well close to two days behind schedule. His response was amazing. He denied my timing, saying that it was only 20 minutes between set-ups. "Dick, I timed it," I said. "You're wrong," he insisted and simply denied everything. I knew what the problem was. There was no way he was going to collaborate and he was not going to permit me to talk to his cameraman. He was in total denial. Before calling John Goldwyn to give him an update, I called a psychiatrist friend of mine with a Los Angeles practice who knew industry types.

"Tell me about denial," I said.

"I can't." he laughed. "Denial is tough. It's almost impossible to get through."

I called John Goldwyn and brought him up to date. Denial, too long between set-ups, doesn't talk to the actors or to anyone other than Mr. Murphy.

"What do you recommend?" asked John.

"Fire him," I said, "otherwise we've got a disaster on our hands."

"I can't," said John. He wouldn't explain to me why, but he must have had a very good reason. John was a smart young man.

"Okay," I said, "then let me fire the cameraman and get someone in there who's not only faster but someone I can talk to."

"All right," John said, "you can do that."

Great. I'd been there six days. Three days shooting and I can't fire the director, but I can fire the director's friend the cameraman. In a sense I was satisfied, because I truly believed when I told Dick that we were letting his friend and cameraman go, he would say, "If he goes, then I go too". That's what a friend would do.

Well, guess what? When I told him we were letting his friend go, Dick Pearce didn't say one word. Oh yes, he did say, "You tell him," which I did; a very short talk that was one of the most difficult professional conversations I've ever had. At the end Mr. Murphy stomped away. We brought in a pro, Matt Leonetti, who took over the show. The rest of the production schedule played out. Steve worked heroically to make his character come alive, and showed us as he has so often just how versatile he is. Debra directed every scene she was in herself, and insulted Mr. Pearce over and over again in front of the whole crew. Liam Neeson was not then a star, but he was every bit the gentleman he is today, and was embarrassed by the tone set by the director and Ms. Winger. Lolita Davidovich also ate Mr. Pearce alive, refusing to accommodate scheduling pressures. I believe it was Mr. Pearce's inability to communicate that carried the production to this disastrous point. With the arrival of Matt Leonetti, the film moved along close to schedule, but the saddest highlight was the third day in the big tent, packed to the rafters with extras, when we had the opportunity to shoot the 2,000 extras close up after Steve's big "healing scene". Matt and I finally got Dick to list some twenty specific crowd shots that he wanted, but by the time we got to them, we barely had time for ten. He and I went to Dick and said, "Tell us which of these twenty you want," and he froze. He just couldn't tell us which shots were the most important to him, so Matt and I picked our ten and that's what was shot.

Because of the Christmas release, the company had a team of editors on the show under the brilliant Don Zimmerman. I believe that what they did made it a decent film. I thought Steve's performance was amazing, but the fact was nobody cared. The campaign of "*real miracles reasonably priced*" simply reached no one. The last

profit statement I received from Paramount showed a loss of $40 million. What a shame, and how predictable. The subject matter was a disaster. The professionals on the picture really did good work, but it was sad that so much went into a movie and so little came out.

Man of La Mancha

"To dream the impossible dream...."
- Joe Darion,
Man of La Mancha lyricist

The wrong play. The wrong cast. The wrong director.

I just loved that song, "The Impossible Dream". Maybe I should have known it was "The Impossible Film".

Electra Glide in Blue and Ned Kelly

"Should he be holding that riding crop?"
- The Author

We've already talked about The Beatles and how exciting it was to see their transition to film with *A Hard Days' Night* and *Help!* My thinking was "why stop there"? The music scene of the 60's and 70's was alive with so many talented people, why not give some of the best an opportunity to expand their horizons and give film-making a try. Sounds logical, right?

I particularly liked a group known then as The Chicago Transit Authority, later to become Chicago. Doing some research I learned that their manager, 27-year-old James Guercio, had been a well-known studio musician, songwriter and was a multi-talented young man pushing his new group up the charts fast. In addition to being a good musician, it seemed he was also an excellent promoter, an absolute necessity for a successful music group. I got in touch with him and just tossed out an idea: would you like to direct a movie? Although he seemed a little uncertain at first, he warmed to the idea as we talked about movies in general and his favorites in particular. I became more excited about the prospect of finding a project that would interest him.

Not long after our talk, he got back to me with an idea. He had read a script by Rupert Hitzig and Robert Boris, a story about a rookie Arizona motorcycle cop who wants to work in homicide.

The idea was interesting and UA certainly had a history of taking chances with creative talent, letting their filmmakers run with the material they liked. Material yes; budget no. Jimmy had a $1 million budget, but had a vision for shooting the scenic Arizona desert locations to look like a John Ford western. He wanted Academy Award-winning cinematographer Conrad Hall. Conrad Hall didn't fit into a $1 million movie. And just as Mr. Guercio would settle for nothing less than the best for a Chicago album, he certainly wanted nothing less for his first directorial effort. The deal, negotiated by his gentleman attorney, John Eastman, was more than fair. He said he'd take no salary in order to get Hall. That's how he got Hall.

When the film was delivered in 1973, we thought it was fresh and interesting. A western, but with motorcycles instead of horses, cops instead of cowboys, and a great music track that included Chicago musicians, Isaac Hayes and other major artists. We were excited about the idea of a new film, a new director, a new look at an old subject and that's where the wheels came off the bus.

"What if we make the ad campaign as much about Guercio as the movie?" said the marketing heads. They wanted something bold, something to make a statement, something eye-catching. We went with it. One poster featured Jimmy standing hands on hips, wearing jodhpurs, riding boots, holding a riding crop, directing his first movie. What were we thinking?

Well, we were thinking we should take it to The Cannes Film Festival. It got in and was roundly booed.

Looking back, I can't imagine how we deceived ourselves as fully as we did on this one. If it had been marketed differently, might it have succeeded? I have no idea, but with our help it had no chance. No how.

In writing later about the movies of the seventies, Janet Maslin said, "*Electra Glide in Blue* is the most over-promoted and widely reviled film of the 1970's." So *she* was the one who saw it!

The film began and ended Mr. Guercio's directing career. Thank goodness he kept his day job.

Sadly, this wasn't our first musician-related misstep. In 1969, my dear friend Tony Richardson got in touch to say he was working

on a script with Ian Jones about the Australian outlaw Ned Kelly. Although this story had been told numerous times, Tony said he and his producers had a new angle. That angle was Mick Jagger as Ned Kelly. Could Mick Jagger act? Who knew or cared? It seemed like a great idea, and if anyone could make it work, Tony Richardson could. By now The Stones already had nine gold and platinum albums, so a huge audience of Mick's fans would surely flock to the theaters to see the rock icon "act".

During the filming I would get intermittent reports of rock-star-related problems (not the least of which was Mick's ex-girl-friend overdosing), weather-related problems and multiple cast illnesses. Nonetheless, a movie got made, but we were probably more excited about the UA album that would accompany the film. Shel Silverstein, another good friend, was composing the music, and he had arranged for the soundtrack to feature Waylon Jennings and Kris Kristofferson, with Mick agreeing to do one track.

I thought it would be fun to stop by a recording session one night. Accompanied by my buddy Herb Gardner, we entered the control room of the studio where Shel was working with Waylon and the then-unknown Kristofferson. It only took one or two deep breaths and I knew I was getting slightly stoned. It was a happy place and when you're happy, everything sounds good. Everything except one word in the lyrics - the name of an Australian town where Ned Kelly robbed a bank: Jerilderi. Happily high, the singers couldn't pronounce it or sing it. So everyone just laughed through many takes. That was all we did for much of the evening.

Unlike *Electra Glide in Blue,* we didn't harbor any illusions about the outcome. The soundtrack was great; the film was not. Nor was Jagger. And based on the box-office, his fans preferred him on the concert stage, not the screen. The film was roundly panned and, to my personal disappointment, neither Tony nor Mick chose to attend the London premiere. But they weren't too embarrassed to cash their paychecks.

My (Brief) Life in Rock 'n' Roll

"Which two ladies would you like?"
- Anonymous record promoter

In the first few years after Messrs. Krim and Benjamin revived the dormant United Artists, one of the initial ways they reduced their risk in financing each independent film on the release schedule was by selling off the publishing and soundtrack rights to their films. In 1957, Max Youngstein convinced them to let him found United Artists Records and United Artists Publishing. In retrospect, it was absolutely the right thing to do. By controlling publishing rights to the scores where possible, and distributing soundtracks to their films, the company was able to maximize financial benefit in the films themselves. Publishing income can be like a river of gold that never stops flowing. Yes, it was the right thing to do, but they gave it to the wrong man to supervise. Max, their partner and friend, loved music, particularly modern jazz - so he essentially created a label to maximize his own tastes and those of two friends. One of them, Kay Norton, ran the operations, and in less than a year it became a cash drain that the company had not anticipated. When Max finally decided to move on, he left a mess of a record label behind.

I was given the job of cleaning it up, whatever it took. What it took was a new, professional executive, as well as creative leadership. I was thirty years old, and I knew very little about the record business, but I knew one very important thing: owning the

copyrights to the recorded music was essential and income from publishing hits was a goldmine. The company had been selling rights off to reduce negative film costs for too long. It was time for a change. In the 50's and 60's the major labels such as RCA and Columbia distributed their own records to retail outlets all over the world. The smaller labels and the independents went through privately owned distributors who competed with the majors for airplay in the world of popular music. For the indies, everything was about getting their singles played by the disc jockeys all over the country, making it onto Billboard or Cashbox's Top 100. From the single hits came the albums. UA had to depend on independent distributors who carried multiple labels, and they had to be begged and pleaded with to pay attention to our product and get airplay. Everyone wanted a piece of the action.

I had just become the head of Motion Picture Production and Marketing, and now I was the executive in charge of the new United Artists Records and Music. One week after I got the record gig, there was a major convention of Independent Distributors and Labels in Miami Beach at the Americana Hotel. Of course, I had to be there. I checked into my suite and at about 9 p.m. I was unpacking when there was a knock on the door. I opened it and standing there was a gentleman I'd never seen before, surrounded by three very attractive - no, very, very attractive, sexy women. "David," he says, "I'm so and so (no memory of his name) from xyz records (also no memory). Welcome to the convention! Any one or two of these beautiful ladies would love to spend time with you. How would you like that? Which two would you prefer?" I told him I wasn't interested, but was most appreciative of his thoughtfulness. Really, I did. Welcome to the music business of 1961! It was a wild business; one clearly built on relationships - all kind of relationships.

It wasn't long after when Andy Miele, our head of sales, asked me an unusual question. He said that Ed Dinello, our Connecticut distributor, had asked him to pick the UA single of his choice and he would "break it" (make it a hit) in the Hartford market and, hopefully, it would catch on from there and move up nationally. Andy had done Ed a favor and this was Ed's repayment. I

believe Andy knew the record I was going to choose. A friend, Ken
Greengrass, represented a group that I really liked - four students
at Wesleyan University in Connecticut, known as The Highwaymen.
Their repertoire was folk-oriented, they'd already done an album
for us, and there was one particular cut I liked; the classic folk
song "Michael, Row the Boat Ashore" (Hallelujah, Michael Row
the Boat Ashore, Hallelujah) ... please sing along as you read this.
Andy called Ed back and said "Michael," please. Ed went to work,
and a few months later "Michael" was the number one single in
America. Nobody asked him how he'd done it.

So now we had folk music, jazz, some acts like Steve Lawrence
and Eydie Gorme, not to mention our successful theme music
from movies recorded by the cornball-but-very-popular piano duo
of Ferrante and Teicher, with hits from *Exodus, Gone with the Wind,*
and *My Fair Lady,* to name a few. Famous in elevators all over the
world.

We certainly needed more than that, so I used my new respon-
sibilities to expand my connections, flying to Detroit to meet a
record producer I hoped would deliver some hits for the label.
Berry Gordy was the hot new kid on the block and, oh yes, the
founder of Motown Records. We met in the Motown office and
although it was a relatively new company, the walls were already
lined with gold records and photos of their stars. My UA Records
was on a lower floor of the movie company's building at 729
Seventh Avenue and we may have had some records on our walls
but, believe me, this was a different environment. Berry and I liked
each other, maybe because we had a friend in common, Clarence
Avant, a manager of artists like Sarah Vaughn. Or maybe he took
a little pity on me in my new position. It seemed that in addition
to running Motown, Berry also managed a number of artists, and
he agreed to help us out by delivering Marv Johnson ("You've Got
What It Takes") and Eddie Holland ("Jamie"). Perhaps he didn't
think these clients were what Motown was looking for, but I cer-
tainly was happy to have them.

I was on a roll now, getting Jerry Leiber and Mike Stoller to
produce for us after they left Atlantic Records, and they brought

in Jay and The Americans, The Clovers and The Exciters, which helped us attract Bobby Goldsboro, Manfred Mann, and The Easybeats.

During these years the music business was all about different sounds and different genres, covering Motown, R&B, folk and folk rock, The British Invasion, and the beginnings of hard rock with new artists emerging like Janis Joplin and The Rolling Stones. I wanted us to have as broad a representation as possible, in as many categories as possible, and as we added major artists like Don McLean with his hit "American Pie", Gordon Lightfoot, and Gerry and The Pacemakers we began to make stronger inroads on radio stations playlists and with the record-buying public.

Wanting to keep our movies maximized, I brought in well-known producer/arranger Don Costa to manage A&R (Artists and Repertoire) and he started by delivering hit cuts on movie themes; the James Bond movies opening theme songs provided big hits, most famously with Shirley Bassey and *Goldfinger*, then soundtracks from *It's A Mad, Mad, Mad, Mad World, The Greatest Story Ever Told, Fiddler on The Roof, Man of La Mancha* and *A Funny Thing Happened On The Way To The Forum* - all successes.

I knew we were getting increased respect and visibility in the music business when I was asked by a mutual friend if I'd give some advice to an up-and-coming manager; his name was David Geffen. Meeting at his home in L.A., we sat by his pool and he explained that he'd primarily been focusing his creative efforts on managing artists, but he was also interested in record producing, maybe starting a label. Because he knew I was also running our film business, he said he had sometimes thought about movies. "What should I do with my life?" David asks. Believe me when I say that my advice, which I think was along the lines of "follow your passions," had absolutely nothing to do with him becoming an entertainment mogul. Managing major performers (one of his new artists, Jackson Browne, was at the pool that day) - check. Creating a powerhouse label (Geffen Records) - check. Movies (well, there is that entity, SKG - Spielberg, Katzenberg, Geffen - that makes up DreamWorks) - check.

But back to *my* music company. Since I was responsible for both film and music, everyone at the company knew I was open to anything that might help us cross-pollinate the two worlds. We had a flourishing European film operation, and the staff in the United Kingdom paid particular attention. It seemed to work pretty well because that's how we got the deal with The Beatles. Having the soundtracks for *A Hard Day's Night, Help!* and *Yellow Submarine* were tremendous assets, as were all the Bond films, the Clint Eastwood trilogy of *A Fistful of Dollars, For A Few Dollars More* and *The Good The Bad and The Ugly, The Thomas Crown Affair, Alice's Restaurant,* Frank Zappa's *200 Motels, The Pink Panther, Never on Sunday,* and *The Magnificent Seven,* to name only a few.

The UA Record business had survived earlier dysfunction, and was on a profitable path fueled by a good business model. Although it was still under my management responsibilities, I could hand off day-to-day operations to the team that was in place. My main focus was the movie business, but the two were always linked. The movies sold the soundtracks and the single releases, and the singles and the albums sold the movies. There is no question that music and movies are a marriage made in heaven, both then and now.

Paths of Glory (not the movie)

"How do I get into this business?"
- The most common question the Author has been asked.

This book is filled with films and filmmakers that I take great pride in having worked with over the decades. There is, however, another responsibility that I have always felt personally. It is one that gives me a great sense of achievement, and it is neither in front of nor behind the camera; it is finding and developing new creative and executive talent. I credit Max Youngstein with training and preparing me for a future in the front office, and dealing with the producers whose ranks I later joined. One of the pleasures of my life in film is somehow sensing the potential in younger people with whom I've worked. Every time I lecture to a room full of filmmaker hopefuls at colleges and universities around the country, I repeat something that seems simple and obvious, but doesn't get recognized as often as it should: people who make the movies *behind the camera* are always looking for people who want responsibility. On every film that I have produced I am always aware of the PA's (production assistants - each film has a bunch of them) who want responsibility, not caring whether it's getting someone coffee, moving a crowd around, or just running an errand. Moviemakers always pay attention to someone on the crew who does a thankless job cheerfully, and asks to do even more.

On the next few pages are the remembrances, both theirs and mine, of several special people who I sensed had "it". I know that our business is filled with stories like these because movie people are very generous when they identify commitment and talent. In the case of these four, it was there to be seen - all you had to do was look. I'm filled with pride at their success (for which I take *no* credit). Let me introduce you to them.

The Producers

Laurence Mark's recollection: "After working as an executive trainee at United Artists under your sponsorship, I left there when you did. You gave me a job on *Lenny*, the first movie I ever worked on. I was one of the three production assistants on set, the truly lucky one assigned to Bob Fosse and Valerie Perrine (I watched Bob rehearsing Valerie's strip tease more times than I could count). I then worked in the AD Dept. on *Smile* shepherding Young American Misses on their appointed rounds, and following that, in the Unit Publicity Department during the shooting of *The Royal Flash* in Bavaria and England. On to Assistant to the Producer on *Won Ton Ton, The Dog That Saved Hollywood* where I met Madeline Kahn, who became a dear friend, along with exactly 100 stars from "Hollywood's Golden Age", like Dorothy Lamour, Rhonda Fleming, Victor Mature and Alice Fay. When you went to Paramount, you kindly brought me with you, and my first job there was the Marketing/Production Liaison Director, an emissary from the Marketing Department to films in pre-production and production. My most significant assignment was on *Grease*, which became the springboard to my next job as Paramount's Executive Director of Publicity. And the rest, as they say, is history."

Larry Mark has a list of producing credits longer than my very long arm, but some of the highlights are: *Working Girl, Jerry Maguire, As Good As It Gets, Dreamgirls, Julie & Julia,* and in his spare time in 2009, he produced the 81st Academy Awards with his *Dreamgirls* producing partner, Bill Condon.

Bonnie Arnold's recollection: "I first met you in the summer of 1986 when I was the production office coordinator on *The Leader*

of the Band, filming in Atlanta. You came into the production office and told me you had been asked to become President of Columbia PIctures; then you asked me about *my* career goals. I told you I wanted to be a producer. You said, 'Then you have to leave Atlanta', and told me if I came to L.A. after I finished the film you would put me to work at Columbia. When the film was finished and you left Atlanta I wondered if that would actually happen. Literally the next day, Sandy Lieberson called me, said he heard I was moving to L.A. to work for David Picker, but that it would have to wait. Sandy was producing a movie for Columbia called *Stars and Bars* and he said, 'David Picker told me I had to hire you.' After that movie wrapped I moved to L.A. and came to see you in your office, and you made several key introductions that lead me to work on a number of films. But in 1992, you played another important role in my career. I had a serious question about taking a producing job with Pixar in San Francisco. You told me two things, 'First, it is really hard to get a producing credit on a film you haven't developed, so if Disney offers that, take it. Second, who wouldn't want to do a location job in San Francisco?' Oh yes, and in 2007, you sponsored my membership in the Motion Picture Academy. The rest, as they say, is history."

Bonnie Arnold has already built an impressive list of producing credits including *Dances With Wolves*, *The Last Station*, *Toy Story*, *How to Train Your Dragon*, and *How to Train Your Dragon 2* (in production).

The Executives

Jeffrey Katzenberg - I was first introduced to Jeffrey when he was working on New York Mayor John Lindsay's Presidential campaign. Jeffrey was in his very early 20's (he had been working on Lindsay's political endeavors since he was fourteen), and was already part of hizzoner's inner circle, working with Dick Aurelio and Sid Davidoff. It seemed apparent that he could handle any level of responsibility, problem-solve, and get results. When Lindsay created the New York Mayor's Office of Film to promote production in the city, Jeffrey expressed an interest. He was a young man

I could see flourishing in both the creative and business side of the industry, so I asked him to join me when I went to Paramount in 1976. To give him every opportunity to learn our business across the board I had him move through various key departments, among them marketing, acquisitions, and negative pickups (buying independent films for distribution through your studio), then made him my assistant. I don't have to tell you that he not only learned quickly, he thrived. Of all the films I developed, acquired or greenlit while I was at Paramount there was just one project that I was simply not interested in: Charlie Bluhdorn's favorite - a movie based on the TV series *Star Trek* (more on that in a later chapter). Jeffrey became Barry Diller's assistant after my departure, and I told Barry that as my parting gift to him Jeffrey would get *Star Trek* made. Of course he did, and his career speaks for itself. Later, as chairman of The Walt Disney Company, he brought in their biggest hits, including *The Little Mermaid, Beauty and The Beast* and *The Lion King,* then he went on to his founding partnership with Steven Spielberg and David Geffen in Dreamworks Studios. He was born to succeed.

Tom Rothman - When David Puttnam asked me to join him at Columbia, I knew who I wanted to take with me. Tom Rothman was a young lawyer who had handled some deals for me at Frankfurt, Klein and Garbus in New York. Brown and Columbia Law School-educated, he was clearly a partner in the making. I told him that I believed if he came with me to Columbia he would someday run the studio. Tom recalls his decision like this: "I met you face to face for the first time when I brought over some papers for you to sign on the set of *Beat Street.* I was so nervous being in the presence of a legend that, for the one and only time in my life, I lied about my age. You asked me how old I was, and I thought 28 sounded too young, so I said, ' ...29, well I'm 28, but I'll be 29.' You, mercifully, instead of thinking I was an idiot, thought I had potential and, as you had with so many others, took me under your wing. I worked for Arthur (Klein) and was point on your account; one fateful day you called to say you were going to Columbia, did I want to come along? I had just been made partner and didn't know what to

do. So I flew out to L.A., and together we went to lunch at David Puttnam's house. I knew opportunity when it knocked. So later that afternoon, I came to your hotel and said 'Okay, you got me.' And thus began my 28 year journey in Hollywood. It was the biggest turning point in my entire life, and one I have never regretted for a second. One that only happened because you had faith that I could be 'more than just a lawyer' and took a chance on me. I married in L.A., raised two glorious children, went on to run Goldwyn, and then Fox (including the longest run at Fox any studio head ever had, except for Darryl Zanuck himself). In other words, if I achieved anything in my time, it's all due to you. One more moment that stands out: I remember the first Academy Awards we went to in 1987, just after I got there. As you went down the aisle to take your seat up front, you said to me 'Remember, its the job, not the man...' Well, in your case, it was both!"

Over the years, Tom's love and understanding of film has shone through. It's not just the blockbusters he has overseen, such as *Titanic* and *Avatar,* but his appreciation for the smaller, more independent-minded films like *Slumdog Millionaire,* and *Beasts of the Southern Wild* that illustrates his connection to film and filmmakers. That's what attracted me to him in the first place. I believe that whatever Tom does in the future can only make the movie theater a more thrilling place to be.

I'm so proud of Tom, Jeffrey, Bonnie and Larry - so very proud.

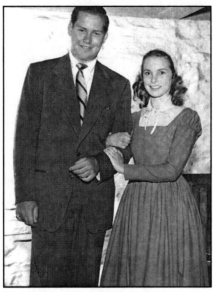

My first trip to L.A., and my first
movie-star meeting - Janet Leigh.
(Collection of the author)

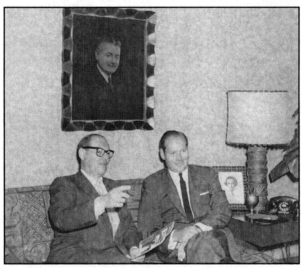

Three generations of Pickers: David V. Picker (framed),
Eugene Picker, me, sister Jean Rae Picker (under the
lamp). *(Collection of the author)*

On the set of *The Naked Edge* (l. to r.) Max Youngstein, Michael Anderson (director), Deborah Kerr, Walter Seltzer (producer) me, Arnold Picker. *(Collection of the author)*

The United Artists team (l. to r.) Arthur Krim, Arnold Picker, Robert Benjamin, me. *(Collection of the author)*

The Command Performance of *Tom Jones*. The author meeting Prince Philip.
(Collection of the author)

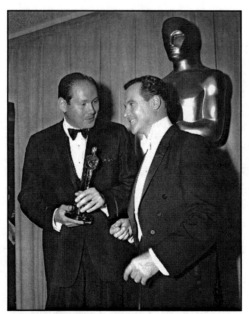

Holding Tony Richardson's 1963 Best Picture
Oscar for *Tom Jones*.
*(Copyright © Academy of Motion PIcture Arts
and Sciences)*

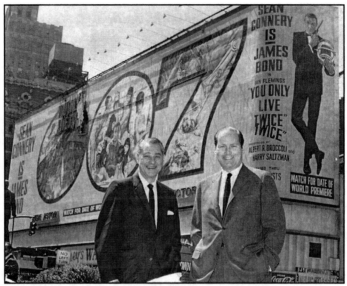

With Arnold Picker in Times Square in front of the biggest billboard UA ever bought. *(Collection of the author)*

With Ilya Lopert on the set of *The Train* with producer/star Burt Lancaster. *(Collection of the author)*

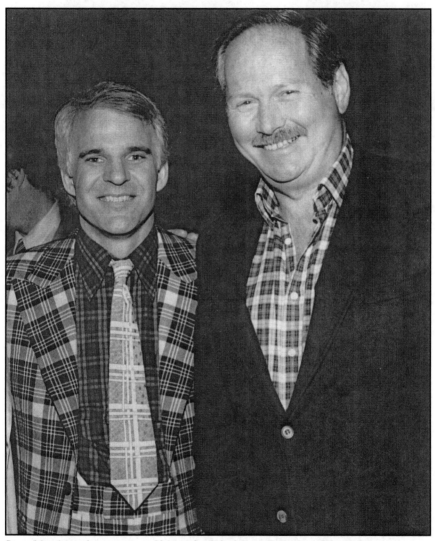

Steve Martin and me at one of his early club dates. *(Collection of the author)*

With Steve Martin, Carl Reiner, and the "family" on the set of *The Jerk*. *(Collection of the author)*

With director Michael Ritchie and the Young American Miss contestants on the set of *Smile*. *(Collection of the author)*

With John Huston on the set of *Escape to Victory. (Collection of the author)*

Celebrating with producer David Puttnam following his 1981 Best Picture win for *Chariots of Fire (Collection of the author)*

Bob Fosse and Dustin Hoffman on *Lenny*. *(Collection of the author)*

On the set of *The Crucible* with Arthur Miller. *(Collection of the author)*

With Emmy-winning director, Allan Arkush, and the cast of *The Temptations* on the set of one of my favorite projects. *(Collection of the author)*

With another Knick fan. *(Collection of the author)*

Rob Reiner, Norman Lear and me at Norman's PGA Award celebration. *(Collection of the author)*

Interviewing Woody Allen at a Producers Guild Event. *(Photo by Andrew White. Courtesy of The Producers Guild of America)*

With four friends at a charity event at New York's Paramount Theater, Sept. 20, 1964.
(Collection of the author)

Woody Allen

"The title is 'Bananas.'"
- Woody Allen

I was scouting locations in Toronto when I got a message to call Juliet Taylor, who cast all Woody Allen's films.

"David, Woody Allen's re-shooting the scene. He needs you in New York next Monday. Can you make it?"

I asked if I had screwed it up and she said, "No, Woody does this a lot. He's decided he wants to change the emphasis or something and honestly if he didn't like your work, he would have re-cast your role. No, he wants you." He liked my work! What a thrill; I'd done okay. How had this happened?

It had actually happened many months before, occasioned by a call from Juliet asking if I'd be willing to read for a role in Woody's new film. He and I went back, way back, to 1963 when I was head of production at United Artists. He'd written a script for producer Charlie Feldman that we'd developed entitled *Pussycat, Pussycat, I Love You.* We made a deal with Charlie to finance and distribute the film, and changed the title to *What's New, Pussycat?* with Warren Beatty to star. Pre-production dragged on while Woody did multiple script rewrites to accommodate both producers and star, and eventually Warren was lost to a scheduling conflict on another project. In a casting twist, Peter Sellers replaced Warren, Woody played a supporting role and the film was a big success worldwide.

In 1966, Woody wrote and directed his first effort, *What's Up Tiger Lily*, taking a Japanese film and turning it into a spoof by adding film and narration. It was original and funny. Then he made *Take the Money and Run* and that convinced me that UA could be a home for this most original talent.

Sam Cohn was Woody's agent. Ah, Sam. I miss him very much. No agent in my entire career cared more for his clients, nor was wiser about their potential, their needs, their idiosyncrasies, their nurturing, than Sam. He was one smart fellow. Also, he was a snob, an elitist, pompous, caustic, and arrogant while at the same time trustworthy, wise and fun. (And for some reason he constantly chewed on small bits of paper.) In other words, he was a piece of work, and it's always more fun to deal with smart people than dumb ones. Sam represented, among others, Bob Fosse and Herb Gardner, and the two of them along with Paddy Chayefsky were a trio of pals who loved being together, and were always there to critique and help the other's work in any way, at any time, anywhere. Sam and I were their trusted friends, and there was no greater time than sharing the insights, the in-slights, and the everyday drama of their lives over a steak at Wally's on 49th Street.

There was never a shortage of opinions with that group, and with Sam in particular. After *That's Entertainment,* an amalgam of excerpts from MGM's library of the 30's, 40's, and 50's that opened nationally as a feature film, Sam commented to a table that included Piedy Gimbel, a woman of wit and wisdom, that he didn't think too much of it because it was too expurgated (of course it was; it was a movie that only included clips of other movies). Piedy turned to him and said, "Sam, you know what you are?" "No," he answered sipping from his third or fifth scotch on the rocks. "What am I?" "You are pompoose," she said exaggerating the word "pompous" to make Sam feel extra self-important. We all laughed, Sam most of all.

Sam came to my office and made a proposal that I had only encountered once before, and that from the brilliant filmmaker Ingmar Bergman. Sam wanted a six-picture deal where Woody Allen would tell me a story and if I liked the idea, it was a "go".

It struck me as arrogant, but Sam convinced me that for Woody to work his best, this formula was necessary. So I made the deal and that's really all it took; a smart agent who knew his client and a company that was designed to respond to creativity. We shook hands and set up a meeting to discuss the first film.

Woody and Sam came over, and after a bit of a chat Woody started telling me the first movie he wanted to make under this unique arrangement. In effect, he said: "The movie is about a jazz clarinetist, a brilliant musician, maybe a genius, but whose personal life is a catastrophe." He went on from there with a little more detail, from the women in the musician's life, his addictions, his lack of character – he talked for about five minutes, and as I listened, I couldn't believe my ears. I had just made a unique deal with a great comic talent, and he wanted to make a serious, dark biopic of some bastard musician who's not worth spending ten minutes with, no less an hour and a half and $2 million of UA's money. I looked at Sam, who seemed to be looking out the window. Woody stopped talking. "What do you think?"

Sam was still not looking at me, so I had no choice but to look at Woody.

"It's approved, but it'll have to be the sixth picture in the deal. I really thought we were going to do some comedies together. That's why we made the deal."

As they left Woody said, "I'll get back to you soon." I wasn't sure I would ever hear from him again. (Not long ago at a quiet dinner, Woody and I reminisced about those early days. He laughed and said, "Well, I finally made that movie I first described to you, except I switched it to a guitar." It became *Sweet and Low Down.*)

A few days later, Sam called and said Woody had an idea. "The title is *Bananas.*"

"Approved." was all I said.

Woody played the perfect neurotic nebbish trying to get the girl by fighting with revolutionaries in a fictional banana republic. And despite many bodies falling in the course of this hysterically funny "war", Woody refused to use any blood in the film. He said blood just wasn't good for comedy.

Bananas was a success, so what next? Woody hadn't decided, but an opportunity arose that I thought we could both take advantage of. Dr. David Reuben, a psychiatrist in San Diego, had written a bestseller entitled *Everything You Always Wanted To Know About Sex, But Were Afraid To Ask*. A producer, Jack Brodsky, had gotten Paramount to acquire the rights, and I'd heard through the grapevine, shall we say (actually a friend at Paramount) that they had no idea what to do with it. I called Jack to ask if the studio would give it to him in turnaround. I had an idea that I thought would work, but I couldn't do anything until I knew he'd gotten the rights back, lest Paramount get wind of it and try to move in. Jack trusted me and got Paramount to agree. I called Woody and said I had an idea for the title of his next picture - *Everything You Always Wanted to Know About Sex, But Were Afraid To Ask*. I also said he could do anything he wanted with it, since the title was the only thing of value. A few days later, he said he could make it as series of short episodes connected only by the general subject of sex. I didn't care; who would? It was a go.

Many months later he delivered the picture and I loved it; particularly the episode where all the actors are dressed in white, playing sperm cells. I had never seen anything quite like it. Nor had anyone else. Certainly not Arthur Krim. When he saw the film he asked me to tell Woody to cut the scene out. I refused. Needless to say, Arthur finally agreed to keep the scene and later, after I left UA, he became the man Woody trusted most during his most fruitful years. At the time, however, Woody wrote me a note saying "Thanks for having faith in me when Arthur Krim thought I was on a level with kiddie porn."

Woody made *Sleeper* in 1973 and had started *Love and Death* when I left United Artists. The corporate relationship that began under my aegis continued after my departure in the mid-seventies, and was taken over by Arthur Krim personally; a most unusual situation. Woody continued to deliver a parade of wonderful films to the ongoing management of the company where he had started. We saw each other over the years, mostly at New York Knicks games where our season seats were within waving distance. As his

successes mounted, we corresponded, his sense of humor always shining through.

One of Woody's creative traits was occasionally casting non-professionals in roles he thought could use a bit of authenticity. One day in 1988, Juliet Taylor, his casting guru, called me and said, "Woody would be interested if you would read for a role in his new movie, *Crimes and Misdemeanors.*" I was flabbergasted. I couldn't even imagine how he would think of such an idea, and I didn't quite know how to answer her. She pushed me. "Look, it's $1000 for the day; that's all we pay. But come on. Come read for us." So I agreed.

Woody was casting in a projection room on the East Side. I arrived and awaited my turn sitting next to Caroline Aaron, a professional actress. I was concerned that I was taking a role (if I got it) that was usually played by someone who did this for a living, but Woody had done this often enough before for it to be accepted by the Screen Actors Guild as an occasional exception to their contract, since he kept so many of their members employed. I was nervous. Juliet gave me the sides (the scene) to read and for the first time, I saw what Woody had in mind for me. It was Page 1, Scene 1, a country club in Westchester County where a doctor was being honored and making his acceptance speech. My role, if we could call it that, was to introduce him. It was over one page long, and if I got the role, I would have to memorize it and act it. Two of the lead actors in the film, Martin Landau and Claire Bloom, were in the audience, so clearly the scene was about their response to what was being said. The doctor was never to be seen from or heard from again, just like my acting career if I actually got the role. Caroline went in, left, and shortly after, Juliet called me in. There was the director – there was Woody Allen, the man who wanted to make his first major movie for me, a twisted tale of a drug-addicted musician, but who gave it up for *Bananas* and *Everything You Always Wanted to know about Sex* – and I was supposed to read the role, acting as a doctor you'd believe introducing Marty Landau to be honored at a dinner. It made little sense, but I read it, several

times. Woody thanked me and gave me no clue what his reaction might be. Juliet walked me out, thanked me for coming and told me she'd call me when Woody had decided. If I had sympathy for actors who did this for a living before – and I did – I had a lot more now. What a way to make a living – or not to. Why would anyone want to be in a profession where the vast majority of the time you don't get the job!

At 9:30 p.m., Juliet called me at home to say I had gotten the part. I was too stunned to think of anything except that Woody was an out of his mind. Production was to begin shortly, so I should go see Jeffrey Kurland, the costumer, and if I had a tuxedo I should bring it with me (I had two, like every studio executive who has to wear them too damn often). A contract would be forwarded, and what did I think about that? I didn't know what to think. Jeffrey chose one of my two tuxedos (thus saving the production a few bucks) and I awaited my call. The location was the dining room of the Beach Point Club in Mamaroneck, New York. Transportation called and said I would be picked up in a car that would also be bringing the lead actor in the show, Martin Landau. He became a friend that day, and still is. Generous of spirit and capable of telling a humorous story in every accent known to man, he made me feel, for the moment anyway, at ease. It was hard to forget I had a one-page speech to say on-camera. Some people really had to make a living this way – not only remembering the words, but acting them as well.

Upon our arrival at the set, the second assistant director escorted us to the dressing room. Mine was one part of a four-compartment trailer; a small room with a john. I was told I probably wouldn't be on camera until after lunch. What? I wasn't nervous enough? Then I met the key crew and felt safe for the moment. Hair and Makeup - the Salad sisters, Romaine Greene and Fern Buchner, the best in the business - had worked for me on *Lenny;* the producer Bobby Greenhut, who had also worked for me on *Lenny;* the still photographer Brian Hamill and Sven Nykvist, the great Swedish cinematographer, all of whom I knew and all of whom embraced me. The morning hours flew by, and lunch was

called. I was the first set-up after lunch. Two- hundred-fifty dress extras, the stars of the movie, my new best friend Marty Landau who made everyone feel that way and he meant it - and oh my god, Claire Bloom, who had sat on the bed while Charlie Chaplin tried to calm her down in *Limelight,* as she said to him while he described the slow loss of his career on the stage, "Why don't you come back?" to which he said "I can't; I must go forward." The scene brings tears to my eyes every time I see it. Claire Bloom, who played opposite Charlie Chaplin, and me, sitting at the actors' table at lunch; just people working together.

"Action!" said Woody. Sven had two cameras rolling. I was standing up on the podium, praising and introducing Mr. Landau. Two takes. Another set-up. Move the two cameras. Two more takes. We've got it. Then several camera shots covering the cocktail party preceding the dinner. I was covered several times, then it was a wrap. Woody thanked me and it was over.

Many weeks went by, and I'm back in Toronto shooting *Stella,* a remake of *Stella Dallas* for Disney. It was a difficult show. For the only time in my career I worked with a director, John Erman, who treated the crew like shit and who couldn't stand Bette's choice for director of photography, a Brit named Billy Williams. The atmosphere was poisonous, and I constantly tried to ameliorate the director's conduct with the cast and crew. Then Juliet Taylor called. She explained that Woody needed to reshoot my scene. I saw my acting career fading in front of my eyes. I didn't want that to happen, but my responsibility to the production won out and I, regrettably, told Juliet I just couldn't make it. My potential nomination for Best Supporting Actor bit the dust.

In October 1989, *Crimes and Misdemeanors* opened. I went to see who had replaced me. Was it Karl Malden or Jack Warden? No, it was Bill Bernstein, one of the partners at Orion Pictures who had left UA when Krim and Benjamin formed their new company. Bill Bernstein of all people. A fabulous business executive, but a good enough actor to replace me? I was dubious.

The picture was wonderful. I've always felt it was one of Woody's best. So I wrote him a note telling him so, with one caveat. "In the

opening scene the actor who played the doctor introducing Marty Landau was barely adequate." Woody responded by thanking me for the note and added that the actor he wanted for the role unfortunately had to go to Europe for a sex change operation.

Robert Altman

"I hope Picker dies."
- Robert Altman on hearing the author was in the hospital.

I don't care what anyone says, Robert Altman was a prick. Yes I know, and even agree, that he made some very, very good movies. *Nashville, Short Cuts, Gosford Park, The Long Goodbye, M*A*S*H,* and *McCabe and Mrs. Miller* (if I could have understood the dialogue) are memorable. There are others that are appropriately best forgotten. His output over a long lifetime was prodigious and for that alone he's entitled to recognition. He certainly can't be criticized for his effort or his determination. A lot of that comes with the territory. I didn't even disagree with his being awarded an honorary Oscar in 2005, but there's really no correlation between talent and decency. Even with an Oscar he was a prick, and here's why.

In the late 70's, I was in the hospital recovering from gall bladder surgery. Herb Jaffe, an old friend and former colleague at United Artists, was having a drink with Altman. On telling him of my hospitalization, Altman's words were "I hope Picker dies." Herb was gracious enough to pass along Altman's thoughtful comment. I knew instantly why he felt this way, and couldn't wait to never talk to him again. Mr. Altman simply didn't like it when someone told him the truth, especially if it conflicted with his need to self-promote.

In the early 70's, I made a deal with Elliot Kastner and Elliott Gould to make a movie of Raymond Chandler's *The Long Goodbye*, with a screenplay by Leigh Brackett. Elliott was to play Philip Marlowe, and I promised him that only having a one-year option on the property, we would try to attract a director who would agree to work with him as the lead. Elliott, a fine actor but not exactly box-office, agreed that I could have six months to find a quality filmmaker who would use him. After that, we'd be free to recast with a major star. This was not written into his contract, but we shook hands on it. The arrangement was tested very quickly. Upon announcing our acquisition of the project, word came that Peter Bogdanovich was interested in directing the film. We had struck gold. No one was hotter than Peter. *The Last Picture Show, Paper Moon, What's Up Doc.* This was a home run. Of course I'd make the deal and, oh yes, a small item, Elliott Gould was to play Marlowe. The response was good news and bad news. Yes to the deal, no to Elliott. Peter, one of the most sought-after directors in town, was married to the brilliant production designer Polly Platt. The two of them were fabulous together (to prove my point, look at Peter's credits when he was married to Polly, and then after their divorce). She brought incredible insight and intelligence to everything Peter did in those years. But anyway, Peter wouldn't use Elliott. He simply didn't think he was right for the part. And I believe you should never force (even if you can contractually) a director to cast an actor they don't want. Nor would Peter wait to see if the script was still available six months down the line. And why should he? He was hot and had a list of projects to choose from. My position was clear, no Gould, no picture. To this day, Elliott has never forgotten that I honored our word.

Who was next? Robert Altman, that's who. He'd worked with Elliott in *M*A*S*H* and agreed to his starring as Marlowe. The film quickly moved forward. As usual with United Artists, I never saw it until it was cut together. What I saw was a very, very good movie. Now it was UA's turn to create the campaign and open the film, and we did. But we didn't do it very well. Sold as a straight film-noir thriller, it opened in several cities to very disappointing

business. I called our team together and told them to cancel the New York opening, push back the release, do a new campaign and try to get it right. I don't know if we ever got it right, but we tried a quirkier approach, we opened to excellent reviews in New York and the picture performed well. I don't believe it has happened very often that a major company pulls a picture out of release to change a campaign. Usually changes are made during the release and nothing much is affected. But I believed in this film, was proud of it, and wanted UA to give it another chance. When the picture was re-released, *The New York Times* commented on the change of campaign, which didn't bowl them over, but the film got a rave review. At about the same time, Mr. Altman gave an interview in which he alone took credit for forcing United Artists to change the campaign and start over again. Thank you, Mr. Altman.

I was furious. Companies are often blamed by filmmakers for the manner in which their films are treated, the philistine nature of the corporate mentality, etc, etc. Majors are easy targets for blame for anything from content to campaigns, and certainly in my career some terrible judgments were made in marketing some of our films (see *Electra Glide in Blue* and *Gaily, Gaily*). But in this case where a positive action was taken by the distributor because they believed in a film, a simple acknowledgment or even, god-forbid a thank you, would have been appreciated. But not from Mr. Altman; He wanted the credit.

I called him the day I read the piece and told him I was offended that he would take personal credit for something he had nothing to do with, and wouldn't it have been classy to acknowledge for once perhaps that a studio did care? His response was short and to the point. "Oh, it's just publicity, nobody really cares" (except him, of course).

Cut to 1976. It's the morning of my first day as president of Paramount. I'm in Barry Diller's office and he hands me a script. It is *Breakfast of Champions*, based on the Kurt Vonnegut novel, to be directed by Robert Altman. Barry tells me that Paramount has a deal with Altman to make the film at a pre-approved budget. The problem is that Altman's budget is considerably higher, and

Paramount has no obligation to proceed unless they so choose. Could I possibly read the script that night because he told Altman he would ask me to give a quick answer? (I can only imagine what Altman thought when he heard that.) Sure, I said I'd read it immediately. I never read a script wanting to deliberately dislike it, but I must admit I didn't want to like *Breakfast of Champions.* I do believe in my heart that if I had liked it, whatever my personal feelings about the man, if it was good for the company I would have recommended it. I must also admit, however, that I wasn't upset that I didn't like the script at all, and couldn't figure out why anyone would make it at any price. The next day I told Barry we should pass on the movie. And not so long after that, Altman wished me dead. Hey, fair is fair.

In the early nineties I attended a meeting of The Creative Coalition in New York, a group of liberal activist show business folks who were working to influence some areas of public policy. Harry Belafonte and I were talking next to the bar when across a crowded room who enters but Kathryn and Robert Altman, and they head right toward us. Harry and Robert were friendly and as an aside, Harry's performance in Altman's *Kansas City* was worthy of a Supporting Actor nomination never granted because the film was such a complete mess. (Sorry, I couldn't resist.) Anyway, I'm clearly trapped. On the other hand, Kathryn Altman is a formidable and great lady and I always found her a delight, although I could never understand how she could put up with her husband. As he approached I thought about what I would say to someone who wished me dead.

Robert looked at me, held out his hand and said, "David."

"Robert, are you still making movies?" I replied, shaking his hand and smiling at Kathryn.

The Fastest Deal Ever Made

"It's a deal."
- Ted Ashley

Ted Ashley, a superb agent and later, one of the best executives who ever ran a movie company, set up an appointment for me to meet his client Allen Funt, creator of the TV series *Candid Camera*, the show where people were filmed in situations unaware of the camera and usually looking stupid and incompetent.

Ted: "Allen has an idea for a movie. Tell David."

Allen: "Well, it's a *Candid Camera* concept. It's called *What Do You Say to a Naked Lady?*"

David: "How much will it cost?"

Ted: "Uh, $600,000. Allen will guarantee the cost, 50-50 on the profits, etc. That's it."

David: "Fine with me."

Ted: "Okay, it's a deal."

Now that's what you call a high concept pitch, or a low one, depending on your point of view. Total elapsed time, under one minute. And just about the right length for any meeting.

P.S.: The movie was a big hit.

Ingmar Bergman

"Dear David, the important thing is you told me the truth."
- Ingmar Bergman

Early 1964:

"It's Paul Kohner. Do you want to talk to him?" asked my assistant Peggy. Why not? Paul, who was born in Germany and worked for several American studios in Europe in the thirties, was a highly respected agent in Hollywood representing mostly talent born or based in Europe. The good news with Paul was that you never knew what he might have up his sleeve, since his representation was reasonably unpredictable. The other good news was that he was on the phone from Los Angeles instead of seeing you in person because after every meeting with Paul, he asked if he could make a call or two before he left, then wound up in your outer office calling Paris, Rome, Moscow, New Delhi, and who knows where else. He was famous for this.

"Sure, put him through."

"David, this conversation cannot be repeated to anyone or it will make trouble. Promise me that."

"Okay Paul, whatever you say."

"I think it's possible that Ingmar Bergman might agree to make a deal with an American company to finance some of his films. He's never done that you know, and it might well cause a big scandal in Sweden if he leaves Svensk Film, but the timing may be right. If it is possible, you and United Artists would be the only

place. Please you cannot tell this to anyone, you understand what I'm saying?".

I could see the perspiration on Paul's face through the phone. Most conversations with Paul involved some aspect that precipitated perspiration on his part, for although he had great respect for his clients, it was coupled with a large dose of fear of them and that, combined his with natural sense of conspiracy, often led to the wetness. On the other hand, what Paul was saying here was big stuff. He definitely had my interest. "You understand, David, this has to be kept absolutely confidential."

"Paul, stop it already, you made your point. I understand the sensitivity. And of course we're interested in financing and distributing films by Ingmar Bergman. What would you like me to do?"

"I'll get back to you."

As United Artists began to establish its place as a top provider of films world-wide, and in order to compete for playing time with the majors, Arnold Picker realized that if UA could acquire or finance original language product on the Continent it would enlarge its capacity to get important playing time away from the majors. He was right.

Led by Arnold, myself and Ilya Lopert who was based in Paris, United Artists went after the best European filmmakers we could attract to our Company. Ilya, who was Russian-born, spoke French, Italian, Russian, German, and Polish, and played gin rummy in all of them. In fact the only language he spoke with an accent was English. Listening to Ilya talk to one of his cronies was similar to being near the coffee machine at the Tower of Babel. The segue from one language to another was virtually impossible to identify. During the sixties and seventies we financed and distributed films made by many of the great European filmmakers including Louis Malle, François Truffaut, Claude LeLouche, Jerzy Skolimowski, Federico Fellini, Gilo Pontecorvo, Pier Paolo Pasolini, Michael Cacoyannis, Sergio Leone, Marcel Camus, Bernardo Bertolucci, and others. Within this strategy, the idea of being in business with Ingmar Bergman would be an enormous asset, making our International Distribution even more powerful and our presence in Scandinavia preeminent.

"Paul Kohner says this has to be kept under wraps, but we might get Ingmar Bergman," I told Arnold.

"Great," he said and went back to whatever he was doing when I had interrupted him. That was a long conversation with Arnold.

A few days later Paul called and said Ingmar Bergman would be prepared to consider a relationship with United Artists but there were some conditions, the most important of which was that no one could know of this possible deal until it was done because its announcement was very sensitive to Mr. Bergman. There would be some recriminations that the icon of Swedish filmmaking was "selling out" to American interests, and even though United Artists was known to fund many of the world's great film artists, nonetheless the "Swedish" situation would have to be handled with great sensitivity. Mr. Bergman would not give us script approval, but he would give us an outline of the film either in a few paragraphs or orally along with the principal cast. We would have budget approval and that cost would be guaranteed by an appropriate entity. Of course the films would be shot in Swedish. Paul said if these several conditions were acceptable, Mr. Bergman would be happy to meet with me in Stockholm right after the first of the year and give us the outline of the first film.

I told Paul to set up the meeting and that I planned to bring Ilya Lopert with me since he was our man on the Continent and had never met Mr. Bergman. The meeting was set for the first week in January at Mr. Bergman's office at the Royal Swedish Academy, where he was in rehearsal of a play he was directing. "Remember," Paul said, "no one can know why you are coming to Stockholm; not even your own distribution people. If this gets out before the deal is done, it will not happen." I agreed that we would do everything possible to keep the reason for our trip confidential. The whole thing seemed a little paranoid and out of proportion, but Paul was insistent, and the idea of distributing Bergman films was too exciting to jeopardize.

The holidays came and went. I flew to Paris. By coincidence Arnold was also there for meetings with his distribution organization, and when I told him Ilya and I were to fly to Stockholm the

next day to meet the maestro, he said he'd come along. I could
hardly say no to one of the company's owners, much less my mentor
and uncle, but I was not overjoyed. I'd have preferred to be alone.
Ilya was brilliant with creative people if something of a larger-than-
life personality himself, but Arnold was another story. There were
certain filmmakers that Arnold was totally comfortable with, but he
was not a man of infinite patience. Not that he was impatient; he
was just organized, precise, and punctual. There were a few film-
makers he was friends with and could be totally at ease with, but
at most meetings he just wanted to get on with it. So I really didn't
know what lay ahead. I knew Paul would make Arnold crazy with
his nervousness, his obsequiousness with his clients, and his style
in general. I'd gotten a message from Paul saying that after the
Bergman meeting we were invited to dinner at the Operakalleran
by Max Von Sydow (a client who had made some films for us) with
a group of his friends, including both Bibi Andersson and Harriet
Anderson. However they could not know the reason for our being
there, and therefore Paul had made up a story about some interest
we had in perhaps acquiring a small Swedish distribution company
and chain of theaters as the reason for our trip. The meeting with
Mr. Bergman was for 7:45 p.m. and the dinner at 9:00 p.m. Paul said
that would be sufficient time. He would pick us up at the Grand
Hotel and drive us to the side entrance of the Academy, where we
would be escorted to Mr. Bergman's office for the meeting.

The night before our scheduled flight from Paris to Stockholm,
it started to snow. I mean it *snowed*. It was still snowing the next
morning and afternoon, and all flights were cancelled. Ilya was
now having second thoughts about going. He hated to fly; it ter-
rified him, and for a man who had to fly a lot, this was not a good
thing. Twenty-four hours passed and it was still snowing. Canceling
the trip made no sense; we were only a short flight away, and so we
decided to wait it out. SAS Airlines promised we'd have seats on
the first flight out. It was two and a half days later that an impatient
Arnold Picker, a terrified Ilya Lopert, and I went down the runway
at Orly headed for who knew what. It was still snowing lightly in
Paris. It was still snowing lightly in Stockholm. But we were on our

way. I've never seen anyone as scared as Ilya. He was truly ashen. He was crammed into a small seat on the all-coach flight, and I really felt for him. From the time we took off to the moment we touched down in Stockholm we never really saw land or lights. Even for a confident flier, it was a little scary, but we finally were in Bergman land.

Paul was waiting at the airport, and so were a couple of United Artist executives from our Swedish office. Paul almost had a heart attack. I took him aside and told him to stop worrying, that there was no way Arnold was going to arrive in a country without our people being there to welcome him. He didn't look convinced. I'm sure he had visions of Mr. Bergman being a *former* client.

The snow had finally stopped and Paul picked the three of us up at 7:25 pm. The city was awash in the beauty of the orange lights that lit Stockholm's streets and buildings. It was as if the magic of a fairy tale world had descended on this beautiful city, and we were on an orange brick road to meet our Swedish wizard. Ilya had really not recovered from the flight yet, Arnold already seemed a touch impatient, and the meeting hadn't even started. Paul, poor Paul, was worried about everything: being on time for Mr. Bergman, being late for Mr. Von Sydow; and being banned from ever entering Sweden again. As we turned past the front of the Royal Academy to its side entrance, I couldn't help but wonder at the almost awesome and extraordinary life I was leading. I was part of a company that was collaborating with the finest filmmakers of our time, and I was sharing in the decisions as to whose films we would encourage and support, what dreams of theirs we would be part of making happen - and yes, I was actually being paid to do it. As my friend, Herb Gardner, once said about writing, "Don't they realize they're paying us for doing something we'd be thrilled to do for nothing?" That's how I felt about my life as part of a company whose goal was to support, encourage, and enable artists to create their work, underwrite their risk, absorb the losses and share the gains. Was it messy at times? Yes. Were the egos often out of control? Yes. Did the failure hurt and the successes exhilarate?

Oh boy, yes. But as opposed to the individual filmmaker who could work for years on a single project, we were underwriting over thirty films a year, and had access to literally any filmmaker in the world. Some people had the nerve to call this "work"! I was collaborating with a group of people who respected my belief in the films I wanted United Artists to underwrite. That, too, was a privilege, and vastly different from the way major studios had operated for decades, where essentially every production executive is trying to find projects they think their boss will like and approve. I was in the enviable position of trying to persuade my bosses to do the films in which I believed. I wasn't always successful (and that's another story), but I usually got my way though ardent advocacy. Now on this glorious, magical evening I was about to meet Ingmar Bergman.

His office had very, very, very high ceilings. On the walls were several of those almost banal huge portraits of the greats of the Swedish theater (you've seen these kinds of paintings in university corridors and stately mansions). The room was very dark and shadowy. The only light source was a lamp, the kind usually found over pool tables, flat and wide, hanging rather low over a large coffee table surrounded by several couches and chairs. Separate and apart, a desk was off in the dark recesses beyond the light. We were waiting for Mr. Bergman. It was 8 p.m.. Arnold was looking at his watch. Paul was looking at his watch and sweating. Ilya was staring off into space, probably thinking about the flight back to Paris the next morning. Mr. Bergman was late.

After another ten minutes, a door opened and a tall, gaunt figure entered the room. He was wearing a green button-down cardigan and his face was apologetic. In impeccable English, Ingmar Bergman apologized to us all for being late. Rehearsal had gone on too long, but he just couldn't end it until the logical end of the scene they were doing. He hoped we'd understand. *I* did. I wasn't sure about Arnold. Introductions were made, and I immediately noticed the single most striking characteristic of this extraordinary man. It is the main reason men and particularly women found him so mesmerizing. When Ingmar Bergman talked to you, you are absolutely convinced that

this particular conversation at this particular moment you are the only thing in the entire world that is of interest to him. He talks to *you*. He listens to *you*. He looks at *you*. He is yours, and you are his. Perhaps I romanticize this, but that's what I felt. I admit I'm a sucker for the creative personality, but Mr. Bergman was astonishing.

What happened next was also remarkable. I knew that the others in the room expected to chat a bit, Mr. Bergman would then detail the idea of the first film, we'd thank him very much and off we'd go. It was soon evident that this was not exactly what Mr. Bergman had in mind. I wish I could remember all the specifics of what we talked about, but I can't. I know it was about movies, and he talked mostly to me. The movies I liked, the movies he liked, particularly those of Fellini. He said they'd only met once and had agreed to send little code messages in their movies to each other, but he wouldn't say what they were. He asked me what movies United Artists was doing and what filmmakers we were in business with (at that time I had started dealing with Mr. Fellini to make some pictures for us, which he eventually did; Fellini's *Roma* and *Satyricon*) and on and on and on, all about movies.

Ilya had little to say. Arnold's impatience was barely concealed, and he kept staring at Kohner, willing him to have Mr. Bergman get to the point. And Paul, well, poor Paul was just terrified. It was clear that his client, Mr. Bergman, was in no hurry to get to the point, and it was also clear that we were going to be late for dinner with his other client, Mr. Von Sydow. It was now almost 9 p.m.. Finally the pressure on Paul won out, and he gingerly said to Mr. Bergman that he knew the gentleman from United Artists would love to hear the idea for his first film. It seemed immediately to shake Mr. Bergman out of his chattiness and he responded very quickly and very warmly. "Of course," he said, "of course." He paused, "It is called *Persona*. It is about a husband and wife, and how the husband's memories of his past threaten their relationship." He stopped. It certainly took less than five seconds to speak the words. He stopped and looked at all of us. No one said anything. Arnold looked at me and then at Paul. Paul looked at the nearest wall. Ilya looked sad. It was quite clear what had occurred. Perhaps we had all thought the meeting

was about hearing the outline of Mr. Bergman's proposed film, but for Mr. Bergman the meeting was about meeting the men from United Artists and seeing if he wanted to make films for them.

As we went back down to the car, Arnold let Paul have it. "This is what I came from Paris to hear?" and so on. Poor Paul. What could he say? Now we were thirty minutes late for dinner, and of course we couldn't explain why because of Paul's admonition. As we drove to the restaurant, knowing Arnold as I did, I let it lie. There was no way we weren't going to make the deal. We'd had a wonderful conversation about film and I was confident that Mr. Bergman would work with us. He was testing us, not us testing him. How could it be any other way?

We entered the restaurant and headed toward the table of twelve where our host, the charming Mr. Von Sydow, awaited us. Before we could even be introduced, Bibi Andersson, one of Mr. Bergman's favorite actresses who was sitting beside Von Sydow, turned to Kohner and said, "So Paul, how did the meeting with Mr. Bergman go? He said he was so looking forward to meeting the gentlemen from United Artists!" Some secret meeting! I remember little else from that dinner except the grilled rack of reindeer (Blitzen, I think) and some aquavit.

Ingmar Bergman made four films for United Artists that were released worldwide. He followed *Persona* with *Hour of the Wolf*, then *The Passion of Anna* and *Skamen (Shame)*. Other than to get a call or note about the general content of each and approving each of the budgets, there were no more meetings. *Persona* was a major international success, and *Hour of the Wolf* did quite well. When each film had been delivered to New York for their initial screening, I sent Mr. Bergman a cable telling him how much I admired the work and how proud we were to be able to distribute his film. The third film was *Shame (Skamen)*, a riskier venture both because of subject (war) and cost, but the success of *Persona* and *Hour of the Wolf* made it impossible to reject. When *Shame* arrived in New York, I screened it and was deeply disappointed. I felt the film didn't work and that we would

probably lose some serious money. What could I say to Mr. Bergman in a cable? So I said nothing. I sent nothing.

A week later: "It's Paul Kohner, do you want to talk to him?"

"Sure, put him through."

"David, Mr. Bergman says he hasn't heard from you."

"I know. I'll get in touch with him."

Dear Mr. Bergman,

I'm sorry to say I didn't respond to *Skamen* as I did to the previous films, but after all it is not my reaction that's important. The audience will be the ultimate judge.

Respectfully,

David

Dear David:

The important thing is that you told me the truth. As far as the audience is concerned, if they do not like the film, it will bother me … for about five minutes.

Yours,

Ingmar Bergman

The Brooks Brothers

"Never talk out loud in an elevator."
- Richard Brooks

This is the story of the Brook(s) Brothers, two filmmakers who, on the surface, would seem to have little in common, but from whom I learned so much because of traits they shared. I know they didn't know each other, but I wish they had. In their unique way, they have contributed to the common goal of creativity and capital that has been referred to already but in ways that are totally different. The fact that they almost shared the same last name is alliteratively convenient, but as you will see, they shared a lot more than that.

I hate it when I read the way contemporary critics (if they can be called that) casually throw around the word "genius." It is a word easily abused. In my career, I could only apply it to Fellini, Bergman, and Peter Brook. His work in the theater, certainly in my experience, stands alone. The first time I saw a play directed by Peter was in December 1965 in New York. It was entitled "The Persecution and Assassination of Marat as Performed by the Inmates of the Asylum of Charenton Under the Direction of the Marquis of Sade", known in short as *Marat/Sade*. It was an unforgettable experience. Let me try to paint a portrait of what the evening was like.

The theater was full for an 8 p.m. curtain, except there was no curtain. The asylum chambers were open to view. A little after 8 p.m., residents of the asylum appeared from all sides of the orchestra and

balcony talking to each other and members of the audience as well. You were instantly part of the drama and the place in which it was happening. The cast and members of Britain's Royal Shakespeare Company included Ian Richardson, Patrick McGee, and Glenda Jackson. As the play-within-a-play unfolds, the audience is taken by a combination of sight, sound, light and dark, horror and humor so rich and unpredictable as to really be indescribable. You literally had to be there to share the horror, the insanity, the intensity, as within the four walls of the Martin Beck Theater you had actually become a participant in the madness of it all. The production of Peter Weiss' play as directed by Mr. Brook simply challenged the theatergoer as no other drama I had ever seen. As the play slowly came to its climactic end, ever so slowly without the audience realizing it the lights in this theater, *ever so slowly,* had come back on. When the actors stopped talking, they froze in position – some on the stage, some on the floor of the theater. Those in our seats were totally stunned. The lights were up, the performers were frozen in place, there was no sound, only a kind of stillness as the audience didn't know what to do. I didn't time it but it must have been several full minutes before anyone moved, and finally, slowly, they started toward the exits. When I realized the cast was not going to move until we were gone, I stayed until almost the last person had left and still, not one inmate of the asylum had budged. I remember it today as well as that night forty years ago.

I was determined to see if Mr. Brook, whom I didn't yet know, would be interested in making *Marat/Sade* into a film. I had seen his film *Lord of the Flies,* an odd and extremely difficult story to translate effectively to the screen, but nonetheless daring in its execution. A meeting was arranged and a friendship began that has lasted since then. Peter was excited about a film version of the play but being the perfectionist that he was, had to devise a means to make it within a limited budget that would make the film a reasonable investment. The figure was less than half a million dollars.

Here was his challenge - he had a script and a cast that already knew most of the words. How could he film it? He hired David Watkin, at the top of the list of most creative cinematographers

in the business. Among his films were *Out of Africa, Moonstruck, Chariots of Fire,* and many more. What he came up with was ingenious, and permitted Peter to shoot the film almost never having to wait for a set to be lit. It was done by building the entire interior of the asylum and lighting every piece of it before the shooting started so that as the action moved from set to set, room to room, either for a wide or close-up or hand-held shots, each part of the set had been pre-lit. Peter was able to shoot the film in 17 days - an astonishing achievement - and the critical acclaim rightly noted how he was able to transfer his energy and genius from the theater stage to another medium.

In the fall of 1986, Peter called and asked if I would come to Paris to see his production of *The Mahabharata.* It was ending a year-long run at the Theater du Nord, a space created for his works. He wanted my advice. I felt it was an honor to even be asked. He told me about the play of which I knew nothing. It was in French. Okay, I speak a little and I was sure someone would help me. It ran nine hours. Nine hours. He was going to keep me there for nine hours in French. There were two intermissions of 20 minutes each; time for a quick sandwich and a drink. Oh, and you sat on benches, not seats. The performance I was to attend would be Saturday afternoon from 1 p.m. to 10 p.m., the next-to-last Saturday of a one-year run. The play had originated in Avignon, an outdoor venue where the performance started at 9 p.m. and ended with the climax as dawn actually arose across the open-air theater. Written by Jean Claude Carrière, it was based on a Sanskrit epic, probably the longest ever composed. It is described as "a collection of tales and legends including the fascinating story of a feud between two parts of a single Indian family waging a war that culminates in a vast, cataclysmic battle told in a heroic and moral context. The ultimate battle waged on cosmic grounds is about the human spirit, and that shrinking from one's moral duty and refusal to act even when it is most difficult pose the greatest danger to the survival of the individual and the species." Okay, that's what I was about to see. Since it had moved from Avignon to Paris, every performance had sold out. Peter had told me that his reasons for asking me to

see the play was to help focus how he could get it on film, and although it was scheduled to come to the Brooklyn Academy of Music in an English translation, he would prefer that I saw it in the original version in Paris in French.

I arrived in that great city Friday morning, rested and had dinner with Peter that night. He said he would pick me up the next morning and have a cup of coffee but he wanted to get to the theater by 11 a.m. even though the performance didn't begin until 1 p.m. He didn't tell me why but it seemed awfully early and I had a long day ahead of me.

After coffee and a croissant, we arrived at the theater at 11 a.m.. Peter's multilingual cast was waiting for him, and then I found out why the early morning call. This is who Peter Brook is. After a sold-out run with only four performances left, he had called the cast together to give them his notes from a performance he'd seen a few nights earlier. They were ready and eager to listen, correct, adjust or modify based on Peter's suggestions. Still improving, still refining, still creating. It was simply incredible.

I took my seat at 1 p.m. The play began. I only understood some of the French but I got all of the visuals and all of the intent. To say that it was mesmerizing, or that the time flew, or any of the other English language clichés to describe brilliance, is a waste of space. It was simply a work unlike any other I'd ever seen. I stayed Sunday and Monday with Peter and his documentary filmmakers to talk about how to capture the work on film. I did not believe anything could be captured that would replicate the impact of what I'd seen. The work was simply too complex, and clearly there was little commercial potential. Peter knew that of course, but it was important to him that in some form, it be preserved on film. I never saw all the end results, just a few pieces. I did, however, see the English-language version of the play when it opened in Brooklyn, and it was clear to me that the impact was nowhere near that of the original French production. Somehow the transposition to another language, the nature of the venue – whatever – had an impact. It was impressive, but not the same.

What has never left me about Peter Brook was his knowledge of theater, his detailed, always-adjusting belief that the work can be improved, his relationship with the artists around him, his understanding of every detail of every aspect of a work always in progress, the monumental belief that it has to be the best that it can be, and that the best is always worth working for and believing in. He was a force. So simple, so clear, so touching. His work was that of genius, and to be able to watch it and listen to him and help him fulfill his vision to as wide an audience as possible was a rare privilege.

So that brings me to the other Brook(s), Richard Brooks, a wonderful filmmaker and a pal from whom I also learned so much. First, let me get this out of the way. Richard Brooks was not a genius, but he was damn special. He was a reporter in Philadelphia who decided one day that he wanted to write movie scripts, moved to Los Angles, met some movie people, made a few friends, and tried to get hired by a studio to write a movie. His genre seemed to be tough guys in a tough world and that indeed was a mirror of who Richard was. A tough guy in a very tough world, Hollywood. He wanted to give it up but his friend John Huston, son of the brilliant actor Walter Huston, a fellow writer and director, convinced him to stay and they collaborated on the screenplay of *Key Largo*. He wrote *Brute Force* for Universal, and soon after MGM gave Mr. Brooks his first directing opportunity on a script that he wrote entitled *Crisis*. His career was underway. In the following years he had major critical and box office successes with both Academy award winners and nominations for *Elmer Gantry*, *The Blackboard Jungle*, *Cat on a Hot Tin Roof*, *The Professionals*, *In Cold Blood*, *The Happy Ending*, and *Looking for Mr. Goodbar*.

I first met Richard in 1960 as Max Youngstein's assistant, when UA was planning of the release of *Elmer Gantry*. Richard's usual attire was baggy cotton pants, short sleeved open-necked sports shirt, sneakers, no socks, and almost always a pipe in his mouth. He was brusque at first, but if he felt he could trust you, you could reach him. Among the fascinating things about him were the

stories he loved to tell about the characters he'd met on his march through Hollywood. The rules of his life were his absolute distrust of anyone's ability to keep a secret, and his insistence on total control to any extent possible of his work and his environment.

As our relationship grew, trust developed, he let me into his world and we became friends. To be trusted by Richard meant to be in a very exclusive club. I only knew two other members, the wonderful lyricists Alan and Marilyn Bergman. Among the people that Richard *didn't* trust were literally every studio executive, every referee in the National Football League (since he bet on almost every game, when he lost he was convinced that the referee was in on the take), most women, all projectionists (he insisted that whenever a studio screened his films, the projection room had to be locked so the friends of the projectionist or unauthorized studio execs could not sneak in), and all film delivery services during previews prior to opening. I have a vivid picture of Richard, a very strong man, carrying his film cans from his car and into the theater and up the stairs to the projection room personally. He trusted no one. Barry Diller had to read the script for *Looking for Mr. Goodbar* sitting in Richard's office with the door closed; he wasn't prepared to let it out of his sight. As a final piece of advice, he told me never to talk out loud in an elevator because you never knew who might be listening.

In 1968, Richard made *The Happy Ending* for us at United Artists. It starred his wife Jean Simmons who was nominated for an Oscar for her performance. The movie was unlike anything Richard had done before. The story of an unhappy housewife's struggle with addictions was a version of what was going on in their own life together. I visited the location in Denver, and I sensed the sadness in Richard and this movie. It never seemed to capture the energy or physical and visual excitement of his earlier work. The two days I spent in Denver, however, showed me a side to Richard that if I had never visited him during the creative process, I would never have understood. Yes, I knew of his demand for perfection and his desire for protection of his finished work, but on the set I saw something that deeply impressed me. Richard knew

everybody's job on the crew in depth, in detail, and in most cases could probably do it better. When one of the cameras went on the blink, Richard and the cinematographer took it apart to fix it. He knew every light and every lamp on the set, the sound equipment, and so on. He knew his craft; he knew how to get the most out of his crew, whose loyalty to him was almost fanatic. Look at his work on *In Cold Blood* -the lighting, the nature of the set-ups - and then look at *The Professionals,* one of the best westerns ever made, and you see an artist in absolute command of all aspects of his art.

That was Richard, as that was the other Brook. *The Happy Ending* was not a success, but years later Richard turned *Looking for Mr. Goodbar* into a commercially viable film for us at Paramount. His life was changing, however, and I heard from the man himself what, on one level, Hollywood was like. Richard and Jean lived in a lovely house on Charing Cross Road in Bel Air; a beautiful, upscale enclave next to Beverly Hills. Twice a week when he was not filming, he would screen new movies in his house. He was on the studio circuit, the "in crowd" for courtesy prints of as-yet-unreleased movies. The rules for attendance at movies at Richard's house were specific, and if you didn't follow them religiously you were uninvited. No latecomers, no comments to the screen unless started by him first - which almost never happened because he had too much respect for the craft and its participants - and no phone calls or interruptions. Not complicated, but enforced.

When Richard and Jean Simmons broke up, her personal problems finally becoming more than he could deal with, his own career heading towards its down years, he sold the house and bought a home in an enclave far from the glitter of Bel Air. The screenings ended, and sadly, but perhaps predictably, so did the friendships. Only Alan and Marilyn Bergman, his new girlfriend Cherie, and me when I was in town, stuck close. And this tough guy who gave his all to his craft in an industry he had served so well, was able to smile and turn and say to me, "Just like the NFL. I think the game is fixed."

Richard told me great stories about the studio days, and like so many voices in my life, I still hear his. Here's one: Jack Warner

calls him into the office one day to talk about the script for *Key Largo*. I only met Mr. Warner once, but stories about him abound. Richard says, "We're talking about a scene in *Key Largo* when suddenly Warner looks at me and says, 'You know, kid, there are three kinds of movies you should never make. You know what they are? Movies about bullfighting, anything to do with ice or snow, and any movie where a guy writes with a feather.' "

Peter and Richard, the Brook(s) brothers. Brothers in love with craft, with perfection, with detail, with storytelling - what a pair.

Truman Capote

"I want to get to the top of the mountain...."
- Truman Capote

Richard Brooks introduced me to Truman Capote while the two were working on *In Cold Blood*. The three of us shared a few dinners complete with wonderful stories, anecdotes and gossip. After that there was a time when Truman and I had lunch every four or five weeks, always at his favorite 'watering hole' as Walter Winchell used to say, the Colony Restaurant. He was, of course, a famous raconteur, telling me and many others over the years that what he loved to do most in the world was talk. That's what went on at these lunches, covering a wide variety of topics; his favorites were movies, writers, the craft of writing, theater and his many women friends whom he adored. I was a young movie executive and he was Capote. It wasn't as if either of us wanted or needed anything from the other, but we enjoyed each other's company. During one of our lunches he told me he had a home in Palm Springs and if I ever got there on one of my trips to Los Angeles I should give him a call and come by.

Some months later I was in Los Angeles in a meeting with Harold Mirisch, and he asked me what I was doing that weekend. "Heading back to New York," was my answer. "Come on down to Palm Springs with Lottie and me. We're having some friends over for dinner Saturday night and we're screening the new Elizabeth

Taylor film, *X, Y and Zee*. It will relax you." Why not? I can call
Truman and have a chance to take him up on his offer.

I arrived at Harold's house late Friday night and after breakfast
the next morning called my short friend. "Delighted! Come have
lunch with me and bring your bathing suit. You have to swim in
my pool." I thought 'uh oh' – not that there had been any hint of
a sexual approach from my famously gay friend, but I still said to
myself, 'uh oh.' "So you'll come, one o'clock. Bring your bathing
suit," he reiterated.

I told Harold I was going to visit a friend for lunch. "What
friend?" he asked. In La-La land even the good guys like Harold
have to know everything about everybody. I reluctantly admitted
I was going to have lunch with Truman Capote. His face lit up.
"Please ask him to come over for dinner and the new Liz Taylor
film. We'd love to have him as our guest." You bet he would.
Truman, very choosy about who he saw and where he went, was
notorious for not socializing with the Hollywood crowd. Having
Capote over for dinner and a movie was something Harold could
dine on for several seasons; the celebrity coup of his winter. I com-
mitted to nothing, fading Harold with a grunt, as Damon Runyon
would have said. I wasn't going to be the bearer of an invite. At
best, I would mention the movie and if Truman picked up on it,
move on to the invitation. If he didn't, the subject would be over.

At 1 p.m. sharp, I pulled into Truman's driveway, bathing suit
in hand. "You can change in the pool house. We're having lunch
there. Egg salad sandwiches, okay with you?" Truman Capote, a
bathing suit, and egg salad sandwiches – amazing.

As we sat down he said, "Before you eat, take a dip in the pool."

"I'm not much of a swimmer," I said. "In fact, I'm not much of a
swimmer *at all*." (To graduate Dartmouth, you're required to swim 50
yards. I finally managed to do it my senior year because of procras-
tination and two failures.) Water was to cool off in and get out of as
quickly as possible. It was also to fish in - any time, any place, any fish.

I took a dip. "Have you ever had a swim in water like that?"
he asked. I had no idea what the fuck he was talking about. "The
water," he said, "it's special. I have something added to it to make

it softer." Well, I'd been in it for almost a minute and it had felt, well, like water. But he was the host, I was the guest, so I told him it felt like no other water I'd been in (it almost *was* the only water I'd ever been in...).

The egg salad was as special as the water. I mentioned the Elizabeth Taylor picture, and he mentioned he had plans. No fool, Truman. He was way ahead of me and he had no intention of hanging the Truman Capote scalp on Harold's belt. The time flew by as it always did between us, and I headed back to Harold's house.

When I arrived, he was in the pool on one of those floats you can lounge in and put your glass in the armrest. All smiles, he wanted to know about lunch. He really wanted to know about Truman's hoped-for appearance, but he held back and I just wanted to have some fun with him. So I said I was going to jump into his pool and test the water. "What're you talking about?" he asked. "The water's fine."

"Well, I don't know about that. Truman had some special stuff in his, and I want to compare his to yours," I replied. He looked aggrieved.

"My water's great."

"I'm sure it is," I said, "but let me just compare the two," I said as I stepped into the aqua-blue Mirisch water. "Harold, I'm sorry to say they are not the same. There's something about Truman's pool that's just different. I've just never been in anything like it." Harold looked dismayed. "And Truman can't make it tonight," I added, "but he says thanks for the invitation."

Poor Harold. His pool was lacking, his guest list was bereft of the celebrity name, and all he had left was his family, friends, Howard and Ruth Koch, and me. And a dreadful Elizabeth Taylor movie.

The next morning over bagels and lox, I couldn't keep Harold on the hook and confessed that water was water and would always be just water. He perked up a bit, but I believe in his heart of hearts he thought I was just being kind, and that Truman's water was as special and elusive as Truman's presence.

In Truman's interview in an early issue of *Playboy* magazine, he was asked what he had hoped to achieve in his lifetime. He answered, "I want to get to the top of the mountain where although the air is thin, the view is exhilarating."

Those words have been etched in my mind since the day I read them.

Mort Engelberg

"Drama is life with the dull bits cut out."
- Alfred Hitchcock

There are no dull bits in Mort Engelberg's life. I've known Mort a long time, and when I contacted him to refresh my recollections of people, places, and events in our careers, he sent me the following email. I wouldn't dare change a word:

"Before I got to UA, I was a unit pub boy for MGM on *The Dirty Dozen, Far From the Madding Crowd,* and *The Comedians* (18 weeks with Taylor and Burton, one of whom liked me, and one who hated me, but chose to keep me around for torture rather than picking up a phone and telling MGM execs to fire my Jewish ass). During this time I did not sleep with Julie Christie, but I had a shot at both Alan Bates and John Schlesinger. Incidentally, *Madding Crowd* was shot in nasty Weymouth in the winter, and Schlesinger and I exchanged a lot of books - one that I happened to give him was *Midnight Cowboy* (which he later gave to you). It was an idle-time thing, not a movie thought then.

When I joined UA in 1969-70, I worked in publicity and was sort of Freddie (Goldberg) and Gabe (Sumner)'s gopher, working my way up to maven for production publicity - hiring and working with the units publicists and photographers. But there were other duties; remember our film, *Quemada (Burn!)*? There came

a time when Pontecorvo (the director) and Brando had a problem. Pontecorvo's response was to do 32 takes of the bad guy spitting in Brando's face; Brando's solution was to hire local banditos to kidnap Pontecorvo's kid. For reasons unbeknownst to me, you dispatched me to Cartagena to fix things. I went, I hung around for about a week, stayed out of the way and smiled a lot. My first quasi-producer job. Like they tell new doctors ... do the least possible harm.

Shortly after, I escaped to L.A., and worked for/with Herb Jaffe (UA's L.A. topper) for about two years. Although my vote wasn't worth much, I voted with you on *American Graffiti*. I left UA to become a quasi-partner with Ray Stark. The first project I sold to Columbia was an idea I had that became an original Jerry Belson screenplay, *The Great Cape Girardeau Leap* (later to become *Smokey and the Bandit*), and somehow Burt Reynolds fell into the thing. We met and he said the only person in America who can direct this is Hal Needham. I quickly agreed, then spent two days trying to find out what or who a Hal Needham was. We met, bonded, and got Burt to give us 13 days between pictures. Burt had made this picture six times in a row, including *White Lightning, WW and the Dixie Dance Kings* and *Gator*, but it did well. And even though I also made Steve McQueen's last film, *The Hunter*, as well *The Big Easy* and 13 others, *Smokey and the Bandit* will be my obit lead.

My political interests kicked in during the 80's and by 1991 I had met Bill Clinton, and went to work on his first presidential campaign. I spent 11 months on a little plane with him, one other fellow, and the occasional reporter. People either never heard of him, or thought it was a waste of my time. Our headquarters consisted of three rooms in the back of a paint store in Little Rock, and on the plane I was acting national security advisor, press secretary, baggage boy, etc. He knew from day one that I did not want a job, nor did I want to be a federal judge or ambassador. I have been a volunteer ever since that way, as I told him, he cannot fire me. I invented the bus trip in 1992, did the train trip from D.C. to the convention in Chicago in 1996, and have done most of the big (and often ticklish) foreign trips, including the Israel/Jordan

peace signing and a bunch of others. He has told me a number of times that "you are one of the few people who don't want anything from me", and I have told him many times that these past 23 or so years have been the most fun I've ever had.

Sorry for the unabomber manifesto, but I am jet-lagged after our recent 11 day trip to the UAE dealing with a lot of sheiks."

See, I told you there were no dull bits......

Bob Fosse

"My life is a mass of lies."
- Bob Fosse

I've written about my friendships with many of the most talented, creative people of my generation. One that I treasure deeply was Bob Fosse.

Born in Chicago and stagestruck at an early age, he grew up dancing and performing. During a short career at MGM he was a featured performer in a few of their musicals, including the movie version of *Kiss Me Kate*. He once told me that during this time at MGM he used to sneak onto the stage and watch as Fred Astaire rehearsed his routines; from that moment on, Fosse would put out his ever-present cigarette with the same foot movement Astaire used when stepping on his own discarded butt. Hollywood and performing in studio musicals had been his comfort zone, but the theater was calling, and in the mid-50's he made the leap, choreographing his first Broadway musical, *Pajama Game*. From there to *Damn Yankees*, and an iconic career was well-underway.

In 1965, UA financed the first theatrical musical Fosse both choreographed and directed. Frank Loesser, the brilliant composer and lyricist of such shows as *Guys and Dolls* and *Most Happy Fella*, played and sang his latest, *Pleasures and Palaces*, at a backers' audition and UA (me) went for it hook, line and s(t)inker. Fosse and Loesser - it seemed a natural. I went to the show's opening in

Detroit where I left with the feeling it was a "work in progress", but Bobby believed in the show strongly enough to offer an investment of his own money to move the show on to Boston. Despite his commitment, it closed in Philadelphia several weeks later when Loesser felt it just wasn't working. But from there the Fosse magic developed into the Fosse genius. In 1973 he became the first person to win all three awards in the category of Best Director in one year- the Oscar for *Cabaret* (beating out Francis Ford Coppola for *The Godfather!*), a Tony for *Pippin* and *Sweet Charity*, and a Emmy for *Liza with Z*. That was Fosse.

Our close, personal friendship began later when I started spending time with what might have been New York's movie and theater equivalent of the Algonquin Roundtable. At Wally's Restaurant with Bob came Herb Gardner, Paddy Chayefsky, Sam Cohn, and nights filled with laughter, talk and many stories. Paddy had written *The Hospital* for us at UA, and Fosse had asked me to do *Lenny* with him. Everything was open for discussion - wine, women, movies, plays, life. Examples: "My life is a mass of lies. I have three different dates tonight," Fosse told me after I asked what he was doing that evening. And in a scene that eventually ended up in the Fosse autobiographical movie, *All That Jazz*, Bob, lying in his hospital bed after a heart attack, asks Paddy to witness his will.

"I won't sign anything I haven't read," Paddy responded. And we all laughed, most of all Bobby.

There was one project I was deeply and emotionally connected to, a film about the homeless in New York, *The Saint of Fort Washington*. Although the story was neither a musical nor a sexy topic, I thought it might interest Bob. He said he'd be happy to take a look.

The voice I heard on my answering machine that night was his. "I'm in Washington, and I've got the script with me. I'll read it and we'll talk when I get back." That's what I heard. The voice of my friend - who died just a few hours after he made that phone call. I didn't erase the message for many months. I simply couldn't say goodbye to Bobby. Not then, not ever.

Norman Jewison and Hal Ashby

"Can you get me two tickets
to the Rangers game tomorrow night?"
- Norman Jewison

"Topol is in town and I want to take him to the hockey game. And guess what - they're playing the Leafs!" Norman was referring to his hometown Toronto Maple Leafs, and I didn't think it had much to do with Topol, an Israeli actor probably not steeped in the lore or love of the Canadian national pastime. They had both just finished shooting *Fiddler on the Roof* for us. I had season tickets to the Rangers and knew Irving Mitchell Felt, the Chairman of Madison Square Garden, owners of the team, so getting a seats for a world-famous director, as well as the star for the about-to-be big hit film musical *Fiddler on the Roof,* was not a problem. "Jewison, Topol - great. They'll sit with me in my box," said Irving. Norman was thrilled. My seats were only two sections down from the owner's box, so we agreed to meet after the game for a drink.

It was a few minutes before the game was to start. Irving waved to me as I mouth my thanks, and just then my two celebrity friends walk in. The Canadian and the Israeli have made a stop and arrive at their seats wearing full replicas of the Toronto Maple Leafs shirt waving Toronto Maple Leaf flags. Irving looked at me like I committed heresy, but by the game's end (who remembers the score ?), the charm and spirit of the Canadian director who knew and

loved the game, and the Israeli star who was in his ignorance ador-
able and funny, won Irving over.

When we agreed to purchase the rights to *Fiddler* for Norman
to direct for the Mirisch Company, it wasn't that expensive. Most
industry experts felt that because of the "Jewishness" of the mate-
rial, the film might not appeal to a large enough audience to make
it a sound investment.

They also probably felt that using Zero Mostel, whose stage por-
trayal of Tevye was over-the-top exuberant, would be a problem. He
milked it every night for all his worth, and his all was worth a lot. A
condition of Jerome Robbins' deal to direct the show on Broadway
was his right to direct the film if he so chose. I had hoped he would.
When UA had financed the Mirisch production of *West Side Story*,
Robbins, who had directed the Broadway production, co-directed
the film version with Robert Wise. Their relationship was a disas-
ter. Despite the fact that the film won the Oscar, the collaboration
between the disciplined, able Mr. Wise and the brilliant, domineer-
ing genius of Mr. Robbins was simply a nightmare. Robbins spent
some weeks on the show before "being fired". His inability to control
everything on the film as he did on the stage made shared creative
responsibility impossible. I desperately wanted Robbins to direct a
film on dance, *Fiddler*, or something else, and I felt I could bring
control to the production. We met in a tavern on Sixth Avenue and
he told me without wasting a word he had no interest in direct-
ing the film version of *Fiddler on the Roof*, so the rest of our time
was spent talking about what he might want to direct. I suggested
Nijinsky and we left to continue our conversation another day. We
never made a deal to do anything.

Norman's version of *Fiddler* was a big hit, and he went on to
make *The Russians Are Coming The Russians Are Coming*, *In The Heat
of The Night*, *The Thomas Crown Affair*, and *Gaily, Gaily* (sadly, sadly)
for us at UA. Working with Norman as editor on these films was
Hal Ashby.

One phone call from Norman was all it took. "Hal Ashby
has earned his chance to direct," he said. "I'll produce it for the
Mirisch Company if you'll greenlight it." Done. I met Hal when he

edited Tony Richardson's version of the dark, satirical comedy *The Loved One* and the films with Jewison. It was clear he was entitled to his shot, so I greenlit his first directorial effort, *The Landlord*, and it showed just how talented he was. From *Harold and Maude* to *The Last Detail* to *Shampoo* to *Bound for Glory* to *Coming Home* to *Being There*, he demonstrated his special talent in guiding varied and complex stories into brilliant motion pictures. In the end, however, his career was sabotaged by his increasing dependency on drugs.

I was invited to Hal's wedding to Joan Marshall. It was an experience unlike any I'd ever had in my life. It clearly showed the consuming, demanding aspect of his life that, sadly, was out of control. The "happy event" was held on a shooting stage that had been decorated for the occasion. On arrival, I embraced Norman and Dixie Jewison, and I could see the concern on Hal's mentor's face.

"Have you seen Hal? He's been asking if you were coming. He's over there," Norman said.

Looking in the direction of Norman's pointed finger, I saw Hal standing alone. The music blasting from the sound system was the latest Cream album. Seeing me approach, he opened his arms, hugged me, and whispered in my ear what sounded like, "What am I doing here?" I wish I could say he was coherent, but he wasn't. He was absolutely stoned. "Getting married," I answered. His only response was to repeat, "What am I doing here?" I rejoined Norman, shaking my head. "I know," he said. "I know." Soon everyone gathered for the ceremony, the lights dimmed, and Joan made her entrance. Wearing a long white dress, she was accompanied by two nurses, one on each side, holding her so she could walk steadily. I can still see both of Joan's wrists and lower arms covered by bandages. Whether or not she had attempted suicide I never found out. The sight of this woman being held up by caretakers walking down the aisle toward her husband-to-be who had just cried in my ear a few minutes before, "What am I doing here?" is indelibly inscribed in my memory. It was deathly sad.

Ravaged by their habit, these two unhappy people married each other that afternoon and needless to say, it didn't last. When

I got to Lorimar in 1979, Hal was finalizing a cut of *Being There.* Brilliant performances by Peter Sellers and Melvyn Douglas carried this bizarre film to his last triumph. By now his habit had completely taken over his life. Before my arrival at Lorimar, the company had committed to make two films with Hal, *Second-Hand Hearts* and *Lookin' to Get Out.* As the new head of production I had to deal with him. But I couldn't. No one could. He could be seen but he couldn't be reached. The films were basically incomprehensible. In Las Vegas filming *Lookin' to Get Out,* Hal had done setups that he never would have permitted had he been in control of himself. In one, as a few people leave a hotel entrance, he simply had them do it over and over again, and after each take he'd move the camera a few feet in one direction or another. His brilliant filmic sensibility had crashed under the poisonous pressure of his addiction.

Hal's editing room was in his house in Malibu. The last time I saw him, he showed me a couple of scenes cut together that made little sense, but he was so gone and so ill and so stoned that it wasn't a get-together as much as a farewell. He was the saddest man I've ever known.

Herb Gardner

"I'm a great old man."
- Marcus Soloway in "The Goodbye People"

Sam Cohn told me not to produce Herb's movie, but I did it anyway, and when I was finished I didn't talk to Herb Gardner for five years. In all my years in the film business, it remains the most painful memory I have. I loved him and I lost him, and I should have known better.

Our friendship began in 1962, when I read about a new play that had opened in Boston titled *A Thousand Clowns*. It sounded like it might make a good low-budget comedy so I flew up one afternoon to see it. Sold out from the rave reviews, I had only been able to get a seat halfway up in the balcony. When the curtain rose, I heard the voice of Herb Gardner for the first time. It is now 2013 and Herb has been dead for some years, but I can still hear his voice. As I write this in the New York Public Library for the Performing Arts on Amsterdam and 64th Street in New York City, I have open in front of me *The Collected Plays of Herb Gardner,* published in 2000. Reading the introduction by his friends who performed in them, reading the dedication to his friend (and mine because of Herb) Shel Silverstein, and hearing his voice again reawakened those years. I never thought I could write about them, but about to turn 82, reading Herb's introduction and once again hearing his unique

voice in my head, I realized that I had to write it down. If not for you, then at least for me.

Life with Herb (Herbie/Herbs) was a vaudeville turn, a soap opera, a million (or more) laughs, an adventure and, at its end, total sadness and hurt. I believed that our friendship could overcome the danger that constantly lurked in Herbie's creative head, but Sam Cohn was right and I was wrong.

I loved *A Thousand Clowns* and agreed to finance the movie after the play opened in New York. Produced by Fred Coe and Arthur Cantor, directed by Fred, the play opened on April 5, 1962. It was a big hit.

Fred also produced and directed the film with a modest budget and the same cast as on Broadway: Jason Robards, Barbara Harris, Martin Balsam, Barry Gordon, Gene Saks, and Bill Daniels. Filming began in 1964 and, as usual, it went on my list as a "picture in production". Since the total control was in Mr. Coe's hands, I looked forward to getting a look at it. Months went by. Although I'd met Mr. Gardner, we were not yet friends. I was just the guy who financed his play and he was the screenwriter. I left several messages at the cutting room for Mr. Coe, but got no return call. I tried for several days and finally someone answered. I asked for Fred.

"He's not here. Who's calling?"

"It's me," I said. "David Picker. Who's this?"

"Hi David, it's Herb. Maybe I should come by and see you."

He did. He told me Fred was no longer working on the picture, and slowly the story emerged that Fred had left, or given up, or gotten pissed, or who knows what; but it became clear that Herb had taken over the show. He was the creative force working with the editor. There was no producer or director in sight. I told him they were way late on the delivery date, so he agreed to preview the film in front of an audience in a few weeks.

I decided to have the preview in a theater in Fresh Meadows, Long Island that drew a middle-class Jewish audience. In those days unfinished films were shown on two projectors that were synched up - one for picture, one for sound. I had the head of our

projection department team up with the theater's usual projectionist just in case there were any problems.

Herb had trouble at the theater when he showed up carrying the film because he looked so young, they refused to believe he was anything but the delivery boy. He finally got up to the projection booth where our expert looked at the picture and sound track and saw so many splices (the connections between celluloid frames that "cut" together different shots) that he wasn't sure it could run through the projectors without breaking. His solution was to have the film's author (Herb) put on a pair of gloves and, as the multi-spliced film and soundtrack ran separately through the projector, have him guide it between his gloved fingers to make the transitions smooth. It worked; the film didn't break. The audience laughed and it looked as if we could have a modest hit with this quirky little film. We did, and Herb was nominated for an Academy Award for Best Adapted Screenplay and Marty Balsam for Best Supporting Actor.

I joined Herb and our mutual friend Ellie Klein, the wife of our lawyer Arthur Klein, and escorted them to the Oscar ceremony, a first for them. Crowds gathered along the sidewalks leading up to the Oscar theater entrance, gawking into the limos as they passed, trying to get a glimpse of this mega-star or that. One young woman stuck her head into the rear window of our car, open because from the first time I met Herb up to almost, but not quite the last, he was smoking one of those five-pack-a-day Camels that eventually destroyed his lungs and his life. "Oh," she said to her friend beside her as she withdrew her head, "It's nobody." I don't think I ever heard Herbie laugh so hard. "It's nobody. That's us. Nobody," he said.

Herb didn't win his Oscar, but Marty Balsam did. It was a great night.

That's how it began. The friendship just seemed the most natural thing in the world. I was there for Herb and he for me. I traveled to Mexico with him, flying from New York to El Paso, then a car across the border, to the local justice that granted him a divorce from his first wife.

One day he asked me if I thought we could get money to film his play *The Goodbye People*, and would I produce and agree to let him direct it. That was when Sam Cohn told me not to do it, but my ego took over. I believed that because of our friendship, no, our love for each other, I would be able to guide and control Herb's total need, no less obsession, to protect his written word.

I failed, and I believe this is why. While still a student at Antioch College in 1959, Herb came up with a series of comic drawings called "The Nebbishes". They were syndicated in over 70 newspapers in the United States and became a national fascination, even to the extent of appearing as statuettes, on cocktail napkins and posters among other uses. He made good money from it and after several years discontinued the series. A prized memento is a drawing he did incorporating me into his characters' world, holding many of the little Nebbishes on my shoulders with the caption "I am reliable". From these drawings Herbie moved on to writing his first play, *A Thousand Clowns*. On his written page each scene, paragraph, sentence or speech began a certain distance from the top and side of the paper and looked perfect in its size and dimension. In other words, he *painted* his words as if they were *pictures on a page* - so if you suggested the cut of a speech or a sentence within the speech, it was to him as if you were *disfiguring his drawing*. In addition, the New York theater, under the control of the Dramatists Guild, gives the writer final control of his work. No producer can arbitrarily cut, change or modify any speech without the writer's agreement. Of course, the movies don't have that restriction. Writers can be hired, fired, rewritten and rewritten, ignored, insulted, kissed and kissed off. Herb had written mostly for the theater, had controlled his content, and was really not open to suggestion. He might listen if he had to, but more likely he nodded and moved on in his own direction.

Norman Lear, Herb and I were friends, so I went to Norman and asked him if his company would fund *The Goodbye People*. He knew the dangers as I did, but he knew I would be there to make sure the show was supervised and he trusted me. The friendship

between the three of us would see us through if trouble arose. I was sure of that.

Casting *The Goodbye People* was easy. All the Herb Gardner actors wanted to do it. When I say they loved Herb, they did. The fact is, almost everyone did, and it was totally understandable. Herb was the most seductive man I've every known. I don't mean that in any sort of negative way. He was funny, he was brilliant, he was adorable, he was huggable, he would do anything for you. The only thing he couldn't do was cut his script or make his mind up about how he wanted to direct the movie. Because of his lack of shooting experience, I suggested that we get our key crew to give us extra time in preproduction to walk through the script on location. The physical setting was not a big deal; the whole show took place in Coney Island with limited construction needed. I wanted Herb to give the department heads a clue as to how he wanted to set up his shots. They all agreed - cameraman John Lindley, designer Tony Walton, the first assistant director, and co-producer Mel Howard - all gave Herb the gift of their time so later when we got to the actual shoot we'd be prepared. Herb had some dental problems that were causing him pain and I begged him to go see a doctor. He refused, saying he didn't have the time. After weeks of prep, I mean four weeks of *free* time from the crew, we had gotten maybe halfway through the script. Herb couldn't make his mind up about anything. He was not the affable, warm, loving, funny Herb that I knew. I believe he was frightened. In response to my pleading to cut the script, he finally gave in. He cut one line. That's the absolute truth. One line.

The filming began and it was a nightmare. Herb as a director was a disaster. During a film shoot the entire crew reflects the style of the director. If they feel confidence, they deliver on all their responsibilities in a manner that enables the director to achieve his or her creative goals. If the crew lacks confidence in the director's ability to clearly define his needs in lighting, costume, performance, or any aspect of the film's makeup, the show is in serious trouble. Herb could never make up his mind about anything; he couldn't express his technical or artistic needs clearly, and from rehearsal forward, he

lost the crew. They got nothing from Herb. Even worse than bad decisions on a production are no decisions. If the crew doesn't function, everyone is affected. The actors are frustrated, the producer (me) is frustrated, and the budget is affected as well. Time is wasted. Time is money. Nobody wins. The production was an unmitigated disaster.

The Goodbye People is about Max Silverman, a stubborn old man who believes that he can make a success of a hotdog stand on the Boardwalk at Coney Island and open it in the dead of winter. It is doomed to failure, and everyone tells him that. Especially his old friend Marcus Soloway who comes in late in the play and in one speech tells Max his idea won't work. Gene Saks was a Herb Gardner natural, having starred in the play and movie version of *A Thousand Clowns*. He was a fabulous actor and experienced director. He had one problem: he had trouble remembering his lines. We saved Gene's big scene for the last night of filming, knowing we'd probably shoot until dawn, which we did. As the sun rose in the east Gene finally said, "Silverman, I was not a top businessman. I was good, but not first class. I was an okay husband, and as a father not a knockout. *But I'm a great old man.* I do that best. I was born for it. I'm 74, Max, and it fits me like a glove. You, you're crazy. I wish you well with the business, but I can't join you. I'm too old for it.....now I'm leaving....notice how I don't take the stairs. Regard me, Max, how I take the easy way underneath the boardwalk. I'm 74, Max, and I got one interest in life - 75. You gather me, Silverman?" It was a wrap.

I'd never been so tired in my life. Or so angry. I felt I'd let Norman down and Herb as well. He just hadn't let me help him, but I blamed myself and Sam had warned me.

It's traditional to have a wrap party at the end of every movie and usually they're pretty relaxed, fun evenings. Herb came late and everyone left early. It had not been a happy shoot.

Rick Shaine was our editor. I left him with Herb to go through to a first cut and I stayed away to be as far from Herb as I could. One day I got a call asking if I could come to the editing room. Herb was there with Rick and he took me aside and said to me, "What do I do now?" What do I do now? His first cut was endless

and awful. I said to him, "Now you ask me? Now? Call your friend Fosse." He did, and Bob worked with him for weeks to just get a releasable film put together. It was literally an impossible task.

It opened in January, 1986. The reviews were dreadful and nobody went to see it.

I was so angry, I didn't talk to Herb for over five years. When we finally reached out to each other, we talked one afternoon for several hours. It wasn't as it had always been. I told him every-thing I felt and he understood, and even agreed, he said, "with at least two-thirds of it". It was difficult and unsatisfying. Our contact, already cracked, slowly disappeared. When I heard he was finally laid low by those fucking cigarettes, I went to see him. He was hooked to an oxygen tank, every breath difficult. It was pathetic and clearly only a matter of time. He died in September 2003, because he couldn't breathe, because there was nothing left of his lungs to hold air.

He never had a chance to be a great old man.

Larry Kramer

I think I'd like to write."
- The Author's Assistant

It's time I have an assistant, I said to myself. After all, Max Youngstein made me his assistant and look what happened to me. The work was piling up and it seemed logical. What I didn't think through was that Max had the desire and ability to open up his world to an assistant and make use of a dedicated, eager, "born to the business" young, ambitious me, in a way that worked for both of us. It helped him, it trained and prepared me. It was paradise on earth. Was I Max? No. Yet the idea of an assistant seemed to make sense, but having one was a totally untested notion.

So I started the search. The personnel department put out the word in the company. There didn't seem to be any logical candidate. After all, I was 31 years old and having an older assistant didn't make too much sense, so they looked outside. After screening several possibilities, they suggested I meet a young man named Larry.

Larry Kramer came in for an interview and I liked him immediately. He was obviously very bright and eager. He was working as an assistant to an executive he didn't like at Columbia, and he was looking for a change. After several other candidates didn't interest me as much as Larry, I made the decision. I offered him the job and he accepted.

A few weeks after he started, I realized two things with extraor-dinary clarity. Both of them convinced me I had made a terrible mistake. First, I was totally unable to operate with an assistant as Max had with me. I could assign Larry tasks, but I couldn't include him in everything as I had been included. Being the top guy was new to me. I was learning on the job, and I was guarding my position to both protect myself and to learn without having someone attached to me all the time as Max had done. The other obvious problem was that Larry was not born to be anybody's assistant. He had a very strong, aggressive personality (which I actually liked very much) but it was off-putting in his new position. Larry was pushing for involvement in all things, yet I didn't really know how or what I was prepared to share. The only good thing that resulted from the situation that I had created was that we were both able to acknowledge the problem and discuss it. Larry wasn't the slightest bit shy about his discomfort, for which I respected him, and I acknowledged my need to feel my way into sharing or actually assigning responsibilities to him. What we did do was agree to try it for some months and then re-examine what, if any, progress either of us had made.

Well, it just didn't work. So one day I confessed two things to Larry: one, I couldn't deal appropriately with an assistant and two, he had shown me clearly that he was not cut out to be anyone's assistant under any circumstances. "So what do you really want to do, Larry? This can't and shouldn't go on."

"I want to see a movie being made," he said. "I want to live in London and I want to write." That didn't sound like assistant material under any known definition of the word.

I called Clive Donner, a wonderful British director, who was in pre-production on a small film that we were financing titled *Here We Go 'Round the Mulberry Bush*, and asked him if he would put Larry on as an assistant to learn something about filmmaking. He agreed instantly, and Larry was thrilled. I asked him how much he thought he would need to support himself for a year in London. To this day, we remember different numbers. He says it was $7,500, I say it was $10,000, so let's just say it was $8,750. "You're fired,

Larry. Here's $8,750, go to London, work on the film and write. And my best to you."

Larry left and for a year and a half and I heard nothing from him. One day Peggy, my secretary, says to me, "Larry's on the phone from London." After a couple of polite words, he says to me that he's written a script, there's a producer, Martin Rosen, and a director, Ken Russell, attached. It's mine if I want it. "What's the title?" I asked. "It's based on the D.H. Lawrence novel, *Women in Love*." I read it, we made the film, it was a success and Larry Kramer got his first credit as a writer.

Larry returned to the United States and, in addition to his writing, founded the Gay Men's Health Crisis with a small group of involved friends. In 1985, Joe Papp encouraged him to write a play and the result was *The Normal Heart*. Larry, who lives with his partner David Webster in Connecticut, has remained my friend over all these decades. Other plays, other screenplays, founding Act Up, Larry has become one of the most influential, provocative and authoritative voices of our time. Isn't life absolutely absurd? We tried for years to get *The Normal Heart* made as a film and it didn't happen then, but at this writing there has been a hugely successful, Tony awarding-winning Broadway production, as well as a major HBO film in the works.

Larry has made an impact on the world – this outspoken, dedicated, difficult, heroic man - and left a mark that really can't be measured.

Somebody's assistant? I think not.

Stanley Kramer

"I cannot and will not cut one frame from this picture."
- Stanley Kramer

Who was Stanley Kramer? Was he the filmmaker who produced *Champion, Home of the Brave, The Caine Mutiny* and *High Noon,* or the man who produced *The Wild One, So This is New York, Cyrano de Bergerac, The Sniper, The Happy Time, The Four Poster, The Member of the Wedding, The Juggler, The Five Thousand Fingers of Dr. T, A Child is Waiting* and *Invitation to a Gunfighter?* Was he the filmmaker who produced and directed *The Defiant Ones, Judgment at Nuremberg* and *Guess Who's Coming to Dinner?* Or was he the director or producer of *The Stranger, The Pride and the Passion, On the Beach, Inherit the Wind, Pressure Point, Ship of Fools, The Secret of Santa Vittoria, RPM, Bless the Bears and the Children, Oklahoma Crude, The Domino Principle,* and *It's a Mad Mad Mad Mad Mad World?*

Stanley Kramer was the filmmaker who barely acknowledged the contributions of any director he ever worked with, the exception being Fred Zinneman, who he mentioned "has some talent". Stanley Kramer was the filmmaker who castigated Harry Cohn, the head of Columbia Pictures, who gave him the approval to produce nine films with total freedom to choose the material, cast and director and for all of which Kramer admitted only one made money. Stanley Kramer was the filmmaker whose autobiography describes the films that were funded by United Artists, the company that gave him his first chance

to direct, without giving them any credit for supporting his dreams, and only mentions in passing the name of one executive in the company, and misspells his name.

I got to know Mr. Kramer in his UA years and was witness to his operating style. It was dazzlingly clear. He believed the company was indeed fortunate to have him making films for them, and beyond that he was not interested in any input or opinion. His attitude was one of sublime confidence in his own taste, talent, and marketing know-how, and he actually resented the idea that anyone might be able to help him or suggest anything of value in the making or distribution of his films. Of course, it was only in the making of his films, assuming he stayed on budget, that he had total control. Nonetheless, working on the planning and distribution of his films was always confrontational and difficult. He wanted no input, sought no help, and usually argued about every issue once his film was delivered. By contract with United Artists, he had total control over the content of his film and the final cut once the approvals had been given. He was religious about maintaining his rights, and I always believed he thought he would get a star on the left side of Hollywood Boulevard.

Because this was his history with the company, as I grew into my position, my relationship with him was always limited, deferring and correct. The only executive who had a personal connection was Arnold Picker. Their birthdays were one day apart, born in the same year, and they attended the same high school in New York City, Townsend Harris, a school for students with advanced IQ. It was only in Arnold's office that I once saw Stanley laugh and smile. It was a shock.

United Artists paid a price for his education as a producer and director. *Not as a Stranger*, the first film he directed, was a mediocre film filled with stars based on a medical potboiler bestseller. His next picture was a major catastrophe. Starring Cary Grant, Sophia Loren and Frank Sinatra, *The Pride and Passion* was dreadful. Stanley survived and a year later at United Artists produced and directed *The Defiant Ones*. The film was a triumph of content and controversy, resonating around the world with its depiction of the relationship

between two convicts, one black and one white, Sidney Poitier and Tony Curtis. The United States government tried to deny United Artists a screening in the Mexico City Film Festival because they thought it hurt the image of the country, but UA persisted. The film and stars were cheered. The U.S. cinema light shone brightly as the film showed how generations of backward thinking could be affected positively by one 95-minute movie. I attended a screening of the film in Berlin where again the filmmaker was cheered. It was heady stuff; Stanley was a hero and UA was very proud.

The films that followed for UA were in consecutive years: *On the Beach, Inherit the Wind, Judgment at Nuremberg* and *Pressure Point*. It was in her review of *Judgment at Nuremberg* that Pauline Kael wrote in *The New Yorker* that "Stanley Kramer should be reviewed for his intentions and not his movies." As an aside, she described Abby Mann, the screenwriter who had originally written the piece as a TV drama, as "Mr. Fix it for Original Sin."

The company had agreed with Stanley to develop a BIG comedy. A comedy for Stanley Kramer; now that was a daring idea, but with the prestige his pictures had acquired and no recent disasters of major proportion, the company gave it a go. The idea was for a reserved seat, big-screen comic extravaganza. William Rose, working under Stanley's supervision, delivered a script entitled *It's a Mad Mad Mad Mad World* and the company gave Stanley a green light for a giant cast and a big budget. The picture was in production when I became head of production at the company.

Mad World was heading way over-budget. The company had several options. The first, which would have been idiotic, would have been to take over from Stanley, bring in another director and finish it as best possible. We'd never done it before, and we didn't do it then. We simply told Stanley that he had to recognize that he was jeopardizing the company's economic health and he had to get the budget back under control as best he could. He said he'd try. We believed him and let him finish the film. Normally, Stanley would have completed shooting, then post-production, and he would have delivered the completed film but now he was in a different position. He was so far over-budget that now the final cut was ours,

not his. Now the post-production was whatever *we* would agree to, not whatever *he* wanted to spend. Now he had to show us the cut of his movie before locking it. Now he had to do something he'd never had to do before and now I was the executive with whom he had to deal.

So what did he do? He called Arnold and said, "I'd like to show you and David my cut." That was fine with me. There were a few of our creative producers that Arnold was close to, and though his expertise was international distribution, there was little that Arnold didn't know about the movies. If this gave some comfort to Stanley, it was fine with me. I trusted Arnold and if there was any-one who knew how to deal with Stanley, it was Arnold.

The Goldwyn lot was the home of United Artists in Los Angeles, and it was in that screening room at 10:30 a.m. that Stanley invited Arnold and me – just the two of us – to see the first screening of *Mad World*. After the usual pleasantries, Stanley looked at both of us and said, and I quote, "The film is 4 hours and 1 minute long, and I cannot and will not cut one frame." I'm a boxing fan, and I remember when Joe Louis knocked out two-ton Tony Galento with a right hook to the gut. That's what it felt like. Four hours and 1 minute – that's a lot of nerve to tell a company that trusted you. That kind of running time was more than rude, more than ungrate-ful, more than anything but a total disregard of the contract he had made with us when we had okayed production. Every picture by contract had a running time within which the film had to be deliv-ered. Did the company always enforce this clause? Of course not. It was a subject that was always discussed if there was potential for excessive length. With *A Mad World*, clearly a big show, even two or two and a half hours might be fine. But 4 hours and 1 minute and "I can't cut one frame? That was just "fuck you" to the people and company that had supported his dreams for many years.

The lights dimmed, the picture came on the screen, and a long, long, long, long, 1 time later it ended. I was stunned and so was Arnold. There really wasn't a lot to say to Stanley. I don't remember the words, but our intent was very clear. There were some very funny scenes in the movie, but cut it, cut it way down;

and if you don't, we will. That was the bottom line and Stanley had little choice but to agree. He knew we meant it, he said he would do the best he could, and we waited to see what Stanley would do. Let me say that in the making of these cuts, not once did Stanley do them because he wanted to make them, or believed in them. He did it because he had no choice. There was nothing collaborative or gracious about it.

What he did was cut out about forty minutes. I still felt it was too long. Stanley being Stanley, pleaded his case and the company agreed to try it at this length for one engagement. If it worked, then fine, but if it didn't, he would have to cut it again. It didn't. The picture was just too long. What's so fascinating is what happens to the comedy core of the film when excessive greed takes over. What happens is you lose. Yet Stanley's excessiveness in this cut never seemed a problem to him. Now he had no choice. He got the film down to 2 hours and 40 minutes and finally it played well enough. I always felt it could have lost another 15 or 20 minutes, but by then we had our fill of each other and locked it up.

The picture did well, but Stanley only produced two more films for the company, both duds: *A Child is Waiting* and *Invitation to a Gunfighter*. He went on to make *Ship of Fools* and *Guess Who's Coming to Dinner* at Columbia, then he came back to UA with *The Secret of Santa Vittoria*. My guess is Columbia had gotten fed up with him by then, too. The book was on the bestseller list for months; the tale of a small Italian town that tries to hide its wine from the occupying German army in WWII, it starred Anthony Quinn, Anna Magnani and Virna Lisi. At the end of the first screening of the film several UA executives stood and applauded Stanley's effort. Some did not. In his autobiography Stanley mentions this fact, and interestingly enough adds that the UA execs thought they had a runway hit on their hands. Then he adds "as I feared, they had nothing even close." Now that's chutzpah and an after-the-fact lie. The truth is that after the screening Stanley took Arthur Krim aside and asked if the company would consider buying out his profit share as he needed some money, and Krim, a tough negotiator, asked him what he wanted. Stanley said $2.5 million. Arthur offered him

$1.25 million and Stanley turned him down and left. If Stanley really felt he had a bomb as he intimated, why didn't he grab the $1.25 million? Not a small chunk of change in 1969 or today. The picture was a giant flop and Stanley got nothing. He went on to make several more duds before he finally retired.

So what should we think about Stanley Kramer? I don't know how you feel, but I guess you know where I stand.

Irving Lazar

"David, how much do you pay for your underwear?"
- Mary Lazar

At the very top of my list of all-time favorite characters stands (not sits; he was too short for that) Irving "Swifty" Lazar. Meticulous in dress and manner (totally), true to himself (absolutely), he had rules and he lived by them - Irving's word was his bond. He was a legend not only in his own mind, but in everyone else's as well.

I was a young exec at UA when we first met and we hit it off from the start. I loved being with him, learning from him, and I adored his wife, Mary, as well. She, too, was meticulous, but after a few drinks she loosened up. The three of us just enjoyed talking.

I never called him Swifty; to me he was always Irving. One night at dinner Irving showed me how he did business. It was a single piece of paper tucked in the inside pocket of his jacket, a handwritten spreadsheet, listing every company that owed him commissions on his clients' deals. He wanted the payments spread out, and the card listed how much each of the major studios owed him over the next ten years. It was a great deal of money. He said he'd never shown it to a studio executive before. I was blown away by his trust, and I've never mentioned it until now. I know he'd say "It's all right, kid."

As he put the list back in his jacket pocket, Mary turned to me and asked, "David, how much do you pay for your underwear?" I couldn't remember ever being asked that question before, but

coming from the exquisite Mary, smiling over her third or so "on the rocks", I could only laugh. "No, I'm serious. How much do you pay?" I confessed that I bought briefs in packages of six for $10. (This was in the '60's.) "Well, how much do you think your friend pays?" she asked. I couldn't believe this conversation, but I went along.

"I have no idea."

"Sixty dollars each," she said. "Silk, from Sulka in New York (one of the city's most expensive haberdashers). And I bet you don't airmail yours from Beverly Hills to New York each week to be laundered and pressed. That's how he likes them done."

How delicious. Irving was impeccable, and Mary was a delight.

Norman Lear

"Life is about having a good time."
- Norman Lear

An unlikely couple walked into my office in 1967 - Norman Lear and William Friedkin. Unlikely, because Norman, already a well-known TV writer, was smart, funny, and charming, while Mr. Friedkin, on the other hand, had a single response to everything from "Hello" to "How do you see the direction of this project?" - a loud, "Outta sight, man!" They came to pitch *The Night They Raided Minsky's*, a musical comedy about Minsky's Burlesque and the invention of the strip tease back in the 20's. The screenplay was by Norman, Arnold Schulman and Sidney Michaels, with Friedkin directing. I'll just summarize by saying that in post-production Norman, and editor Ralph Rosenblum, created a wonderful, funny movie. And Mr. Friedkin was mostly "outta sight".

I believed in Norman. When he brought me his idea for *Cold Turkey*, I loved it and suggested he should add another line to his resume: director. And, as an aside, in the middle of dealing with Friedkin, *Minsky's* and *Cold Turkey*, he found the time to shoot a pilot for a little half-hour TV show he had written, *All In The Family*.

There is nothing I need to add about Norman's iconic career over the last forty years, but I have to focus for a moment on his impressive social and humanitarian works. In 1981, he was a founder of People for The American Way, an organization devoted

to promoting fairness and opportunity in our diverse society; then in 2000, he and his wife Lyn purchased a rare, original copy of the Declaration of Independence and created a road trip to bring the document to schools and communities across America. Another dimension of a talented, compassionate, involved, giving man.

I'm happy to say that we began a personal friendship that has spanned the decades. Our families have mourned the passing of friends and loved ones, and celebrated birthdays, weddings, and milestones. And, as you would expect with Norman, we've also had a lot of fun.

At the top of the list, let me introduce you to "The Yenim Velt" (I understand it's a form of Yiddish for "Old World"). They were five couples who wanted to get out of town (in this case Beverly Hills), get away from show business, agents, the daily trade papers, rumors and unpleasant truths. Just get away for a few days of friendship, good food, wine, a few laughs, perhaps a little tennis. Just get away every now and then.

In the early 70's, there were five "member" couples: Norman and (the then-Mrs. Lear) Frances, Carl and Estelle Reiner, Dom and Carol DeLuise, Mel Brooks and Anne Bancroft, and Larry and Ann Gelbart. For one particular outing the DeLuises couldn't attend, and an invitation to join the group was extended to my then-wife and me. Being from the "executive" branch of the business vs. the "creative" branch, I was flattered at the invite, and looking forward to spending a few days with some of my favorite people. I didn't know what lay ahead, but I was sure it wouldn't be just another day at the office.

The group changed venues with each outing and this particular year La Costa, a tennis and golf resort between Los Angeles and San Diego, was the site of this most unusual social event. Each year a different couple was given the responsibility for organizing the location, the activities and Saturday night dinner. The challenge wasn't just scheduling events; it was more like what can you do to top whatever had been done before? And this year belonged to Norman Lear. The main event was to be the Saturday night dinner. The instructions to attendees: black tie. Black tie at a tennis

resort? In the summer? With only ten guests? What did Mr. Lear have in mind?

Promptly at 7 p.m., all invitees showed up at the cottage where the Lears were were ensconced, all in appropriate tuxedoes and gowns; although I seem to remember Mr. Gelbart had kept on his sneakers from the afternoon's tennis match. I must admit, everyone looked pretty snappy. The lighting was sophisticated, enhanced by a roaring fire. Cocktails were served, and at 8 p.m. we were asked to be seated at the beautifully laid out table. There was a loud knock at the front door of the cottage, Mr. Lear rose to open the door, then sat back down at the table. Music could be heard outside, then through the entrance stepped a tuxedoed gentleman playing a violin. I can't remember the song, but it was lush and romantic. The violinist proceeded into the room, followed by *another* violinist, followed by *another* violinist, followed by *18* more violinists, surrounding the dining table, playing schmaltzy melodies throughout the entire dinner. And that's the year Norman topped the chart of the Yenim Velt dinners.

And I have loved this man for as long as I have known him.

Steve Martin

"Excuuuuse me."
- Steve Martin

During my United Artist years when I was given the added responsibility of the UA record and music operation, I became friends with a record producer and personal manager named Bill McEuen. He had a small group of clients. The Nitty Gritty Dirt Band was his main musical act, his brother John the lead banjo player in the group. Although we were from different worlds, Bill and I hit it off. Longhaired, bearded, low-key, he had a very rare nose for comedic talent as well as superb musical taste. His two-volume Nitty Gritty Dirt Band *Will the Circle Be Unbroken* remains to this day one of my favorite albums. His home was Aspen, Colorado. His wife Alice was his partner in taste as well as life. They had an unerring eye for talent in all shapes, sizes, and styles.

Early in 1974, Bill asked if I would fly to San Francisco to watch an as-yet-unknown comic he was managing appear at The Boarding House, a small but influential venue for new artists. He had befriended his client in Aspen, where both had their homes, and he felt it was time to expose his protégé to his friend, who might help the career of the new talent.

The nightclub probably held a hundred or so people the night I came to see this comic that Bill was so excited about. An offstage voice announced, "Ladies and gentlemen, the Boarding House is

pleased to present, in his first appearance in the city by the bay, Mr. Steve Martin." To a round of applause out on the apron of the small stage, bounced Steve. "Well, excuuuuse me." The audience laughed, and didn't stop for 30 or 40 minutes. Coming back after several curtain calls, he took the microphone and announced, "Everybody in the audience follow me, we're going outside." We went. And I witnessed something I'd never seen before. This comic proceeded to seemingly ad lib another 15 or 20 minutes to passersby, cars, a red light, a street vendor, a police car who had stopped to see what all the excitement was about, and after an absolutely brilliant performance, escorted everyone back to the club to pay their checks and leave, but sure to keep talking about Steve Martin for a long time. It was an utterly amazing performance by a totally unexpected man.

I grew up in New York City, Jewish (my wife says I'm Jewish only for the food and the jokes—she may be right), with a family in show business. When I was a kid, I met Eddie Cantor, Sophie Tucker, Jimmy Durante. I had grown up with Milton Berle, the Ritz Brothers, Martin and Lewis, Henny Youngman, and so on. I knew them all and loved them all. The Amazing Ballentine, a magician who never finished a trick; Willie, West, and McGinty, three men trying to build a house but who seemed barely to survive every broken ladder and pail of water; or Harrison and Fisher, beautiful ballroom dancers who glided with ethereal grace - oh, was that a misstep I just saw? Or, oh my god, did he just drop her to the floor? And all these wonderful comedy turns in an industry now long gone. I'd seen all the standups: Danny Thomas, Jackie Miles, Burns and Allen, Henny Youngman, all of them. But I'd never seen anyone like Steve Martin. I think the real reason was disarmingly simple but at the same time highly complex. It was tied to expectation. The great tradition of Jewish or ethnic comics had stood up for decades, but suddenly in the Boarding House that night I saw someone different. I saw a handsome young man whose brown hair at a very early age had started to turn gray; I heard a young man's voice that sounded pure Orange County; a clean cut American adult with no accent or shading of any kind,

and he was squeaky clean. There was no sexual innuendo or any other kind of innuendo. He was square. He was good-looking. He was ridiculous. He was physical - he made toy balloons. He was broad - "excuuuuse me". And he was brilliant.

When we met all of that disappeared and he became just Steve Martin - a soft-spoken, modest man in manner and style, a young man who was knowledgeable about art, played the banjo at a professional level, and wasn't "on" in any way, shape, manner, or form. All the comics I had known - Berle, Alan King - were always "on." The comic lunch table at Lindy's was always playing "can you top this". It was funny, it was exhausting, it was enthralling, and it was nothing that even closely resembled the world in which Steve Martin lived.

Steve's career started slowly moving up the ladder and, to me, it was totally predictable. The following year I became head of production at Paramount. I went to Bill McEuen and negotiated a deal to develop a film for Steve. And I guess because of my background in the business and seeing so many shorts made by the major studios in the thirties and forties, like MGM, when I was growing up, I suggested to Bill and Steve that we do something unusual to introduce Steve to his future film audience.

"Let's make a six- or seven-minute short. I'll put it out with one of our big summer releases to show off the next big, funny movie star." They loved the idea and they suggested a writer named Carl Gottlieb to work with Steve, both the short and the first feature film script that I would put into development. A few months later, Paramount shot the first short the company had made in decades. Titled *The Absent-Minded Waiter*, it starred Steve, Teri Garr, and Buck Henry, and *it was funny*.

Time had passed and it was clear my stay at Paramount was not going to extend beyond the negotiated length. Michael Eisner had joined the company and I was working with him, trying to give him the most help I could to fill him in on the material in development. Steve had asked if the company would give him the okay to show the short at the opening of his new tour. He was now playing to audiences of over 10,000 people in large arenas. I agreed, and

the short was nominated by the Academy for an Oscar as Best Live Short Action that year. It didn't win, but the feature script that Steve and Carl were writing was still in development.

As my time at Paramount ended, my projects were turned over to Mr. Eisner and his people, and a few months after my departure Bill McEuen called and asked if I would meet with Steve. It was a special moment when I sat down with them. Steve was now a big attraction on tour. The career Bill had planned, and to which I had contributed, was right on path. And here was their news: Michael Eisner and Paramount had rejected Steve and Carl's script and had given it back to them in turnaround. It meant that they were free to reimburse Paramount for its development and take it anywhere they wanted. And they wanted me to join them. Even though I was producing for Paramount, I was not exclusive and thus free to do so. Michael Eisner, unknowingly, had just done me the greatest favor he could have, and to this day I have no idea how Paramount could have made such an error. It could only be attributed to one egotistical posit - Steve Martin wasn't Eisner's idea. Michael may be a lot of things, but one thing he is *not* is stupid. With any analysis of the market, Steve Martin was hot and they had him. And they let him go for nothing. Amazing. Listen, nobody's perfect, but it's hard to know how this came to be except hubris. In Barry Diller's letter to me (attached in the Paramount section), he acknowledges the mistake. But still...!

So I joined Steve and Bill in partnership to make the first Steve Martin full-length feature film. It was called *Good Company* at the time. I thought it was very, very funny, but Steve had a new title suggestion. He wanted to call it *The Jerk*. It sounded weird, it sounded funny, it sounded right.

Flattered and thrilled, Steve, the talent, Bill, the brilliant marketer, and David, the movie maven, had to make some decisions. The first was who was going to make the movie with us. That was my world and my instinct as to who that person should be was instantaneous: Carl Reiner, for lots of reasons. He knew comedy, he knew film, and he was an extremely efficient director. Carl had directed the brilliant satire *Where's Poppa?* for us at UA. He had

made a giant hit with George Burns for Warner Brothers, *Oh God!*, and he was without a doubt not only a major talent but a good and funny man. He would know how to get Steve Martin and *The Jerk* onto the screen with its humor intact and at the right price. I sent it to three studios: Warner, Columbia, and Universal. They all seemed to know something Michael Eisner didn't -there was an audience out there anxious to see a Steve Martin movie. Universal offered the best deal and we signed with them. The fees were fair and the studio gave us fifty percent of the profits, which Steve, Carl, Bill and I shared at equal parts. And the real kicker was that we could shoot the film off their lot, thus saving the overhead fees that they usually charge for any picture filmed at the studio. Since the cost was between three and three and a half million dollars, the 25 percent cost saving by not shooting at the studio would improve our break-even point for profit substantially and also in negotiating our locations I could bargain for the best deal wherever we chose to go.

Making a movie is challenging under any circumstances, but when you have a team who like and respect each other, it can be an exhilarating experience. The four of us were perfect together. The biggest challenge we faced was who would make the breakfast we shared in Carl's trailer every morning during the production. From casting to location to crew, there was never a disagreement, never an edge. There was the fun, joy, and challenge of making *The Jerk* the best movie that cast, script, direction, and production could deliver. All of us participated, all of us contributed. Bernadette Peters, Bill Macy, Jackie Mason, Caitlin Adams joined the cast. Carl's choice of Vic Kemper to shoot was perfect for the film and for Carl. Carl cared about the content of a scene, the comic performance in it, the tone, the pace, the pulse. What he didn't particularly care about was where the camera position was or if it moved. He also felt that the nature of comedy was such that repetition did not help. Two takes should get it, and after that the chance of it getting better was all downhill. In other words, he was a dream on two feet.

The shooting schedule was 35 days on locations all around Los Angeles. The major challenge was Navin Johnson's mansion,

which he bought when the Opti-Grab glasses made him rich, and did we get lucky. In the heart of Beverly Hills on Sunset Boulevard, just down the road from the Beverly Hills Hotel, was a fully furnished, decorated, enormous, gigantic, outrageous estate owned by an Arab potentate. No one had ever slept in it, not even for one night. Nonetheless, every bed was made, every window was double-plated with bulletproof glass, just in case. The cellar was a ready-to-rock disco and so on. The realtor who showed us the house thought the owners might be open to our leasing it. I could barely believe our luck. We got it for the grand total of $35,000. I hesitate to think what it would have cost to build or decorate some unfinished mansion to be as over-the-top as this house was. The irony was that when it burned down many years later from causes unknown, no one had lived in it and no one had ever been inside it except us. So they used a clip from *The Jerk* on all the news shows.

Production was smooth, professional and fun, but there was one moment that can only be described as unforgettable, but also in fact, unique - perhaps the defining example of Steve's comic genius.

Steve and Bernadette are in bed together and Steve has been describing to the sleeping Bernadette how special their time together has been - a few sentences in the script. The camera is above the two of them on a closeup. And as always, it has only taken Carl and Vic a few minutes to decide on the set-up and Vic is ready in no time.

"Take one, action, cut. One more for protection," says Carl. "Cut. Thank you."

Steve looks up at Carl and says, "Can I do one more? I'd like to try something."

"Of course," Carl says.

"How much film is in the camera?" Steve asks.

"Almost a full reel," is the answer.

"Okay," he said. And so it started.

As I recall, there were the usual number of people behind the camera or standing by as needed, perhaps a total of 15 or 20. Hair, makeup, prop, electrics, script supervisor, camera crew,

the producer, the director, all watching. "Ready Steve? Ready Bernadette?" She has no lines to say, she's only listening. "Okay, roll camera, action," and Steve begins to talk. The scripted lines run about 30 seconds, but he starts to adlib an entire speech on just how long they've known each other and how long it has felt like. As all of us listened and immediately realized what he is doing, the response was to laugh because it was so brilliantly funny and inspired, but the only problem was you couldn't laugh out loud because you would have spoiled the soundtrack and the uniqueness of what he was doing would be forever lost. Do you know how hard, how painful it is to try and stop from laughing, especially at an unexpected moment like this? I'll tell you how hard it is. It hurts. You grab something, hold onto anything, cover your mouth, turn away. Anything not to blow the unbelievable performance you're privileged to be hearing—a performance that can never be repeated the same way again, a star turn that will be there forever if you don't fuck it up by laughing out loud. How Steve did it, I could never understand. How Bernadette didn't crack up I never understood. She's hearing new stuff totally unscripted and she never moves. How the crew kept quiet the whole time is tribute to its professionalism, its physical strength in an emergency situation, and to everybody's terror of being *The Jerk* who couldn't control himself. But Steve pulled it off and so did Bernadette and the awe-struck crew watching his genius at work. When he finally finished breathing his last ad lib and Carl could say "cut", there was a collective shout from the onlookers that blew the roof off the set. Laughing, choking from fear of breathing, coughing to clear one's own lungs from not breathing, it was chaos, and then applause and cheering and shouting in admiration of sheer talent.

Shooting went well, and Universal scheduled the picture for release across the country for December 14, 1979. They felt that previewing would be worthwhile and after the first of the three, their only comment was to make sure the film ran 90 minutes, not the 88 minutes we had, just to ensure the theaters could schedule it more easily—whatever that meant. But it was easy to do.

At the final preview Bob Wilkerson, the head of Universal's United States distribution, took me aside. He had a question for me. He was a good old boy, an all-around gentleman, and certainly an expert on the U.S. mass audience film market. He'd been around, loved this business, and was clearly excited by the initial response to *The Jerk*.

We went to a quiet corner in the lobby of the Dallas theater where we were previewing the film for the last time, and he asked me a question no one had ever asked me before on any film. "Son, how much film rental would you be satisfied with on this film?" Now there was a question. I had no idea what to say and I had no idea why he was asking me. I believed the film would do well, but what would I be satisfied with? In those years the press and public were not given weekend grosses like they are now. And he wasn't talking box office gross; he was talking the more important numbers: how much Universal would be getting from the theaters as film rental from *The Jerk*. That number was determined by each deal they had negotiated, but in the most generic sense, it would probably amount to between 40-60% of the box office gross, depending on the city, length of run, and other factors. This is not a book on movie accounting, but film rental is what profit participants' income, if any, is based on, not box office gross.

I decided if I had to come up with a number, I'd simply take the negative cost, about $3.5 million dollars, and multiply it by ten. So I said to Bob, "$35 million dollars."

"Okay," he answered. "That's your figure, not mine, right?"

"That's right."

"Okay," he said. "Here's the deal. For every million dollars in film rental above $35 million I want $1,000 for my favorite charity. For every million under $35 million I'll give you $1,000 for your favorite charity." Holy cow. In my entire career, before *The Jerk* and since, no one has proposed anything even remotely like what Bob proposed that night. I was stunned, not by its audacity, but by its concept. He'd asked me to pick the number. Sure I was a professional, but even so, how amazing it was. We shook hands and hugged.

A few years later I wrote a check to Bob's charity of choice for $19,000.

For his next feature I believe Steve wanted to follow up with a sequel to *The Jerk*. On the other hand, he was being courted by a lot of talents in tinseltown. One was Herb Ross, renowned director of films such as *Steel Magnolias, The Goodbye Girl, Turning Point,* and *The Owl and The Pussycat.* Steve's choice for his next film was *Pennies From Heaven* with Mr. Ross directing.

The dark film was based on a 1978 BBC TV drama, financed by MGM, and was sadly, but predictably to me anyway, a critical and boxoffice failure. A bleak depression-era drama that involved prostitution, rape, murder, and an ending where Steve, after being wrongly convicted of murder tap dances in a big finale after his execution, left audiences either in stunned silence or in outright confusion. Ross was a talented director, but a film like *The Jerk* was way, way beneath his cinematic sensibility. Steve was a bright new star and Ross thought he could utilize him to bring an audience to one of his classy, sophisticated efforts. It was a bad marriage for both sides, and I believe it affected Steve's career in the worst way possible; he lost the trust of his audience. *Pennies From Heaven* was doomed to failure.

Steve came back to Carl and me. The three of us came up with what we believed then, and believe now, was a great idea. The idea was to integrate Steve's character into a plot utilizing clips from old movies. The result was *Dead Men Don't Wear Plaid,* a film incorporating clips from 18 vintage movies into a plot with Steve as a film noir detective. The clips were combined with footage of Martin and other actors shot in similar black-and-white set-ups, creating a new story from the mix. Clips of Ingrid Bergman, Humphrey Bogart, James Cagney, William Conrad, Joan Crawford, Bette Davis, Cary Grant, Ava Gardner, Fred MacMurray, Ray Milland, Ida Lupino, John Garfield and others all lay in studio vaults longing to be used in our brilliantly conceived follow-up to *The Jerk*. It was special, it was unusual, it was black and white, it was witty. It was a big flop. The conceit didn't work, even though some critics were astute enough to understand its special quality.

We knew we had to get back to the "wild and crazy guy". And so came *The Man with Two Brains*. Same actor, same director, same writers, same producer - oh yes, and we added Kathleen Turner fresh off her performance in *Body Heat*. Surely this would bring back *The Jerk* magic. We thought so. Warner Bros. thought so. The only people who didn't think so were the paying public. The "wild and crazy guy" was gone, and so was his audience. It hurt us all to be so wrong, but in this business you just never know; and if you don't know that you don't know, it hurts a little more.

The good news for Steve, of course, is that his career survived nicely with films like *Roxane, All of Me, Dirty Rotten Scoundrels, Parenthood, The Pink Panther,* and many more. He also has a wonderful career as a writer, essayist, art expert, musician and magician. Extraordinary versatility. Did I mention he's a master card manipulator, too? Believe me when I say you don't ever want to play cards with him. He'll shuffle the deck in front of your eyes and deal two hands of five card stud poker. No matter how many times he shuffles, or how many hands he deals, he will turn over four aces in *his* hand every time. Now that's a talented man.

Elaine May

"What do you mean there are two reels of negative missing?
- The Author

The day I started at Paramount Barry Diller handed me two problems, Robert Altman and Elaine May. Altman has already been covered. Elaine May was more complicated. Brilliantly funny, partnered with Mike Nichols doing stand-up comedy for years, she became a screenwriter, then a director. Her first two pictures as a director, *A New Leaf* and *The Heartbreak Kid,* showed real promise, and then came *Mikey and Nicky.* Paramount had committed to production on this low-budget film, starring Peter Falk and John Cassavetes, before Barry Diller took over as chairman, and before I joined the party. The rumor of the long shooting schedule and over-budget-run had preceded my arrival at the studio. When I got there the film had already been in post-production for over a year. Elaine was a special talent, but along with her talent came a lack of certainty about what she wanted her films to be. In order to protect her options, she grossly over-shot every scene, and to say that her demands on the set bordered on the ludicrous were an understatement. There are directors who know exactly what they want, and they are so specific about it they literally cut in the camera (seeing the how the film's scenes will edit together as you shoot them) – Sidney Lumet, Billy Wilder and Terrence Young worked that way. As an example, these directors might shoot 90,000 feet

of film on a movie. They visualized how they were going to cut the final version as they shot and after editing there was very little left on the floor.

So, Elaine May directed this little two-character movie and she shot – are you sitting down as you read this, I really hope so - over one million feet of film. That's right, one million feet of film; 200,000 would have been more than enough. I was told that in a scene shot one night in a cemetery while the actors were interacting, talking, arguing, and fighting, the camera ran out of film, but Ms. May wouldn't yell "cut" because she thought the actors would be upset. So everyone just stood around while they performed before a camera that had run out of film.

As Barry and I went over our program of releases, he told me that there was a problem with *Mikey and Nicky*. There were two reels of negative missing from the lab. Gone.

"Can you help us with Elaine?" Barry asked me.

"Probably," was my answer.

I immediately suspected what had happened. Elaine didn't trust Paramount, and was afraid that they might take her off the film's post-production, so she'd orchestrated a little drama. I called Bert Fields, Elaine's lawyer. His reputation was that of being hard to deal with, but my experience with him was that although he was a strong advocate for controlling his clients' rights, he was also fair, and responded to equitable solutions to difficult problems.

Without in any way accusing Ms. May of having been involved with the film's disappearance (because of the real or paranoid possibility that she would be thrown off the picture), Mr. Fields and I worked out a "what if" solution. What if the missing negative was returned to the lab? Would Paramount agree to preview her cut of the film in an appropriate venue in New York and Philadelphia? Would I personally attend the screening so that I could be involved with Ms. May in suggesting cuts or changes?

"Yes, that can be arranged," I said to Bert.

Several days later, I was advised that a package with my name on it could be picked up at a post office address in Connecticut. Lo and behold, the missing reels of negative reappeared.

The picture was completed. The picture was previewed. The picture bombed. I hoped that I wouldn't have to deal with Ms. May again. It had all seemed unnecessary, and dramatic, and time-wasting, and in the end, so fruitless.

But my hopes were dashed when some years later I joined David Puttnam at Columbia, and who was lying in wait but Elaine May, and *Ishtar*!!

In 1985, the then-studio-head at Columbia, Guy McElwaine, greenlit a project titled *Ishtar*. The producer was Warren Beatty, the director was Elaine, and the script was written by the two of them. They were friends, and had collaborated on *Heaven Can Wait*, a film I had greenlit with Barry at Paramount some years earlier. Partly because of its success Warren had gotten McElwaine to give the go on what turned out to be one of the great financial and creative follies of its era. Conceptually, it was a throwback to the screwball Bob Hope and Bing Crosby road trip movies of the 40's - two friends, opposite in personalities, facing trial and tribulation - usually no longer than 90 minutes of slapstick silliness. They had low budgets, big stars, and experienced Hollywood directors who delivered on schedule, on budget and on time. *Ishtar* was to star Beatty and Dustin Hoffman. It had high concept, high budget, undisciplined direction, and a producer and co-stars who were friends of the director.

Shooting ran three months over-schedule, and millions and millions of dollars over-budget. One example showed the insanity of the production; a desert location originally chosen was filled with dunes, as most African deserts are, but upon arriving at the site, Elaine May decided she didn't want the dunes. She wanted flat desert. Too late to make a move, the production was forced to flatten out the dunes. Enough said.

To those who were not directly involved in the adventurous tales of the runaway production, it might have been great comedy. It was hardly funny to the management that succeeded McElwaine, or those that had to deal with the egos and content of the completed film. That would be David Puttnam and me; two guys new to the studio, new to this fiasco. Mr. Beatty, one smart producer and

filmmaker, was stuck with the results of his friend's catastrophic performance as director. The film became a joke to the Hollywood press, and soon to the national audience. It was fun to talk about, especially if you didn't have to pay to see it. It wasn't fun if you had to publicize it, and try to get audiences to pay. It was even less fun if you were part of the company that had financed and distributed the film in the first place. And that was no joke.

Mike Medavoy

"It's my birthday."
- Mike Medavoy

The Academy of Motion Pictures Arts & Sciences announced that at the 1979 Academy Awards, Bob Benjamin, the chairman of United Artists, was being honored with the Gene Hersholt Humanitarian Award for contributions to our industry, and Arthur Krim, the honoree in 1974, was also a part of the celebration. I couldn't have been prouder. I had worked for them for 18 years, rising from a marketing assistant to the president of the company. They had given a 30-year-old the opportunity to run production and marketing. When we were acquired by Transamerica, the insurance giant, the atmosphere slowly changed, and at the end of my contract in 1973, I opted out of being a corporate executive and into a three-picture producing deal with the company. It was most unusual because I was allowed to make any three pictures of my choice, and I made *Lenny, Juggernaut,* and *Smile*.

In 1976, I was asked by Barry Diller and Charlie Bluhdorn to become Paramount's president of production. My Paramount office had several large windows facing the studio street and if someone I knew walked by, I would often stick my head out to have a conversation. On this particular morning Warren Beatty was walking by. We were about to do *Heaven Can Wait* with Warren, and we knew and liked each other.

"Hey, I'll see you at Medavoy's party for Arthur and Bob," he said.

"What party?" I asked.

"You're not invited? The redheaded guy is having a big group over to honor his bosses before the Oscars and you're not invited?"

Warren was just as dumbfounded as I was. It just didn't make sense. Mike Medavoy, a former agent, had been brought into UA to supervise production by Krim, Benjamin and Eric Pleskow, who replaced me as president when I left. And now this gentleman was having a party to honor his bosses and everyone in town was going, but I hadn't been invited?

I'm not a social creature, especially not in Hollywood. The celebrity world, the perception of success, the bullshit is anathema to me. Of course, as president of Paramount I was on many A-lists, but my socializing was truly restricted to a few close friends. However, in this case it wasn't about not being invited. It was about not being invited to a party to honor the men who had mentored me and to whose company I had made significant contributions for almost two decades. It was a personal affront, and I took it that way. So I did something I had never done before in my career, and found myself almost embarrassed to do; I called Medavoy and said very simply that Warren had mentioned the party for Arthur and Bob and I felt deeply slighted at not having been invited. Without missing a beat, Mike answered that it was, in fact, his birthday party and he was only inviting over a few friends. I was mortified. It confirmed a deep suspicion that my call had been a mistake, and so I said that to him. I apologized profusely, he accepted graciously, and I hung up. I was so deeply, deeply ashamed, so upset with myself that I called Mike again. He picked up.

"Mike, I just had to apologize again, I feel so stupid."

"Well," he said, "Really, it's *not* my birthday. We're just having a few industry folks over that we are in business with, you know, like the Mirisches." I was stunned not only by the lie, but by the ease and the glibness with which it flowed from his lips. The only thing that came out of my lips was, "Mike, go fuck yourself."

I was furious. What kind of prick was this? And why after the initial lie did he suddenly blurt out the truth? Did he figure I'd

find out eventually? I had no idea, but I was furious. I called Arthur Krim. He was out. I called Eric Pleskow. He answered. I told him what had just happened. He said he'd get back to me, and about thirty minutes later, Arthur Krim called. He asked me to come to the party. I told him I wasn't sure I could go to Medavoy's house, but I'd see him and Bob at the Oscars. "Please try to come," he said. He also said he'd understand if I didn't. I didn't.

I didn't go because intuitively I felt that UA had now begun a descent from the magical precedent-setting era of its rebirth in 1951 when Krim and Benjamin acquired the company from Mary Pickford and Charlie Chaplin, to the sad-but-true cliche of a "Hollywood" operation typified by Medavoy's deceit. That sad prediction came true when several years later the UA management left Transamerica to form Orion Pictures, and that company had a limited run. First Benjamin, then Krim, passed away. Eric Pleskow disappeared, never to be heard from again in the film business. Bill Bernstein joined Paramount as a Business Affairs executive, and Medavoy, well, Medavoy just continued as a Hollywood producer.

So I told the story of this party incident to *all* my friends. I had no compunction about it. It was an act that seemed to me bigger than just a simple lie. It represented a way of doing business or dealing with people that was abhorrent in its cynicism and its disrespect, and it came from someone who was part of a company whose success and existence had been established by a code of conduct that had been exactly the opposite.

Some years after the incident, Medavoy called and asked if we could have lunch. I agreed. I couldn't begin to imagine what he had in mind. He surprised me. He asked me to stop telling the "it's my birthday" story. Several people had reported back to him, and he was embarrassed.

I agreed, but now several decades later I'm writing about it because, on the human level, the movie business is just another way to make a living, and how one conducts oneself can't be excused by the nature of one's vocation. So Mike Medavoy is allowed only one birthday party a year. Period.

Richard M. Nixon

"And if successful, proceed with Ruth and David."
- Nixon's Enemies List

I have met four Presidents of the United States. Dwight D. Eisenhower handed me my diploma the day I graduated from Dartmouth College in June, 1953. I saw President John F. Kennedy at Peter Lawford's Malibu home; he was fast asleep and I left before he awoke. Lyndon Johnson invited me to dinner at the White House where I sat next to Supreme Court Justice Arthur Goldberg. And then there was Richard Milhous Nixon.

I was on President Richard Nixon's enemy list, kind of. The enemies list was the informal name for a list prepared by White House Special Counsel Charles Colson in 1971, created for the purpose of identifying potential political enemies. The plan was for people on the list to be harassed with tax audits, government litigation, etc. What a privilege. When that notorious list was finally made public, the very first name mentioned (and clearly not in the order of importance or celebrity) was my uncle, Arnold Picker, described as the financial organizer of the presidential campaigns of Senator Ed Muskie of Maine and Senator Henry Jackson of Washington. The description of why Arnold was worthy of being "an enemy" concludes with "and if successful with Arnold, proceed to Ruth and David." Clearly whoever wrote those words had done their homework. Ruth, Arnold's wife, would have been a danger

to anybody, particularly if one preferred soft matzoh balls in your Passover soup to her hard, tasteless ones. Even more dangerous to the administration would have been her performance as the Lord High Executioner in the Yiddish language production of Gilbert and Sullivan's *Mikado*, that ran for nine sold-out performances at the Broward County High School in Ft. Lauderdale, Florida. Ruth was a great amateur singer and performer, and she brought down the house at every show. The performers, all over sixty, included Abe Schwartz, 76, who played Nanki-Poo. No wonder Nixon feared this woman.

All my connections in those years were Democrats. Arthur Krim became one of the closest confidantes to President Lyndon Johnson, and United Artists had connections to the Kennedys, including a deal to finance and distribute several pictures made by Peter Lawford's production company. One, *Salt and Pepper*, a low-budget action picture starring Lawford and Sammy Davis, Jr., directed by the talented Richard Donner, was actually a commercial success.

The enemies list had not been made public when I was invited to San Clemente, Nixon's California White House, to join film industry leaders to discuss the state of the business. I despised the man, but who wouldn't be curious to meet him? After all, he was the President of the United States. I accepted, along with other Democrats such as Lew Wasserman and Ted Ashley, who ran Universal and Warner Brothers, respectively.

As I drove south on the California coast towards San Clemente, I was beyond curious. My name was at the gate where there was little or no fanfare. "Just park over there and walk into that building," said the guard, and so I did. And was I in for a surprise. The President arrived and chatted with us all. He had done his homework, was informed, clear in his awareness of the issues and a very good listener. The meeting had been scheduled for 90 minutes, and whether it was a set-up or not, at the end of the scheduled time the President told his aide to push back his next appointment and he sat with us for another hour. I remember he sweated profusely (apparently he did that a lot), but more importantly,

we were taken by his insight and his subsequent follow-through on the subject of the film business, both in the United States and internationally.

The outcome was that when Nixon signed his Revenue Act in early 1972, it favorably addressed many of the issues we discussed that day, but the film industry had been pressing Washington for a decade to help with these very issues, such as accelerated depreciation, tax credits, and helpful international trade rules. And by pure coincidence, I'm sure, re-election fundraising season was just beginning. I don't know how the studios "showed their gratitude", but I know he got nothing from me.

Soon after, when the list was made public I proudly hung it on my wall.

20 MEMBERS OF PRESIDENT NIXON'S ORIGINAL ENEMIES LIST

On June 27, 1973, President Nixon's former counsel, John W. Dean III, released to the Senate Watergate Committee a 1971 memo proposing the use of "available federal machinery to screw our political enemies." Accompanying it was a document listing the names of 20 persons who were viewed by the administration as being unsympathetic to the Nixon White House. These 20—who were given priority over 200 additional "enemies" on a separate list—were to be "screwed" with IRS audits, litigation, prosecution, or denial of federal grants. Next to each name appeared a comment—apparently written by then special counsel Chuck Colson—qualifying the action to be taken.

1. ARNOLD M. PICKER (United Artists Corp., New York, N.Y.)

"Success here could be both debilitating and very embarrassing to the Muskie machine. If effort looks promising, both Ruth and David Picker should be programmed and then a follow-through with United Artists."

2. ALEXANDER E. BARKAN (national director, AFL-CIO Committee on Political Education)

"Without a doubt the most powerful political force programmed against us in 1968 . . . We can expect the same effort this time."

3. ED GUTHMAN (national editor, *Los Angeles Times*)

"It is time to give him the message."

4. MAXWELL DANE (member of Doyle Dane Bernbach, a top New York, N.Y., advertising agency which had worked for Democrats)

Jackie Kennedy

"Are you free for lunch?"
- Ted Sorenson

In the early 70's, Ted Sorenson, John F. Kennedy's close friend and speechwriter, called to ask me a favor. I had met him through Arthur Krim during the UA days and I could hardly say no. He asked if I would have lunch with Jackie Kennedy to discuss her potential interest in producing films. Stop right there. It led to a moment in my life that excited my mother more than any new job title, any Oscar, any grandchild. My elegant beauty of a mother could now say to all who would listen, that her son David was having lunch with Jackie Kennedy.

Upon arrival at the Kennedy apartment, I was greeted by Nancy Tuckerman, her assistant, and escorted into a room facing Central Park. A table was set for two by the window. Jackie was taller than I expected (she was in fact 5'9", although she always told people she was 5'7" because, as the story goes, she believed it was better to be thought "petite"). Mrs. Kennedy rose to greet me and gestured that we move to the table for lunch. She said that Ted remembered me from United Artists and thought I'd be willing to give her some advice. I was, to say the least, taken by surprise but flattered and all ears. She was a star, seductive - not in a sexual way - but with a style that people with power and position often exhibit. She made you feel that you were very important to her and could

help her achieve her goals. From her almost mystical world of politics and notoriety and rumor and glamour, it was impossible not to respond; you were well and fully seduced.

It seemed that this legendary icon was interested in "film", but she was unclear about what category: major studio film, independent/art house film, fiction, documentary. She wasn't sure. I suggested that, realistically, documentaries would probably be the most logical and satisfying. The medium was challenging; it could potentially have influence in many aspects of life, and it would be the most relevant use of her position and influence. She agreed, so I suggested she meet with a friend of mine, Jerry Feil. Jerry was a jack-of-all movie trades - cameraman, editor, documentarian, and very smart about film in all aspects. He seemed a logical person to guide this unusual wannabe in the right direction. I set up a meeting and they clicked. For several months Jerry made himself available, arranged his schedule around hers, and the two discussed how her new interest in film might be focused. And then one day she didn't respond to his call for the next meeting, and he just never heard from her again. I called Mr. Sorenson and all he could do was apologize. Perhaps she had a reason, but reasons can be explained in a phone call. Noblesse oblige, not very nice, not very well-mannered. My mother was the most disappointed.

Eunice Kennedy and Sarge Shriver

"We've been through this before."
- Eunice Kennedy Shriver

In 1999, I was at Hallmark Entertainment helping them expand their TV/film business when the CEO, Robert Halmi Sr., told me that Bobby Shriver, son of Eunice and Sargent Shriver, had a project for a TV movie. Since the family knew of my name from the JFK years, would I meet with Bobby and his mother to discuss it? The project was a two-hour television movie originally entitled *Mary, Mother of Jesus*, and the title explained everything. Eunice, a devout Catholic, wanted the film made, NBC was interested, and it didn't seem very complicated. Bobby was not particularly knowledgeable about film, but didn't seem hard to handle and the project was his mother's passion. I had met Sarge during the years at UA and now, sadly, he was beginning to fall into the dementia that would cloud the rest of his life. Everyone was deeply supportive of Eunice's love for the project and determined to make it easy for her. I put together a creative team to work under our supervision and made it clear that Bobby could use this as a learning experience. He seemed reasonably comfortable. He had his mother looking over one shoulder, he didn't really know what to do with his public life, and saw this as an opportunity to get something done.

Location Budapest, the summer of 1999. Terrific crew, an excellent studio setup, and locations that fit the script. This was not a big biblical saga—it was the small personal story of Mary.

Everything was going smoothly. Eunice and Sarge arrived to see the work in progress, and everyone took good care of them. And then, *then*, the horrifying news broke on July 16, that John Kennedy Jr., the son of JFK and Jackie, had been killed when his plane crashed on a flight to Cape Cod. I immediately began preparing for a charter jet to get Eunice and Sarge back to America as quickly as possible, and I went to their suite at the Marriott to discuss any plans we could facilitate to help them at this terrible time. I didn't know what to expect when I got there. Eunice appeared pale and drawn. Sarge was silent. I explained that we would do whatever they wanted and needed - a plane, reservations, staff to travel back with them - anything. She looked at me, thanked me, and then simply said, "We're staying here. We've been through this before." That was all she said. I knew her religion was the strongest thing in her life, but this kind of stoicism, this fatalism, was almost shocking. "We'd just like some privacy for a while, but thank you," she said. And I left.

Several days later, not having directly communicated in order for them to have their privacy, Eunice called to say that she and Sarge would be joining us for a dinner that had been previously scheduled at a restaurant owned by our cinematographer. Eunice, Sarge, and Bob arrived last. She was dressed up, coiffed, and quiet. Little was said - it was a strange and uncomfortable evening. Their stoicism, their faith, their . . . I don't even know how to describe it; their belief in their God, I guess - got them through it all.

"We've been through this before," was all she said.

Otto Preminger

"Get out of my office, or I'll throw you out."
- Arnold Picker

I once read in an industry publication that in 1953, Otto Preminger released his film *The Moon is Blue* without the seal of approval from the Industry's Production Code Administration. It's the kind of misinformation that is found over and over in books and articles about the movie business by sources, identified or not, who know little or nothing about what they're writing. Simply put, Otto Preminger never "released" a movie in his life. He acted in movies, he produced them, and he directed them. Only the entities that finance and distribute the film could have released the film, and in the case of *The Moon is Blue*, it was United Artists. By the way, the Product Code Administration (the rating agency prior to the MPAA) withheld its seal of approval because the movie used the word "virgin". Yes, you read that right. Did Preminger want to fight the code position? Of course he did. By contract the company could have insisted that Preminger make the changes that would have gotten the seal of approval, but it didn't. Instead, UA resigned from the organization and released the film without the seal. It was appropriate, and the smart thing to do both creatively and financially. Although there were some theaters that refused to play a film without the seal, there were enough that would do it so the controversy around this slight little comedy generated far

more positive results than if the code hadn't objected in the first place.

I joined UA several years after this film had been made, but Preminger had continued his relationship with us principally because United Artists had stood up for *The Moon is Blue*. He delivered *The Man With a Golden Arm*, a provocative Sinatra-starring piece about heroin addiction that also failed to get a code seal because of the subject matter, but which found a responsive audience. Several years after that, he delivered *Saint Joan* based on the George Bernard Shaw play, and the box office wasn't just bad, it was non-existent. It was this film that first brought me face to face with the filmmaker, and I can candidly say that in over fifty years of working with talent from all over the world, he was unequivocally the most unpleasant, arrogant personality I ever dealt with in this business - and that's saying a lot.

Preminger considered himself smarter than any film company executive he was forced to deal with, and he let them know it in no uncertain words. Because he had made some successes for UA, Krim and Benjamin felt a loyalty to him, and he returned the favor by delivering several hits. In addition to *The Moon is Blue*, *The Man with a Golden Arm* and the terrible *Saint Joan*, he made *Exodus*, a big sprawling adventure set in Israel based on the giant bestseller by Leon Uris. One day I was in Arnold Picker's office when Preminger walked in the door, unannounced, impeccably dressed, bald pate shining, fangs sharpened. In his pronounced German accent he shouted – and I mean *shouted* - that an executive reporting to Arnold had to be immediately fired for incompetence. It would have been funny if it hadn't been so outrageous. Arnold told him to get out of his office or he'd throw him out.

Exodus was released in 1960, and it wasn't until 1974 that Preminger submitted another project to UA. It was a script called *Rosebud*. I read it, thought it dreadful and turned it down. A week after I left the company to produce *Lenny*, Otto re-submitted it to Arthur Krim, who greenlit it. Arthur was loyal until the end. It was Preminger's next-to-last film, and it was - surprise - another failure.

United Artists and Transamerica

"I want a 20% return on investment."
- Jack Beckett,
Chairman, Transamerica

In 1967, United Artist's partners decided that it was time to cash in on their majority ownership of the public company. Although I had some stock options, I wasn't directly involved in these discussions. One thing, however, was very clear. They were nervous about the future of the marketplace and did not want to risk losing a potential big payoff for all their years of work. Their salaries had consistently been the lowest in the industry: their wealth was in their stock.

Arthur and Bob spoke with their friend Andre Meyer, chairman of Lazard Freres, a big player on 'The Street' and a friend of theirs in all things Democratic. By now Arthur was spending a lot of time in Washington with his friend President Lyndon Johnson. There were even rumors that Arthur might be appointed to the Supreme Court. He and his wife Mathilde, a well-respected cancer researcher, had also bought a home near the Johnsons on the Pedernales River in Texas. Some found this highly incongruous; the brilliant Jewish lawyer and film executive whose outdoor activity mostly consisted of walking from his car to the Seventh Avenue entrance of the building, along with his beautiful research scientist wife, were now riding the range. The truth was that the Krims and the Johnsons genuinely

liked each other, and the President trusted Arthur not only for his insight but also because it was totally clear he wanted nothing in return from the President; a quality if not unique, then certainly unusual in the world of politics.

It did not take very long for Meyer to come up with the Consolidated Baking Company of Chicago (Sara Lee) as the answer. The company owned by Chicago multimillionaire Nate Cummings was the lucky winner. However, the Street did not like the deal one bit and in less time than it took to make it, the deal was dead. Meyer had his shot, and missed.

Next up to the plate was another Wall Street dealmaker, Ferdie Eberstadt of Eberstadt and Company, and he came up with the Transamerica Company of San Francisco, an insurance conglomerate. Life, Title, you name it, you need insurance - they had it. A deal was negotiated, announced, and the Street seemed satisfied. Transamerica it was. Krim and Benjamin had their deal, and Transamerica had its entertainment subsidiary. Rarely has the twain had less chance to meet.

Those of us in the trenches, even at the highest level, had no input in all the conversations that took place in putting this deal together. One thing was clear, however; a deal was going to get made. Krim, Benjamin, and their partners wanted it to happen, and happen it did. That an insurance company was the lucky winner has always been a puzzle to me. Look at it this way: Transamerica's largest operation was its life insurance company, a business with 100% predictability. The customer buys a policy on his life, pays for it, and when he dies, the insurance company pays off on the policy. Both conditions are guaranteed. So everyone wins or loses, depending on your point of view.

United Artists's business was financing and distributing movies, the hope being that someone would actually pay to see them. Note that I said "hope" and not "guarantee". Suppose UA made a movie and a lot of people came; sounds good. Suppose UA made a movie and nobody came; sounds bad. What it sounds like is that making movies and selling insurance are not really very compatible businesses. In fact there were not many businesses back then that *were*

compatible with movies. That has all changed over the years, as business models now have movie companies as part of conglomerates where films are essentially marketing services for all sorts of delivery systems unknown in the late 60's. But back then, success was basically determined at the box office window, with some help from network and syndicated television.

So now we have Transamerica, a San Francisco insurance giant, owning an eccentric business run by some guys who are used to running their operation their own way without any interference from anyone. What a great idea! Actually this relationship had no chance of ever working. Looking back at it now, it was hugely amusing and entertaining. Talk about a clash of cultures!

Interestingly enough, there are no bad guys here. I liked the Transamerica executives that I worked with. Some I liked very much, despite the fact that there was nary a woman or minority in the bunch. They were decent, hard-working, and they were excited about having this new affiliation. They just didn't know one thing about the business they had bought. It has always astonished me that a company could buy a business and not really research beyond numbers and reputation what was, in fact, the business they were buying. Perhaps they just figured to make it into another subsidiary following their standard definitions and business practices.

So here is the first thing that happened. Jack Beckett, Chairman of Transamerica, got a raise. He had to; I was making $75,000 a year more than he was. As I mentioned earlier, UA's policy on salary scale had a unique definition created by the partners when they acquired the company. They said we own it, so we'll just pay ourselves $1,000 a week. And if we're getting $1,000 a week, and we own the company, why should anyone get paid more than that? (Sounds perfectly logical to me.) And for years they got away with it. When I replaced my boss, Max Youngstein, I was named head of Production and Marketing and got a raise to $1,000 a week. At the majors (Paramount, Warners, Fox) they each had a head of Production *and* a head of Marketing, and they each got anywhere from $300,000 to $500,000 a year. Let me be really clear here:

everyone loved working at UA. We knew we were underpaid by industry standard, but we got major perks in our expenses, and we got some options. Although there was no medical policy, we had an in-house doctor who gave us advice, treated ailments, wrote prescriptions - all at company expense. However, we never had a pension plan, and looking back that was an egregious black mark on the ownership. They just 'never got around to it'.

Shortly after I got the top job in Production and Marketing, I finally went to the partners and said my salary wasn't fair and I wanted a raise. They agreed, and overnight I got a raise of $200,000. I was now making $252,000 a year - by far the lowest pay of anyone in the industry in a comparable position. But I still didn't care. I loved where I worked, and I loved what I was doing.

Jack Beckett was making $175,000 a year as head of Transamerica. This wouldn't and couldn't do..... I was a thirty-something executive making $252,000, so he got a raise. Jack seemed a decent sort, tall and serious (humor was not a long suit at Transamerica). His right hand man was Jim Harvey. Jim, looser than Jack, more of a frat boy, was easy to talk to. Soon after the merger, we met with the top people in San Francisco. In the first corporate planning meeting I attended, Mr. Beckett asked each of the subsidiaries for a five-year projection showing an annual 20% increase in return on investment. I looked at our finance guy and he raised his eyebrows at me. A 20% annual increase in the movie business over five years? Were they nuts? I didn't know what movies we would be making much more than 12-18 months in advance, no less how much business they were going to do. And they wanted a five-year projection? I kept my mouth shut. After all, Arthur and Bob had made this deal. They could handle it. My main interest and responsibility was what movies we would make within the yearly production budget and how we would market them. I'd leave the rest to others. But one thing I knew from this first exposure: it didn't sound good.

Dana Leavitt was the head of Transamerica Title Insurance, based in Phoenix, Arizona. He was a delight. He thought the idea that the parent had bought a film company was beyond understanding, but the deal was done, so he thought it might be good

for his key execs to get a feel for their new sister company. He was having his top 300 sales people to a full-day meeting, and asked if I'd fly down and speak to them, giving them a feel for their new partner. Of course I said yes.

A few days later I was introduced to a roomful of white men wearing suits and ties. I really hadn't chosen a way to introduce them to their odd new relative, but as I stood up to talk, I figured let's just go for it. Here's what I said:

"How many people in this room have been to a movie more than a couple of times in the last three or four months?" I asked. Slowly a few hands rose. I didn't count, but it certainly wasn't more than a handful. I looked over at Dana and he just smiled at me. Okay, I said to myself, you asked for it. "Let me tell you gentlemen (again, no women) something about the company you just bought. In 1953, United Artists resigned from the Motion Picture Association of America, the industry's arm that rates films for moral and spoken content, because we wouldn't cut the word 'virgin' out of a movie called *The Moon is Blue* - I repeat, the word was 'virgin'. Next year (1970) we will be releasing a movie called *The Landlord* with the word 'cocksucker' in it." Dana and I became good friends that day, and the word about UA spread very fast.

Notice came of the annual Transamerica corporate outing with the heads of all its companies at an offsite somewhere outside San Francisco. Since it was the first of these since the takeover, it was decided that Arthur, Bob, Arnold, and I would attend. The schedule and arrangements arrived in New York. I smelled problems. We were going someplace in the middle of the northern California countryside called "The Farm". The execs were housed in bunks, two to a bedroom with a connecting bath. There would be morning meetings followed by afternoon activities (sign up for one - tennis, golf, bike riding, hiking...) Let me be gentle here. I do not believe that the top echelon at UA were spoiled executives who ripped off the company with excessive expenditures or extravagant indulgences. We were, however, in the entertainment business and we dealt with the biggest names in our world, we ate in the finest restaurants, and had suites in the best hotels when

we traveled. Oh and, yes, we flew first class (remember, this made up in part for the low salaries), so although no one was overindulgent, we certainly went first class. From The Dorchester in London to The Georges V in Paris and The Grand in Rome, we traveled well and lived well. Sharing a bunk did not sound promising.

It was like being at summer camp as an 8-year-old. I was 38. Arnold was 56, Arthur and Bob were in their sixties. A common latrine, no doors for privacy, a wire cot with a thin mattress. When we got to the bunk I looked for the phone. There wasn't one. I couldn't believe it. We had pictures shooting all over the world, and I had to have communication. I didn't care if their business was only about people waiting to die - I had to have a phone. I found Jim Harvey. "Are you people crazy? You've got Krim and Benjamin on cots, sharing an open latrine.... I don't care about me, but I've got to have a phone. I'm in the communication business!" He laughed, but he realized I was serious. He said, "There's a phone at the gatehouse where we drove in... that's it." Never again, Jim, never again. I used the pay phone for two days. Arthur and Bob left after one day with Jack Beckett's blessing. It was a two-day boondoggle; fun for insurance guys to play and drink and not have to talk to their wives, or anyone back at the office; it was a nightmare for us. Transamerica got the message, and the following year the meeting was a place with real beds and real telephones in San Francisco. I don't know if they ever forgave us.

Next was the logo. Although UA had a logo in front of our films, it was not always used. We subrogated our corporate image to our filmmakers. It was their films; it was about them, not us. One of our great strengths was that we prided ourselves on having the best filmmakers in the world making films for us, so our logo was not our message.

Transamerica decided to change the logo for the parent company and all its subsidiaries. On my next trip to San Francisco they proudly showed me their (and now our) new logo. All the companies would use it. They had not only designed it for each company's use, but had also chosen its color...kind of a mustard yellow. I was appalled. I told them I wouldn't use it, couldn't use it, and that it

went against everything that we had created at UA, but they stood firm. I called Arthur and told him. His response surprised me. It was clear he wasn't going to fight it. I didn't understand then and I never found out his reasoning, it seemed so unlike him. I had no choice, but at least I convinced him to stand behind me on the color. So I got the color for the pain-in-the neck UA subsidiary changed to light blue. Only UA could use this color, and I know it irritated the parent no end. Bunk beds. Mustard yellow logos. Things were not going well ... and in addition, the numbers were not holding up. The movie business runs in cycles, and though we were close to meeting our projected numbers, it was clear there might be some trouble ahead.

The Transamerica years moved into the early seventies. Arthur Krim spent more time hanging out with the President of the United States, both in Washington and on the Pedernales. Bob Benjamin hung out with his friends at the U.N. Arnold Picker worked for the campaigns of Ed Muskie and Scoop Jackson, both of whom thought they could run for the presidency. Neither came close. I was given the CEO title, which I gladly took even though in practical matters nothing much changed. I still didn't get too involved in long-term financial matters or union negotiations - subjects that were of little interest to me. Arnold realized that the relationship with Transamerica would come to no good end and wanted the partners to leave and form a new company. Arthur and Bob weren't ready for that. I had a contract that would end in 1973, and I knew UA was not UA anymore. It was a subsidiary of a company that had a growing realization they had gotten into a business that could never be run by the precepts that were ingrained in Transamerica's DNA. Then along came *Last Tango in Paris*.

In late 1970, Alberto Grimaldi called me from Los Angeles. Alberto had produced *For A Few Dollars More* for us, as well as the sequel, *The Good, The Bad, and The Ugly*, the incredibly successful Sergio Leone westerns starring Clint Eastwood. "Would you like to finance a film with Bernardo Bertolucci?" he asked. I certainly would, and told him so. Having seen Bertolucci's most

recent film *The Conformist* several times, I thought him to be a brilliant filmmaker who would fit in perfectly with the list of great European directors we had attracted to our company, talents such as Bergman, Fellini, Truffaut, Malle, Germi, de Broca, and so on. Alberto Grimaldi was an unusual Italian producer. He had a great eye for talent, and kept his ego under control. He was highly competent in dealing with European filmmakers whose style was, let's say, sometimes hard to control. Alberto was a professional producer of the first order.

"Good," he said, "but you have to move quickly." He then described a project he and Bernardo Bertolucci had set up at Paramount. They had the outline, the budget, and Marlon Brando was set to star. Their problem was that Paramount wouldn't approve the film with Brando at the budget they had submitted. The studio wanted to use a European star like Gian Maria Volonté who had starred for Bertolucci in *The Conformist,* but was less money and trouble than Brando. Here was the real irony; Paramount had just finished shooting *The Godfather,* but it had not yet opened. It was clear that Paramount didn't know what it had on its hands or they surely would have run with this deal. The budget for *Tango* with Brando was under $1.3 million; hardly a giant risk. Anyway, Paramount told Alberto he could take it elsewhere with Brando, and I was the first call.

"Send me the treatment."

After reading the outline the next day, I authorized our legal affairs department to make the deal immediately. In retrospect, I'm sure I would have made the deal no matter what the content of the outline. I wanted to be in business with Bertolucci and I trusted Alberto. The film was a moody, sensual love story starring a great actor with a brilliant director at a cost worth risking, so my decision was easy. UA had just made a deal to finance and distribute worldwide Bernardo Bertolucci's *Last Tango in Paris.* No one could have predicted what was ahead.

The film was shot in Paris and on one of my trips I stopped by the location to say hello to Bernarndo and Brando, neither of whom I'd ever met, although Brando had made several films for

us. I remember very little about the visit to the set except they were filming in an apartment and I may have hung around an hour or so. Hugs, kisses (that's what Italian directors do a lot). So I went by, I said hello, and I didn't see Bernardo again for a year.

Last Tango in Paris was a title on our future release schedule. Until I could see it and determine our marketing and distribution philosophy with the staff, it was out of mind. Alberto kept me apprised of the progress and everything seemed to go very smoothly. Months went by and finally Bernardo was ready to show me the film. A little about him first. His English was, at best, limited. He was politically way left of center; nonetheless he certainly had a taste for the good life.

It wasn't often that I got major surprises when I finally saw the finished work of the filmmakers we supported, but certainly the quality of the work, the emotional impact of the film, the pride or disappointment in seeing the results of what you have believed in, was deep-seated and very meaningful. I've never enjoyed casino gambling and I believe it's because in my work life I gambled on the passions and talents of moviemakers every day. There is nothing to compare with seeing the results of filmmakers creating the best work they can. The first screening of pictures like *Tom Jones, Midnight Cowboy,* and *A Hard Day's Night* are highs that cannot be adequately described, although I've tried.

"Holy shit." The lights came up in the UA screening room. I turned to Grimaldi. "Holy shit. Lock this picture up. I don't want anybody to see it until I say so." I turned to Freddie Goldberg and Gabe Sumner, the heads of our marketing department, and said let's talk.

I knew one thing. United Artists, who had championed freedom of expression, fought against (and at one time resigned from) ratings boards, financed *Tom Jones,* as well as *Midnight Cowboy,* the only X-rated film to win an Oscar, had a tiger by the tail with *Last Tango.* And one other thing - we had a sensational, provocative, commercial film on our hands.

There's no way to keep the buzz about a movie quiet. Sometimes it's a very good buzz and sometimes it's very bad. Back in the 70's

when there was no internet, when it was all word of mouth, it was easier to control. In the case of *Tango,* there were all the people who worked on the film in Europe, there was Brando himself, and who knows who else. However, not much seemed to have leaked.

Mike Todd, who made *Around the World in 80 Days* for us, was the greatest promoter I'd ever met. The year I started with UA, 1956, we released that film, and I saw how he controlled the marketing. He taught me that when you've got something that people want to see, you should make it as hard as possible for them to see it. The buzz on *Around the World in 80 Days* was very good, and it was going to open "reserved seating" at the Rivoli Theater. Realizing the anticipation was high, Todd insisted that during the advance sale of tickets, UA would say the first three weeks were already sold out. (They were no such thing.) No one walking up to the box office could buy a seat.... sold out. The word spread that the picture was a big hit. And it became just that. Its first anniversary at the Rivoli was celebrated by a circus parade honoring the picture at Madison Square Garden with Elizabeth Taylor riding an elephant. Imagine 18,000 people honoring a movie with a publicity stunt like that. An ironic aside was that sometime later Mike Todd asked my uncle Arnold to fly back from Los Angeles to New York with him after several business meetings they both attended. Arnold had to stay an extra day, and Todd was killed when his plane crashed on that trip.

I listened and learned. Make it hard to see. That's what Freddie, Gabe and I decided. Arthur, Arnold, and Bob saw the movie, and I got them to let me handle this very hot potato. The challenge was staring at us right off the screen. There were going to be *serious censorship problems* with this film. How should we cope with them? We decided on three things. The first thing to do was assure Alberto and Bernardo that we weren't going to ask them to change or cut the film in any way. I don't know if they were surprised or not, maybe they expected it, but I told them they had to let us handle the movie's worldwide marketing and trust us. They agreed, and almost lived up to it. The second thing I did was tell our people that the film was to be locked up, that there would be *no screenings*

for anyone under any circumstances. The third was to put an X rating on the film and not screen it for the MPAA ratings board.

I suggested we get into the New York Film Festival. With Bertolucci and Brando, it shouldn't be too hard. I called Richard Roud, the gentleman who ran the Festival. "How'd you like to close your festival with *Last Tango in Paris?*" I asked.

He was delighted and appropriately so. Brando and Bertolucci? How could he say no? I said okay, but there were some conditions. Normally a film had one or two screenings scheduled, as well as a special showing to the press as a courtesy. I told Richard that the closing night would be the only showing, and that there could be no press screening whatsoever, nor could any press be given free tickets to the closing night show. Only ticket buyers would be admitted. Whoever came, came. In addition, the print would be delivered in the afternoon for a test screening of a reel or two, kept under supervised security, and removed from the hall by security people as soon as the show ended. He balked, but there was no room for negotiation. It was that way or no way. He eventually agreed, and good for him. Although I was appreciative of his agreeing to the terms, he correctly smelled something important and went along with the unusual conditions attached. Distributors want their pictures seen as often as possible to get the word of mouth going. Here was a company that wanted less to, hopefully, get more. Thank you, Mike Todd.

Closing night was sold out, and there was no clue as to the makeup of the audience.

The picture was shown to its first audience on Saturday night, October 14, 1972, with Bertolucci in attendance. When the lights came up at the movie's end, the audience sat there stunned. Nothing had prepared them in any way for what they had just sat through. This rarely happens to any audience, no less one as sophisticated as closing night of the New York Film Festival. Usually there is the pre-production hype, the post-production buzz, a phalanx of publicists trying to influence their pre-screening interest. In this case there was *nothing.* They were on their own. They were the first audience to see the film, and they had nothing to fall back on

except their own individual response. As people exited the auditorium to the lobby, they grouped together and talked. They stayed around a long time, and that's always a good sign. When they leave quickly you're in trouble. We had no idea what was ahead.

Two days later on October 16, 1972, Vincent Canby, chief film critic of *The New York Times*, wrote a piece acknowledging that the film wouldn't open for some time, but having seen it on his own volition at the Festival, he felt free to review it. Phrases like "an invasion of self-assuring middle class privacy" and "anything but pornographic", caught filmgoers' attention. That review was a marketer's dream because we knew the film would have an enormous "want to see" from the upscale audience which gets the word going.

Writer and essayist Clive James describes Pauline Kael by saying, "She's easily the finest film critic yet to appear and already belongs among those critical writers whose aesthetic principles comprise the undeclared philosophical wealth of the last three-quarters of a century." As critic for *The New Yorker* magazine from 1968 to 1991, she was indeed the most erudite and influential critic of her day (especially when it was your picture she liked), and she was one tough lady. On October 23, 1972, to our total surprise, Pauline Kael (who we didn't know was in the New York Film Festival audience, just as we hadn't known about Canby) wrote a six-page review of "Last Tango in Paris" in *The New Yorker*.

These were the opening sentences: "Bernardo Bertolucci's *Last Tango in Paris* was presented for the first time on the closing night of the New York Film Festival October 14, 1972; that date should become a landmark in movie history comparable to May 29, 1913, the night *Le Sacre du Printemps* was first performed in music history........This must be the most powerfully erotic movie ever made, and it may turn out to be the most liberating movie ever made."

Near the end of the six pages, this final thought: "I've tried to describe the impact of a film that has made the strongest impression on me in almost twenty years of reviewing. This is a movie people will be arguing about, I think, for as long as there are movies." How right she was. A phone call from the producer to an

executive who responded quickly and positively, and an artist free to express his vision without corporate overview had created a brilliant film, a marketing gold mine - and Pauline Kael gave us the advertising campaign.

The publicity department was besieged by the press for screenings. Our only decision was which was the one publication we would give an exclusive look. It was *Time* or *Newsweek*. I knew, liked and trusted Shana Alexander who wrote for *Newsweek*. With the opening set for February 20 in an exclusive reserved seat engagement at one theater in New York's East Side (at an increased price of $5 per ticket) we invited Shana, her editor Oz Eliott, and two young reporters, Maureen Orth and Charles Michener, to see the film in our home office projection room. They knew they had an exclusive, saw the picture, and committed to a cover story two weeks in advance of the New York opening.

The following week, Fred Goldberg who headed marketing called and said that *Time* wanted to screen the film and that Henry Gruenwald, the editor, was going to personally view it. I reminded Fred we had committed an exclusive to *Newsweek*. He knew that, of course, but was concerned that if we didn't accede to *Time's* request we'd be blackballed for all our films at the magazine. I told him I didn't care. Would I talk to Gruenwald personally? I said I would, if necessary.

Mr. Gruenwald called. "Why can't I see it?"

"Because I've given my word that I won't screen it for anyone beyond the one screening we've already had. If you'd given your word, wouldn't you stand behind it, Mr. Gruenwald?"

Time and *Newsweek* competed on cover stories constantly, faking each other out, trying to get a hot story first, and even going so far as often printing a short run with a phony cover to fool their number one competitor.

I called Charles Michener at *Newsweek* and told him of the conversation with Gruenwald, and he thanked me for standing firm. Four weeks before opening day, the phone rang at my New York apartment at 11 pm. It was Charlie Michener. "Brando's on the cover of *Time*." I couldn't believe it. They hadn't seen the film and

they ran a cover story anyway. The next morning there it was - Marlon Brando, *Last Tango in Paris*, the cover of *Time* magazine.

It was hard to tell from the *Time* piece if anyone from the magazine in New York had seen the picture, but perhaps someone had gotten to see it in Paris through a friend because it hadn't opened there yet either. It also appeared they had spoken to Brando, who we clearly had no control over. Anyway, there it was. The cover of *Time*, and the film was described using the word "pornographic". I got to the office early as usual so I had time to think and catch up on my desk before the phones began to ring. Arthur, Bob, and Arnold soon arrived, and we wondered what all this fuss would engender. It didn't take long.

About 11:30 a.m., Arthur asked if I could join him in his office. Jack Beckett, the chairman of Transamerica, was on the phone and wanted to talk to us. On the west coast it was 8:30 a.m., and very early for an insurance company CEO to be on the phone. I went into Arthur's office and picked up the extension.

"Good morning, Jack."

"Good morning. Have you seen the cover of *Time*?"

"Yes."

"Well, we've just lost a $300,000 premium from one of our corporate clients because our sister company is distributing a pornographic film." Before Arthur or I could say anything, he added, "so I believe we have to give up the film."

I looked at Arthur and indicated I wanted to say something. He nodded back. "Jack, listen. *Time* hasn't even seen the film because I wouldn't show it to them. Your client hasn't seen the film and you haven't seen the film. How can you say it's pornographic? Is it provocative - yes. It's sensual, but it's a work of cinematic art and it's not pornographic." Jack's response was that he really didn't care. We couldn't be involved with this kind of film and we had to get rid of it. This time Arthur looked at me then pointed to himself. I had no idea what he was going to say.

"Jack, if that's what you want, we'll work it out." I couldn't believe my ears. "Here are the terms. The picture cost about $1.3 million. David and I will buy it from the company and when we buy

it, we will be leaving the company with it." He stopped. There was a long silence on the other end of the phone. Finally, Jack said, "I'll get back to you." We never heard from him on the subject again.

Tango's opening was ten days away. I had not heard from *Newsweek*, but the word on the movie was very positive and advance sales at the Gotham Theater were excellent. Charlie Michener called. "We're running our cover next week. Thanks for being so straight with us, but the movie's so hot we're going with it." I couldn't believe my ears. I haven't researched it, but not many movies have had the cover of both *Time* and *Newsweek*.

Variety's office in Rome called Bertolucci, who was scheduled to come to New York for the opening, to find out what he thought about all the fuss. Bernardo, whose left-leanings often got the better of him, said he was excited, but felt that United Artists showing the film at a higher ticket price was not fair to the middle-class moviegoers and he strongly objected to this discriminatory charge for the mass audience. With the quote in hand *Variety* called me for comment. They caught me by surprise since Bernardo had never mentioned this to us in any conversation when we briefed him on our plans. My response was short. I said, "We didn't tell him how to make his movie, he shouldn't tell us how to distribute it."

Bernardo was due to arrive in several days. He had no objection to being picked up by limo at JFK nor staying in a suite at the Carlyle Hotel on Madison Avenue and 76th Street, not exactly a hotspot for his friends among the masses. Anyway, he was due at our office the next morning to be brought-up-to date on all the future marketing and distribution plans we had. I walked down to Fred Goldberg's office to welcome him. He looked fit and, as always, attractively groomed. He had on a suit and over his arm hung a tan cashmere overcoat. Hug hug, kiss kiss. "David," he said, "I know you don't mind me in the press. I don't mind you either." Or something like that. Then he stuck out his arm and showed me the beautiful coat. "I walked here from the hotel and saw this coat. I loved it, so I bought it and had them send you the bill, okay?" You betcha Bernardo, it's okay with me. We hugged again. Years later when I was president of Columbia Pictures we were able to make

a deal to distribute his film *The Last Emperor*, which won the Best Picture Oscar in 1987. (How would one even begin to describe all this to Jack Beckett and his happy band of actuarials?) To say that *Tango* was a great worldwide success would be an understatement.

When my contract ended in 1974, I decided not to continue as a United Artists/Transamerica executive. As I mentioned earlier, I worked out a three-picture producing deal with Arthur on terms that no one had ever gotten before. I had the right to produce three pictures for the company, each with a budget of up to $2 million, and the company waived all rights of approval, period. Script, director, cast, all of my own choosing. More about these pictures later.

Arnold left the company soon after, and Arthur and Bob stayed on for a few years, then left to form Orion Pictures, taking three other top executives with them. Transamerica had to decide what to do with their troublesome subsidiary, and the sad tale of what they did is worth taking a short look at.

Bill Goldman's quote, "Nobody knows anything", proved to apply perfectly to Transamerica. They looked within the remaining executive ranks and chose Andy Albeck to run the company. Let me be very clear here, Andy Albeck was an honorable man. A very decent man. Trained in the international division of the United Artists operation, he was Danish by birth, spoke fluent Japanese, and had travelled the world extensively for the company. The fact was that his responsibilities were comparable to the head of the Quartermaster Corps of the Army. Andy was expert in all things international when it came to office management, union negotiations, personnel regulations, film distribution, and film marketing. So this decent, honorable man was named president of United Artists. Soon after, Andy had his *Heaven's Gate*. Transamerica dumped the company, and the United Artists that had been so special came to an end.

Looking back at the glorious UA years is bittersweet, though far more sweet than bitter. The Wall Street brokers, the Kerkorians of the world who buy and sell companies, mix and match for the

purpose of making more and more money, the scam artists and the merger managers have taken the great UA product of the Krim Benjamin Picker years and scattered the titles so that James Bond can be an MGM or Columbia picture, or the DVD from 20th Century Fox or Warner Bros.

When I see these great films with logos other than UA, it hurts more than a little. On the other hand, I know that these great films could never have been made had it not been for those special years of the 50's, 60's and 70's when the philosophy of United Artists and its management enabled filmmakers all around the world to make their dreams come true.

Paramount

"I want to make a movie of Star Trek."
- Charlie Bluhdorn
(screaming)

Dick Sylbert never had a chance. He had been appointed head of production by Barry Diller, and it went downhill from there. The fault belonged to neither of them. Dick Sylbert was one of the most talented production designers in American movie history. There wasn't a quality filmmaker who didn't want to work with him because he was not only talented; he was smart, acerbically funny, and most important for me personally, a brilliant fly fisherman. He once showed me his secret hideaway tucked into the attic of his Nichols Canyon home where he made fly rods and tied exquisite flies. "This has kept me sane from all the crazies we have to deal with, as well as keeping me off the psychiatrist's couch."

Anyway, Dick had the job and the fact that he turned down twelve submissions in a row from my production company bothered me, but mostly I understood that in his new position he just froze. He was used to making dozens of decisions an hour to create the vision he wanted his films to convey, but when trying to decide whether or not to recommend to Barry what films to greenlight, his system just shut down. It was not his world.

Barry called me. "I'd like you to meet Charlie (Bluhdorn). We've got to make a change, and I'd like you to consider working

with (under) me as president of production." I knew little about Charlie, but stories were legend. Feisty, Austrian-accented, a screamer, scared of dying and funerals, unable to make a restaurant reservation (Bob Evans' office did it for him), fearful for his own safety (his home in the Dominican Republic had armed guards on the roof), and in many ways irresistible. He cared about money, sugar, money, zinc, money, movies, and money.

We met in his New York office in the Gulf + Western building (or Engulf + Devour, as Mel Brooks called it) on Columbus Circle. It was a dramatic slab of a building overlooking the world and, like much about Charlie, the outside was stylish and flashy, but inside the elevators constantly rattled against the side of the shafts and often broke down.

Charlie knew only one way to speak: at the top of his voice and waving every appendage on his body. Think today of the comic Lewis Black. Charlie was the corporate equivalent; loud, angry, funny, and sly.

I didn't need to discuss my qualifications; they were a given. Like so much in the movie business it was more about the interviewer than the interviewee. Charlie had a big map of the United States on his wall. "You see this?" he screamed. "I don't give a shit about here or here," he said pointing to New York and Los Angeles. "I care about here," slamming his finger into Kansas City. (Little did I know that one day I'd work with the company that *was* Kansas City, Hallmark Cards - but more of that later.) "Kansas City. That's who I want to make movies for, and here's two I'd like you to develop right away." Between the decibel level and the accent, he had my attention. How I love accents. Being brought up in the world of Jewish comics and vaudeville, accents just put me away. Anyway, Charlie had my attention. What movies did he want to develop? I couldn't wait to hear.

"The first is *Star Trek,* then I want to make a movie where the two main characters are Chief Sitting Bull and Adolf Hitler." he screamed. I tried to catch Barry's eye, but it was unavailable. Who cared; I was hooked.

Little did I realize the priorities of life running a studio. Remember, United Artists wasn't a traditional *studio.* In no particular

order the real priorities at a studio are your parking place, the size and placement of your office, and the car you drive. The car was easy; a 1976 Buick convertible. The parking place - convenient, adjoining the building in which I was to work. The office - well that's a matter of some personal style. Trained by my years at UA, I opted for an already furnished, perfectly decent-sized office down the hall from where Barry had rebuilt a suite of rooms to fit his needs. His office was handsome, tasteful, modern and expensive. When Michael Eisner joined a year or so later, his office was handsome, tasteful, modern, expensive, and required a new staircase in order to reach it. In my office I changed the couch. Perhaps I should have known then that studio life was not for me.

My first day was dealing with Robert Altman and Elaine May, as we discussed before. With that out of the way, the biggest challenge can be stated very simply. The company had little product for release or in the pipeline. I had to find the future.

I've known very few people who were more comfortable in their skin, no less their clothes, than Alan Carr. Whether it was the multi-colored caftans he wore around his house barefoot or his velvet suits, Alan was distinctly, uniquely his own person. A personal manager and music producer for years (he could count The Village People among his triumphs), we met in 1976 through our mutual friend Freddie Gershon, Alan's lawyer. Alan wanted to pitch a couple of ideas, and I was desperate to find some product for the company whose upcoming summer release schedule was bare.

Alan's house on Coldwater Canyon was the anointed meeting place. Caftans didn't travel well. He had just acquired the rights to a Mexican film he wanted me to see. He thought it could make a buck. The title, *Survivor*. The subject, a plane that had crashed in the Andes where, in desperation, the survivors had cannibalized their dead co-passengers. The picture in the original Spanish was not very good, but the subject matter was provocative enough to perhaps attract a not very discriminating audience. I agreed to finance a dubbed version and scheduled the film as Paramount's big, hot summer release.

After that conversation Alan then told me his real reason for wanting to meet. *Survivor* was just the appetizer, according to the beflowered producing guru who was just warming up to do what he did so brilliantly. He pitched me an idea. "There has been a show running on Broadway for six years and still running, it would make a smash hit movie, smash, guaranteed gigantic box office hit worldwide." I thought I knew what was coming, and I wasn't happy. "The title," said Alan, "is *Grease.*" I was right. I had seen the show. Actually, I had seen half the show because after the first act, I had walked out. I didn't like the rock score, cartoonish characters and cheesy comedy. I was obviously in the majority of studio executives because in its entire Broadway run not one of the studios - all insightful, daring, keyed in to the heartbeat and desires of the American movie-going public - had shown the slightest interest in this hit Broadway musical. Not one, and not me. I told Alan it was a pass. I couldn't bear the show, and obviously not any of us who got paid really good money for knowing what the Great American Public wanted to see would disagree with me.

Twenty minutes later, I agreed to acquire the rights to *Grease* as a Paramount picture for $200,000 so that Alan Carr could make it into a film that everyone would want to see. Now, that's the definition of what a producer does when he produces. I didn't believe in the show, but I believed in Alan's *belief* in the show.

In the late 60's at United Artists, Lou Adler, a record and music producer, came into my office and asked me if I had ever heard of Cheech and Chong. Of course I had. "I want to make a movie with them," he said. I liked the idea and encouraged him. He tried, but they were too busy and too hot. They didn't want to take a chance on film. Six years passed. We desperately needed to develop product. I called Lou and asked him if maybe now the timing would work for the boys. Yes, they'd be open to it. (Mostly because they weren't as hot as they were a few years before.) Lou brought in a writer/director named Floyd Mutrix to develop a script, and soon after he came in with an outline entitled *Up in Smoke.* It read to me like a stoned version of an Abbott & Costello movie: funny, silly, and way out there - just like the two boys themselves. I agreed to

go to script, and on its delivery Lou told me that he and Mutrix had a falling-out and worked out a settlement so that Lou now owned the script and was the sole producer. I was ready to greenlight the project. Lou looked at me and asked, "Who can I get to direct it?" I looked at him and out of my mouth came a suggestion that to this day I don't understand. "Why don't you do it?" He looked at me amazed. "I've never directed or produced anything. What are you talking about?" I suggested that the boys, whom I'd never met, obviously trusted him. They'd never made a movie, but trust is essential and a team could be put together to work with and support Mr. Adler. The fact is, crass as it may sound, a comedy about these two stoners called *Up in Smoke* was all that was needed. Everyone who went to see it would be eight feet off the ground anyway, so who really cared how artistically or technically well made the picture was. A stoner comedy should look stoned. We laughed, but I was dead serious. This was the beginning and end of the directorial career of Lou Adler.

Grease and *Up in Smoke* were now in the pipeline.

Shortly after that, Robert Redford and I agreed to develop the novel *Ordinary People* for him to make his directorial debut. Robert Stigwood, Alan Carr, and Freddie Gershon then persuaded me to develop a short piece from *New York Magazine*, "Tribal Rites of the New Saturday Night", which became *Saturday Night Fever*. Barry and I agreed to greenlight *Heaven Can Wait* with Warren Beatty, which Warner Bros. had put into turnaround (were they nuts?), and I agreed to greenlight Terry Malick's *Days of Heaven* with Richard Gere in his first starring role. I also agreed to develop a script with Steve Martin, at the time an up-and-coming comic. These were now in the pipeline, but not much was available for release. We picked up what we could.

What I *didn't* do was develop *Star Trek*. Paramount owned the Gene Roddenberry TV series, and it would have made sense to pursue that. But I disliked sci-fi. I didn't like sci-fi books, movies, comic strips, none of it. Had George Lucas done *American Graffiti* for us at UA, I believe I would have passed on *Star Wars*. Back at Paramount, *Star Trek* was nowhere on the agenda.

Barry was star- and perception-driven, and he was very good at what he did. But what I did clearly did not fit into his definition of a studio head. For me, it was content and talent-driven; for him, star vehicles. Not long after I arrived, and well before any of my projects had come to fruition, he told me he was bringing in Michael Eisner and asked if I'd help break Michael into the film world since he'd been strictly TV up to this point. Michael was smart, he listened, and the relationship was compatible under the circumstances, though it was very clear to me that Michael was the future and I was about to be the past.

Studio life wasn't for me. I had a three-picture producing deal which would go into effect at my contract's end, and as I mentioned, Michael did me the favor of putting the Steve Martin project in turnaround, enabling me to join Steve and his partner Bill McEuen to produce *The Jerk*. Thank you, Michael!

Not long after my departure, the projects I had begun at Paramount started to emerge. *Ordinary People* won the Oscar, and I got a shout-out from the producer in his acceptance. *Grease, Saturday Night Fever, Up in Smoke, Days of Heaven, Heaven Can Wait* opened: and Paramount had the most successful year in its history.

In a story in the *LA Times*, reporter Roderick Mann described Michael Eisner as the man responsible for *Heaven Can Wait* and *Saturday Night Fever*. I decided to write the following:

INTER-COMMUNICATION

TO: Charles Bluhdorn
Barry Diller
Michael Eisner

DATE: May 31, 1979

FROM: David V. Picker

SUBJECT: Setting The Record
Straight

Something has been bothering me for many months now and
I hope you will bear with me while I go into it in some
detail for it requires some historical background to be
seen in perspective.

In the 1960's and early 70's when I was part of the
decision making group at United Artists, industry executives
(but particularly at United Artists) kept a reasonably low
profile. The films and film-makers were the stars. In
addition, all our decisions at UA regarding what films to make,
were made as a group. When a project was rejected (or
accepted) it wasn't "I loved it but Arthur Krim wouldn't
do it" or "Arnold Picker supported it but David killed it".
It was a go or a pass. We worked by advocacy within the group
and though projects were born from the ideas of individuals
among us or through outside contacts to each of us, the
decisions and results of those decisions were always joint
responsibilities.

This has obviously all changed. Executives at the various
companies have become "media stars". One only has to look at
the recent Life magazine piece or the Los Angeles Times this
week tracking Fox executives with "Alien" or the Baby Mogul
piece in New West, to see a few recent examples. Executives
feed their ambitions and egos on the interest of the media
on Power in Hollywood.

It wasn't very long ago that I spent a complex, difficult,
frustrating but in many ways rewarding and satisfying period
of time as President of Paramount's Motion Picture Division.
You, Charlie, and you, Barry, made me feel wanted and I
believed I would be able to do an effective job reshaping
Paramount's Motion Picture image which over the past years
with the exception of a few giant hits such as "Godfather"
and "Love Story" had fallen on consistently hard times and I
looked forward to the challenge eagerly. In the time spent
working with Barry I was able to move forward with some of
the projects I believed in, not with others. I believe that
he and I have genuine respect for each other's attitudes but
we fundamentally disagreed on how a motion picture company
should be run. In addition, having run a movie company

-2-

before, I wanted it done my way. Barry wanted it done his.
I think also Barry was concerned that product instigated by
me did not have enough "Big Names" and he was genuinely
concerned Paramount would not get its share of the market.
I could only do it my way, support what I believed in, and
trust that my judgement would deliver enough big hits (as
it had in the past) so that over a reasonable period of time
the company's program would be productive.

Some months before Barry's feeling about me totally
crystallized he asked if I would object to Michael Eisner's
joing the company's top echelon pointing that if I did object,
he would not bring Michael into the company. Several advisors
close to me felt that if Michael came in I would be gone with-
in a year. My decision not to object to Michael was reached
because I felt that if Barry wanted Michael then he should
have the right to have him and I would try to make it work
for the good of the company. From the time Michael became
a part of the operation, I leaned over backwards to be gracious,
hospitable and helpful in any way I could, both on a business,
corporate and social level availing to Michael all the know-
ledge and contacts that were at my command.

Some months after this Barry and I had several dis-
cussions about my future with the company and Barry deter-
mined that he would prefer me to move out of the executive
area and back into producing. In light of Barry's strong
feelings I agreed. He was most fair about the remainder
of the contract and so I returned to independent production.

When Michael joined Paramount, "Saturday Night Fever",
"Grease", "Days Of Heaven". "Up In Smoke", "Heaven Can Wait"
and other films were already negotiated for and in some
instances already shooting but those projects with the
exception of "Heaven Can Wait" which Barry Diller was per-
sonally and totally responsible for bringing to Paramount, I
personally brought. The movie business is strange. Many
people have short memories but certainly Bert Schneider,
Terry Malick, Alan Carr, Robert Stigwood and Lou Adler don't
and they know who believed in, supported and negotiated for
their projects as I believe you three gentlemen also well
know. But hot is hot and as the pictures opened up and their
success began, one name was missing from all laudatory state-
ments and interviews. It was like Stalin in Russia; you
wouldn't know I had ever existed at Paramount. Barry and I
have had occassion to talk about this historical lapse in
the corporate history of Paramount. At one time Barry said
he would try and do something about it but nothing appeared
that I ever saw. As success heaped upon success, the myth
grew larger. Stories in Business Week, Advertising Age,
the New York Times, the Los Angeles Times, etc.. When you
repeat (or fail to deny) the myth, it becomes fact. What
made me write this memo today (one I've started a dozen times
before) was a story in today's Los Angeles Times. Roderick
Mann describes Michael Eisner as the man responsible for "Heaven
Can Wait" and "Saturday Night Fever". What an irony! Barry

-3-

Diller was with me in Atlanta when he left at 7:30AM to
fly to Hollywood and hound Warren Beatty for three days til
Paramount had the picture. "Saturday Night Fever" had been
negotiated, cast and set up weeks and weeks before that.
Michael Eisner was an employee at ABC-TV.

A few months ago I was frustrated by a leak on "Bloodline"
that Sidney Beckerman had made and I discussed it with Barry.
Barry said to me, "You have to play the same game." Well,
as you three well know it's not a game I play, well or any
other way. But now I feel something must be done. I was
responsible in good part for the most successful year in the
history of any motion picture company ever and that company
repaid me with not one public acknowledgement of any kind,
in fact, the exact opposite. I feel that a major injustice
has occurred and I would like the record set straight. I
would appreciate your suggestions as to how this might be
done.

Sincerely,

I never heard from Michael or Charlie, but eight months later
Barry sent me a handwritten letter that read as follows:

Dear David,

*Several times in the last several months I have looked at your 'setting
the record straight' memo and thought with some guilt that I promised a
response and it's getting so late that it may be academic. I once did a rough
draft and then discarded it - my problem has not at all been indifference
but that I find 'setting the record straight' to be a very difficult process. It is
not exactly uncomplicated: varying points of view, with varying emotional
axes as to who did what to whom, who was involved specifically in a given
project, and was it singular or collective - a logical assemblage of facts isn't
easy.*

*The fact, though, is that the central thesis of your feelings was, and is,
clearly correct. Whoever made x or y deal, voted yes or no, or was respon-
sible for a success does not seem to me to be particularly to the point or even
possible to determine with any exactness of clarity. What was clear is that
you were a key reason for Paramount's success and to exclude you from*

that either directly or indirectly would be wrong. I honestly don't believe there was an attempt to do that ... I did make an effort to do the opposite. There was no 'de-Pickerization' of Paramount. It was not an easy time as you know and we were all just trying to get on with things. When success did come we generally did downplay it and certainly did de-personalize it as much as possible; which as you know is something I tend to do generally and maybe dumbly. It is also true that while it isn't fair, there is a tendency when a new person comes into a company he inherits either the good or bad that precedes him, and it is unusually difficult and awkward to correct.

I do want <u>any</u> record to state that a great deal of Paramount's success was directly attributable to you.

Congratulations on the great success of Steve Martin and "The Jerk". I know how long you believed in him, so much before anyone heard the name ... I certainly rejected him early, clearly, and wrongly.

I hope the 80's are all you wish them to be.

Regards,
Barry

When I left Paramount, I swore I'd never ever again deal with studio life. All that proved was that you should never say "never" again...ever.

Columbia

"I'll tell you what it's like working for the Coca-Cola Company..."
- Fay Vincent, Chairman, Columbia Pictures

In the summer of 1985, David Puttnam, the newly appointed chairman of Columbia Pictures, asked me if I would join him in the running of the studio. I had known David for over 15 years, and had been instrumental in opening doors to his film career. He introduced two highly talented English directors to the world scene; Alan Parker (*Bugsy Malone*) and Ridley Scott (*The Duelists*) and subsequently produced two wonderful films, the unforgettable *Chariots of Fire* and *The Killing Fields*. My Paramount years had left a bad taste in my mouth, and the thought of returning to studio politics raised serious doubts in my mind. On the other hand, I trusted David and he convinced me that we would have a great time together. He had taken over the job in August and I wasn't free until January, but we agreed to the schedule. The only thing to do was to work out the financial terms in a meeting with Fay Vincent, the Wall Street executive Herb Allen had brought in to bring some strategic direction to Columbia, a company whose multiple hirings and firings had led to a very messy decade.

When I was much younger, Columbia had offices at 729 Seventh Avenue in the same building where Krim and Benjamin had set up offices at United Artists. Over time, UA needed more space and Columbia decided to move to 711 Fifth Avenue, a very fancy

address for a film company. Then they got bought by Coca-Cola. As I entered the building to meet Mr. Vincent, the Coca-Cola logo stared down at me. This was not Gulf & Western, the conglomerate that had owned Paramount, a ragtag group of zinc, sugar, tin and who knows what other subsidiaries, run by the irresistible maniac Charlie Bluhdorn. This was Coca-Cola, and I had no idea what that meant. Not then, anyway.

Fay Vincent is easy to describe. What you see is what you get. He's a gentleman, a man of his word, someone who listens and is a disarming soul. He smiles easily and pays attention. We liked each other immediately. He knew me by reputation, and he seemed more interested in telling me about the Coca-Cola company than in anything else. We worked out the terms of my deal quickly with one caveat: he offered me two-thirds of what I wanted contractually and the last third "off the record", but with his word that the company would deliver. I accepted. We talked about the film business, my thoughts on what Columbia needed to do to get back on top of the heap, and how much I liked and respected David Puttnam.

Then Fay said to me, "Let me tell you about my problems and what's it like doing business with the Coca-Cola Company." He wanted to put some perspective on this relationship between movies and a different business.

He said, "I report directly to Roberto Goizueta and Don Keough, the chairman and president respectively. Every morning I talk to Keough and bring him up to date on the goings-on in the industry in general and Columbia in particular. These calls are a daily occurrence. At some point I realized there was a serious personnel problem at the studio. Frank Price, who was running it at the time, was clearly politicking both within the industry and at Coca-Cola against the job that I was doing. There aren't many secrets in Hollywood, and most of them get planted for political purposes, but it was clear that he was after my job. I put off discussing this with Don, figuring I could deal with it myself, but there came a point when it got more open and nasty and there was a possibility it would get to Keough through other sources. So one

morning I said to Don that I had a problem that I needed to discuss with him. I filled him in on the details about Price and asked how he felt it ought to be handled so as not to have a strong negative effect on the company. Keough heard me out without a word and after a few minutes I stopped talking. 'Are you finished?' Don asked. 'Yes, that's about it.' 'Okay then, Fay, let me tell you what's a problem for the Coca-Cola Company.' He paused a moment; Keough was a great showman and his timing was superb. 'A problem for the Coca-Cola Company was World War II when we lost almost half of the international market. What you're describing is a personality problem in the company. Just solve it.'

Fay looked at me and smiled. "Price is gone." Little did I know that two years down the road, David Puttnam would be another problem that Fay would have to solve.

What a bizarre period ensued. I flew to Atlanta to meet with the top brass of the Coca-Cola Company. There are company towns, and then there are *company towns*. Kansas City is Hallmark Cards; Detroit - cars, Pittsburgh - U.S. Steel, and Atlanta - Coca-Cola. The top management, Goizeuta and Keough, ran the show and Ike Herbert ran worldwide marketing. Ike was frank, funny, smart and Jewish. He and I immediately connected. His opening line to me was short and to the point. "Coca-Cola is a religion." That's what he said. "Coca-Cola is a religion, and my job is to convince people that they cannot live a life fulfilled if they don't drink the combination of water and corn syrup contained in this uniquely shaped bottle. That's my job." How elegant and wise he was. Goizueta was of Cuban lineage, suave, smart, classy, cool, impressive; but Keough was one of a kind. I truly believed he would have succeeded in whatever he attempted. Forget "hail fellow well met". He knew you, everything about you, sounded like your best friend, uncle, godfather, priest, whatever. Whatever it took to get you to do your job better. He had three religions: the Catholic church, Notre Dame, and Coca-Cola. He knew the name and background of every key executive in the vast array of Coca-Cola executives and bottlers around the world, and he was the contact person

for Columbia Pictures. Why they bought into the film business, I never could fathom. The trip to Atlanta was fascinating. I was treated respectfully and gained a friend in Ike Herbert.

And oh yes, there was Peter Sealy, the head of U.S. marketing for Coke who had been assigned to Columbia Pictures Studios as head of marketing. Soon after I met Mr. Sealy, I came to believe Ike had moved him over to get rid of him. Since my deal with David was that production, sales and marketing would report to me, I got Sealy - but he never got me.

I met David Puttnam in the late sixties in London and we became friends. He had been a photographer's agent and made his way into film. Along with his partner Sandy Lieberson, an American living in London, he had produced a documentary called *Brother, Can You Spare a Dime?* which I thought not only showed a knowledge of film, but a love for it as well. When I became president of Paramount in 1976, I reached out to him about financing a future film. David introduced me to Alan Parker and Ridley Scott as potential directors and I okayed their first feature films. Both were creative, had made commercials for television, and were ready to move on. Ridley's film, *The Duelists,* was brilliantly designed and shot, the only error being an idea of mine and not a very good one. In trying to guarantee a worldwide audience, I suggested casting two American actors as feuding cavalry officers in the French army of the nineteenth century. Harvey Keitel and Keith Carradine, both terrific actors, seemed incongruous in their roles, particularly with their American accents against the rest of the British cast. Nevertheless, the film clearly showed that Ridley Scott was a filmmaker of special talent, and his career since has clearly proven that. Alan Parker also showed his brilliance in the stylish gangster movie *Bugsy Malone* where all the roles were played by teenage performers, no less than the wonderful Jodie Foster. Alan's and Ridley's careers speak for themselves, but as I write this, a large smile spreads across my face. (As an aside, it is now 2013, and four of my favorite Brits can now be addressed as Lord Puttnam, Sir Ridley Scott, Sir Alan Parker, and may I add, Sir Nicholas Hytner,

head of the National Theater in the U.K., and with whom I worked when he directed and I produced Arthur Miller's *The Crucible*.)

I know for a fact that David told the Coca-Cola management what he planned to do, and how he planned to do it, and that they totally supported his plotline. What none of them realized was how Hollywood would respond.

Renting. Notice the use of the word *renting*, and not *buying*, an apartment in Century City to begin my career at Columbia Pictures. The studio had, for most of my career, owned offices on a back lot on Sunset and Gower in Hollywood, but had now moved to a space on the Warner Bros. lot in Burbank. There was a strong nostalgic tie for me at Columbia. It was never looked at as on a par with MGM, Paramount or Warner Brothers, but it was home to several members of my family. My great-uncle Lou Weinberg, my paternal grandmother's brother, had worked for the company in New York for his whole career, rising to circuit sales manager, selling all the major theater chains in the East - Loews, RKO and so on. Short, witty, round, cigar-smoking, able to push his bridge out of his mouth with his tongue to make his kids laugh, and able to tell us off -color jokes at the irritation of my oh-so-proper mother. He sold Columbia pictures to my dad who bought them for the most prestigious theater circuit in New York, and he was a great salesman. My dad's younger brother Leonard had produced a series of B pictures for the studio in the forties and fifties, including one hit that at the time of its initial release was the biggest success in the company's history, the now long forgotten *Bandit of Sherwood Forest* starring Cornel Wilde. My uncle Arnold had run Columbia's International division before he joined UA as a partner. So Columbia's history was connected to my early years, and now I was to be president.

I am a New Yorker. The business in L.A. always considered me that as well. Here's what I love: I love movies. I love seeing them. I love making them, I love talking about them. Here's what I don't love: *not talking about anything else*. There's another world away from the movies. I have never been sure that other world penetrates or exists in a way that works for me west of New York. Groucho Marx

said that when it's 9:00 p.m. in New York, it's 1937 in Los Angeles. That's funny. What I didn't find funny in L.A. was the extremely blurred line between perception and reality. I'll never forget a phone call I received from a young executive whose career I had encouraged. Several years after being on his own, he called to ask if I could tell him how he was perceived in Tinseltown. It made me very sad when he asked because it synthesized what seemed to be too important to too many people in the film business out there – not who they are, but how they are perceived.

So I had left the land of reality and moved to the heart of perception.

Welcome to Columbia. To *Leonard Part 6*, to *Ishtar*, to *La Bamba*, to Peter Sealy, and to my friend David Puttnam's abbreviated time as head of an American movie studio.

Driving on the Warner Bros. studio lot as president of Columbia Pictures was a very strange feeling. My family's lineage, my own experience at UA and Paramount, and now a third round running a studio as No. 2 to my friend the British film producer. The company had floundered for years, and this was not a company with the comfort factor for me of UA, where as diverse as the personalities had been, there was a lineage of professionals who understood the movie business and had long ties to it. At Columbia there was little left of any professional operation with the exception of Gary Martin, the pro who ran the physical operation. There was literally no one to work with. Well, yes, there was one. There was Peter Sealy. Formerly a marketing executive at the Coca-Cola Company, he'd been sent to run marketing at their motion picture subsidiary. From our first meeting, it was clear we were of two different minds. I'd been in the business for decades and was still learning, experimenting, and testing how to distribute movies. Every film was a distinct entity unto itself, and the challenging of distributing each one was to maximize individual audience-getting attention. There was not a "one-size fits all" approach. It required a combination of savvy, instinct, innovation, reinvention, luck, and a few other odds and ends to successfully market certain films. It took no genius to

sell a pre-sold title or a big-name cast, but it took a lot of hard work and imagination to make an offbeat film into a success. Peter Sealy thought he knew everything about marketing. Well, he did know one thing; how to sell a product that had been the number one-selling soda in the world. The same taste, the same famous bottle, having competition only from products that didn't have the iconic logo that was a piece of American pop art. I neither liked him nor believed he had a clue as to how to market movies.

Taylor Hackford, the fine producer and director, had developed *La Bamba*, a biography of Ritchie Valens, a Mexican-American teenager who broke through the charts at age 17 as a rock and roll artist. Directed by a Latino, Luis Valdez, with a soundtrack by the fabulous group Los Lobos, I green-lit the picture. It smelled like money to me. I have always believed that once a picture is green-lit, that's when the marketing begins. There was no way I could trust Peter Sealy to create a marketing plan for the film, so I made the decision to take it away from him and give it to Warner Bros. Records, who had Los Lobos under contract. I'd also give them them the soundtrack album. They loved the idea. Mr. Sealy wasn't happy, but I didn't care.

Scheduled for a theatrical release in August 1987, the goal was to have the impact of the single record release of *La Bamba*, as well as the soundtrack album already established by the opening day of the film. Fortunately Columbia had no record company and Warner Bros. Records was particularly excited to try this for several reasons. First, it would help sell their product, but even more, a Warner Bros. film's marketing campaign would never have been given over to the music and record subsidiary. There was far too much rivalry to permit one division to show up another. Here, with a Columbia picture, they could really show everybody just how powerful and innovative a music campaign for a feature film could be.

Warner Bros. Records timed the release of the single and album based on the August opening of the film, and guess what? The day the film opened in the United States, the Number 1 single was Los Lobos' *La Bamba*, and the number one album in the country was the soundtrack to *La Bamba*, music by Los Lobos.

In those years, there was an organization that predicted opening week grosses for each week's releases. Today the numbers might seem small, but then we were dealing with far fewer theaters, as well as lower admission prices. A $5 million box office would have been a very good opening. They predicted $3 million. Why? Because they never factored in the impact of the record-buying public. The picture did over $8 million opening weekend, and went on to become a very successful film. Peter Sealy never said a word that I remember. So that too was the good news.

All eras in the history of Hollywood had the power players of their times. In the sixties, agents such as Lew Wasserman of MCA and Abe Lastfogel of the William Morris Agency had relationships with the studios and producers that were sometimes confrontational but ultimately of necessity workable, and it had to be so. They were followed by Freddie Fields, David Begelman, Ted Ashley and Ev Ziegler. They all had to be dealt with, all had their favorites and not-so-favorites, but a working knowledge and a code of business conduct existed. In the UA days, our business with these men was done on a basis of trust. Our word was a deal, their word was a deal. If Abe or Lew or Ted said their client was committed, their client was committed. There was too much history to be any other way. As they slowly disappeared from the negotiating scene the deals got bigger, the small club faded away, and the new boys moved in. ICM and CAA were created. The stars had more say-so than the agents, and the agents flexed their muscles with more of an edge while still playing the game with the power brokers. Producers like Ray Stark had everyone's ear - studio heads and talent agents.

Onto this playing field came the new boy from London, David Puttnam. For him there was none of this "I kiss you, you kiss me back", no catering to the long-standing elite of the town, and we're going to do it with a British accent. The only problem was it couldn't work. You may not want to make movies with Ray Stark, but you'd better not ignore him. I've always maintained that in the film world "saying yes" only requires a good reason to "say yes" in the first place. What's far more important, however, is how you say no. That's what counts. David said no before he ever got to

know some of the players, and they didn't like it. Coca-Cola, who had signed onto David's plans for running the studio, caved at the first signs of trouble. I thought that what he was trying to do made sense, but I didn't want him to be so vocal about it. There are ways to say no. There are ways to make new structures within the system. Krim, Benjamin, Arnold Picker, and Youngstein had done it in a new way, and the town never knew what hit them.

David had been there for some months and he was already frustrated by the challenge. It was understandable. David had strong ideas about filmmakers and content, and he was dealing with a community that he was neither familiar nor comfortable with, and it returned the feeling in spades. There is a club in Los Angeles made up of "Who's On Top Now" that runs the show – the top studio heads, the top agents, the top lawyers, the top producers, director and performers. The deals, the winks, the problems, and the way it all works is familiar to those who are part of it. During my UA and Paramount years, my relationships were such that the nature of the business flowed easily – not always successfully – but fluidly. You knew the personalities – their strengths and weaknesses – and they knew yours. Of course there were minefields along the way, and there were sometimes confrontations or lawsuits, but it was done between personalities that you knew, and you knew when to insist and when to negotiate, when to accede, when not to embarrass, who needed a certain path to acquiesce, who needed their egos massaged, who could be moved by real emotion, who you could trust, who you couldn't, *and most importantly as a studio executive,* when to keep your mouth shut. No one cares about what you have to say, because nobody listens. There is absolutely no upside to announcing anything except the production plans.

The movie business in L.A. was a place where familiarity was essential, where knowing how the egos could be handled was essential. David knew none of this. He was indeed a stranger in a strange land, and he was talking out loud. By the time I got there, he knew already it was going to be a rocky road. The one thing I wished David hadn't done was talk about what his plans were for

the studio. I thought to myself, whatever we are going to do, let's do it and not hold press conferences about it. Hollywood doesn't like being lectured, particularly by someone they consider an outsider. His critics said he "shot from the lip" and talked too much not only about what he was going to do, but what everyone else should be doing too. David had no inclination or time for the niceties. Producer Ray Stark was one of the power players who couldn't be brushed aside, and David didn't pay him the fealty he expected. Was he right to do things his way? There's no easy answer to that, but David irritated the power structure and that's no easy thing to overcome. Shortly after coming to town, he gave an unfortunate interview saying he already had his contract expiration date circled on his calendar, and if he made good movies and they didn't work, he'd leave with his head held high, still be a producer and go back to his "day job". I truly believe that in a town that wants to print anything, but particularly anything that could be perceived as controversial, they feasted on the new Columbia Brit who came to town telling them how things should be done. There were forces at work against David's tenure before I got there, and they never went away.

But there were a few bright spots. Back in 1984, I met Spike Lee when I was producing *Beat Street* with Harry Belafonte. Spike had just gotten his master's from NYU's Tisch School of the Arts, and was also a fellow Knicks fan. I had tenth row, mid-court seats and invited him to come to a few games with me. He always said that someday he'd move from his nosebleed seats down to where I was sitting. Meanwhile, Spike had become one of Tom Rothman's clients at his former law firm, and when Tom moved to Columbia with me, we convinced Spike to make his second film, *School Daze,* with us. Both Tom and I believed in him, and still think *School Daze* was one of Spike's better films. And as for the Knicks, when I called Spike a couple of years later and told him I had two seats available if he wanted to move down and sit with me, he broke the news that set his path for years to come. He said, "David, I can't thank you enough, but I'm going courtside." And that's where he's been ever since.

There was also *The Last Emperor*. Bernardo Bertolucci had given the company a first look, and I traveled to London to make a judgment, having worked with the maestro on *Last Tango in Paris*. After the screening of his film at the Pinewood Studios outside London in 1987, I called David in L.A., told him it was extraordinary and we definitely wanted to distribute it. *The Last Emperor* won the Oscar for Best Picture that year.

My 30 months at Columbia were not the highlight of my career; some of the details are elsewhere in this book. Yes, *The Last Emperor* won an Oscar, but there was little else positive and it was clear that there would be no long run. Fay Vincent lived up to his reputation as a man of honor. David and Columbia were not a match made in heaven either. Even though Puttnam told Coca-Cola of his plans, the buzz among the entrenched Hollywood elite and disasters such as *Ishtar* and *Leonard Part 6* contributed to the ultimate demise. David and Coca-Cola parted ways.

It wasn't long after David left that Coca-Cola got out of the movie business. It turned out, to their surprise and chagrin, that it was not "another religion". It was a far-away planet beyond the reach of their largest telescope.

Hallmark Entertainment

"There are only two people that my father likes and respects: you and Walter Cronkite. And Cronkite's not available."
- Robert Halmi, Jr.

And with the those words I got into the business of making movies and mini-series for network and cable television. I use the word "movies" here loosely, for in the entire time I worked with the Halmis, not once in any conversation with any network or cable executive was I able to discuss a project in motion picture terms. Television was a different business, and none of the executives were familiar with or understood film as an art form, a business, or a craft. Not the content, the history, or impact of film was a discussable subject or frame of reference in any conversation. One of my favorite moments was when the head of NBC movies and mini-series Lindy DeKoven told me to make sure that the director of a particular show "moved his camera so we know the film was being directed."

Robert Halmi, Sr., the father of the gentleman quoted in the above chapter heading, is a remarkable man. Without a doubt he is one of the great characters I have known throughout my career. I first met him in 1972. An outstanding still photographer, specializing in the outdoors, particularly Africa, he came in to sell me an idea for a film based on a 11-page story he had shot for *Life* Magazine entitled "Visit to a Chief's Son." It was about his ten-year old son Bob, who had spent ten weeks living with the Masai tribe

in a village in Kenya. The stills that Halmi shot were extraordinary. I liked the idea of making this into a family-friendly feature, so I asked him how much it would cost and who would guarantee the over-budget. Without missing a beat, Halmi, Sr. replied "$600,000, and I will." We agreed, and I advised the business affairs people to make the deal with all our usual approvals – cast, script, director, budget, etc. It was then that I learned for the first time that you could never believe anything Halmi Sr. ever said. He was viscerally incapable of telling the truth. In fact, he knew neither how much the picture would cost or how he could guarantee the cost, but this character flaw came in an extraordinary package. He was smart, creative, charming, thoughtful (sometimes even without an ulterior motive), and the single best idea pitchman I've ever met.

Robert Halmi Sr. was born and raised in Hungary, but his background was fuzzy. Married, divorced, father of three boys, he was a fascinating man who seemed to live life well beyond his means. But no one knew what his means were. One other thing; he was going to make a film for us in Africa, and I wanted to go visit the dark continent.

This was where our friendship began. Robert's life was large, mysterious, and spectacular based on his determination, energy, and absolute conviction that he could sell anything to anybody. The picture was modest but well done, and our friendship blossomed. A trip to Iceland for salmon fishing to help me deal with my divorce; a trip to Panama for deep-sea fishing to celebrate some triumphant deal he had made to do a TV-series outdoors with Liberty Mutual starring the golfer Julius Boros. Robert filmed everywhere, and I enjoyed the benefits of his friendship, as well as the fishing. Bob Jr. grew up smart, with more than a little of his father's salesmanship talent. He decided to go into the old man's business and their company, RHI, was born.

Trying to summarize what Halmi Jr. and Sr. accomplished in television from the late 80's on would be a book in and of itself. They were simply the most successful producers of TV movies and miniseries in the history of the business. From *Lonesome Dove* in 1989, hundreds of hours of TV programming emanated from the company. Emmy nominations and awards, shows shot all around

the world, it was almost impossible to believe what father and son put together, and all that energy and drive continue to the day that I write this. A few titles can give you a feel for the magnitude and diversity of what they produced: *Moby Dick, Gulliver's Travels, Arabian Nights, Merlin, P.T. Barnum, A Christmas Carol, David Copperfield, Alice in Wonderland, Sweeney Todd, Gypsy, In Cold Blood, Journey to the Center of the Earth, The Sunshine Boys* – titles aimed for TV markets around the globe, shot on locations on four continents, and rarely stinting on production values or casting. This was the world I was now entering. How they operated, how they managed all this with a lean, small operation was almost beyond comprehension unless you knew the styles and personalities of this team.

A very smart business formula created ready and willing buyers in the U.S. network and cable outlets, as well as eager foreign markets, What made the company's products so attractive was the fact that RHI would spend maybe $8 million or $10 million to produce a high-quality movie or mini-series, but the networks, cable or foreign outlets were getting that same mini-series for a licensing fee of, say, $3 million for two or three showings. Think about selling each show in 10 markets - it was a good deal for everyone. The networks left them alone in their production process and got big TV names, giant production values, and for a long time, very good ratings. As long as the company could make enough good foreign deals, everything was rosy.

Enter Hallmark Cards, a name known to every American, ingrained deeply in the culture and language. Privately owned by the Hall family for three generations, based in Kansas City, Missouri and already well-established by the Hallmark Hall of Fame movies on CBS, they must have been sold and sold well by Halmi Sr. and Jr. They paid a lot of money for the company. The good news was the father and son had done well, but now they were part of an American institution that surely felt they could keep their financial eye on the new, highly visible, highly unlikely member of the family. I wish I had been able to listen in on those conversations between the Halls and the Halmis. The Halmis were irresistible, and the Halls bought it.

In this new structure, Bob said it would be great if I would consider joining the team to work with his dad. The challenge was appealing, the money was more than generous, the answer was yes. My title was President of Worldwide Production, but my responsibilities also included keeping company with Senior who liked and respected me. And Cronkite wasn't available.

Bob was busy running the financials of the operation, and working day-to-day with Dad just wasn't a reality for him, no less something he wanted to do. I was the answer, for a while.

No one told Halmi Sr. what to do. It was a company that he founded, a company he and his son had sold to Hallmark for many millions of dollars – what could be the problem? Well, the problem was clear to me pretty soon. Halmi Sr. would tell no one what he was doing. He'd sell a miniseries idea to the networks, make deals with the actors and writers and directors, and Bob would find out over the course of time, sometimes sooner, sometimes later. Maybe my presence would make it sooner rather than later. Maybe my presence could give his father time to catch his breath before making a deal, most of which he did almost immediately because he had neither the inclination nor the desire to make the best deal he could for talent with the most efficient budget for production. He had patience for nothing. He basically did what he wanted with whom he wanted, and left it up to Bob to make the numbers look good. And for a while, the newness of it seemed to work. I sat in his office while he wigged and wagged, selling ideas, buying talent, and committing budgets without any concern for the impact they might have on the company's business plan (as if they could have had one with him running his own show). He had a good time running his own operation, letting no one in on his deals until after the fact. Now he was enjoying the company of his long-time friend, for whom he had a real measure of affection.

The most exciting challenge and biggest disappointment of those years occurred when Senior asked me to come up with an idea for a special in late 1997 that we could sell for the Millennium. An idea as big as I could conceive. I did, and it was unequivocally a great idea, and it was simple: get the biggest and best playwrights that I knew and ask them to write up to a half-hour drama or

comedy that reflected their thoughts about the coming year, 2000. Witty, satirical, dramatic, whatever they wanted to write on the events of the new millennium. Senior loved it because he knew he could sell it to a network, which he did in one phone call. Here's a list of writers that I got to be part of what I truly believed could be one of the most important TV events ever produced. Short plays written by major writers that would attract big stars and directors that normally might not have done TV, but for this event, because of its timing, they would agree. And they did. I made the same deal with each writer, paying half their fee on delivery and the other half on production (with the additional clause that they would retain all rights if the production didn't go forward.) The network agreed to finance the costs. So here's who agreed in alphabetical order: Larry Gelbart, John Guare, Elaine May, Terrence McNally, Arthur Miller, Neil Simon, Wendy Wasserstein, and August Wilson. After some months, all but Ms. May and Mr. Wilson delivered their scripts. Some were perfect as written, some needed some cutting, one worried me; but overall I thought the package was remarkable. I don't know what Halmi thought about the content or if in fact he ever read them, but he sent them off to the network with his total support for the project. The answer came back in a few weeks. It was a pass. And the reason? They were too good for a TV audience, or some other rationale that the material was too highbrow.

With the rejection, Halmi lost interest. I begged to go to another network or cable outlet. This was too hard to sell, he said. Well, it certainly wasn't the third incarnation of *Gulliver's Travels* or *Journey to the Center of the Earth.* I believe it would have made TV history. But it never happened, and to this day I have never forgiven the TV network or Halmi for shying away from what would have undoubtedly been great TV programming. It reminds me of the joke about the rich lord of the manor in Victorian England who beds his virgin bride on their wedding night. "That was wonderful," says the no longer virginal lady of the house. "Do the poor people do it?" "Yes," says his lordship. "Well," she says, "it's much too good for them." Arthur, Larry, Wendy, and August are all gone now, but how difficult it was to tell these brilliant artists that their

work had been rejected by the network and Halmi. They were simply much too good for them.

In his seventies, Halmi Sr. had boundless energy and, as far as he was concerned, unlimited funds at his command. He had a very full plate. His office, run by his long-time assistant Kathy, was a source of no information for anyone until well after the fact. The business affairs and legal departments were a merry-go-round of playing catch-up. I listened, occasionally offered suggestions, and traveled with him. He felt comfortable on filling me in with his likes (a few), but mostly his contempt for those with whom he had to do business. "He's an idiot, she's an idiot" was his usual description of the agent or TV executive he felt he'd last outsmarted or out-negotiated. The problem was, because he had no patience, he very rarely made a good deal. Closing a deal was more important to him than making the best one, and saying "no" sometimes meant you couldn't make the deal, and that was not his style.

Slowly I began to suggest that we could still get what we wanted if we played our cards a little differently. The beginning of the end came when he decided he wanted Jon Voight to star in a mini-series about Noah and his little trip on the ark. Jon, who I knew from my days at UA with *Midnight Cowboy,* was not exactly at the pinnacle of his career then, and the chance to get this role was a real opportunity for him. Based on my research, I figured we could probably get him for around $500,000. I walked in to tell Senior this information, and he told me he'd just closed a deal with Voight's agent for $2 million. I couldn't believe my ears. I told him the deal made no sense; not only was it overpaying an actor who, in my opinion, would have accepted any reasonable offer since he was not in demand in features anywhere. The lead in a mini-series would be attractive to him, but in vastly overpaying, the company was negatively affecting the TV salaries of the entire industry. He didn't want to hear any part of it. His response was he made the deal quickly because that's what he wanted to do, and he wasn't interested in hearing any comments on what could have been done, or what impact the deal could have in general. He basically said he didn't give a shit about my point of view. From that moment, our relationship changed. Soon Senior's

schedule was unavailable to me, and I wasn't invited to meetings. It wasn't that he didn't like me; it was the mere fact that I knew what he was doing and was commenting on it, judging it; a form of account- ability that he was not prepared to accept. It took only a couple of weeks for me to realize that the like and respect still remained, but the accessibility was over, and it was over *completely*.

I went to Jr. and told him I couldn't deal with his dad anymore. He smiled and said he wasn't surprised; let's just move on. "Moving on" meant taking over the production of some of the many shows they had. Having gotten my feet wet in the television business, I could supervise a number of productions and Jr. would know that the company was protected both in quality and cost, balancing the unpredictability of whatever his dad was doing.

For the next six years I produced for the Halmis. No one has ever treated me more fairly than Bob, to whom I will always be grateful. With my day-to-day involvement with Senior over, our relationship reverted to polite disinterest on his part. He was doing things the way he did, and no one else was involved except his son, who had to deal with the impact. Bob's skills at overseas dealmak- ing with the networks and cable kept the company active. Then there was the Hallmark Company. By name alone they define the need to send or receive loving or caring thoughts. You've said the name, heard it on dramatic shows, in comedies, in crossword puz- zles, and it is established in the minds of the public from birth to marriage to funerals to bar mitzvahs.

I had the fun of getting to see how the card company operated, visiting its Kansas City operation more than a few times. I got to know a few of their top executives and liked most of them. I never got to know the Hall family, who founded and privately owned the whole shebang. Their small, but very visible, TV division that made the Hallmark Hall of Fame two-hour movies for CBS was totally separate from the Halmi operation. Communication between the two TV entities might have benefitted each other and maximized their companies' negotiating position, but it never existed, and they felt a deep resentment towards the parent's acquisition of the Halmis' operation.

Bob handled the corporate relations, but I learned enough of the card company's operations to be fascinated, and I was challenged to see if there were ways to maximize any synergies that could be established. In the Kansas City headquarters there was an office building with about 700 creative executives designing various products. Cubicle after cubicle of stylists, copywriters, calligraphers, all designing the next set of Hallmark cards to be sent to their own stores as well as other greeting card outlets. Although I never got all the details, it seemed to me that space on the shelves was determined by how many cards are sold per inch or something like that, and that each team of designers made up of specialists in all the categories, fought to get their stuff out on the shelf. As I got to know some of the people, one group came up to me and suggested that since they were designing cards that reflected characters and a story line, if we could sell their storyline as a movie of the week, it would help get their concept on the shelf. The storyline was a version of *Out of Africa*, a woman who moves there and the cards follow her life through weddings, births, etc. How amazing that the synergy might work the other way around, but it never happened and to my knowledge the line never got to the shelf.

Creatively, TV movies and mini-series are different from features. I found that my ability to work with talent stood me well, and my pride in delivering quality work at pre-determined figures worked well in TV. That's the good news. The bad news is that in TV movies and mini-series land, once a show is seen, it's over. Of course, *Seinfeld* and *Two and a Half Men* and all the various *Law & Orders* aside, there's not a lot of satisfaction in making something worthwhile, demanding time, energy, care and dedication, then seeing it disappear immediately. Of course that was my problem, not the Halmis'. They were in the TV business and that's the way it worked. Halmi Sr. made his mini-series; I made mine. Talent, performers and caring creative artists, work hard in the moment, and after that moment their work disappears pretty much forever. If the time slot is wrong, if by chance the competition at the same time is hot, if the marketing for the show is non-existent for reasons that have no relation to the show itself, it's over. Reviews are meaningless because no one cares.

I believe the best of TV is extraordinary. A show like *Downton Abbey* is an education about what quality can be. Every aspect of that show from writing, casting, directing, performing, cameras, music – everything is brilliantly designed and executed. The TV and mini-series business at RHI was exactly that – a business. Sell it, make it, sell another, spend a lot of money, get a lot of money, and get on to the next.

I took pride in what I did, but I could never get over the fact that after the time it first appeared, it was basically over. The sale was the thrill, the cost and size was the thrill, but there was no life beyond. There was no impact on the audience that you could feel. I worked with craftspeople that I liked and respected, and I delivered some good shows. There was one that was special.

Bob called me in one day and asked me to read a script that Lindy DeKoven, head of TV and mini-series at NBC, had sent over. It was the story of the singing group The Temptations. I read it that night and liked it very much. Here was the challenge: the producer, Suzanne de Passe, had come in with a budget of over $15 million and it was way too high. Lindy wanted to know if Hallmark would take it over. I told Bob we could do it, but based on the NBC license fee, how much could we afford to spend on the show? Bob said we had to get it down to $13 million. I agreed to meet with Suzanne's production team and see what could be done. Her strength, and it was a real one, was on the music. As part of Motown, she was well-connected and knew the right people. Her production partner Suzanne Coston, a good lady, was simply not experienced enough to deal with a production as complex and challenging as this one, and the project's creative commitments were underway.

Something had to be done quickly. I believed that my early years at UA when I first took over the record music business played a big factor here. I knew Berry Gordy and had our first hits with him, so I was determined to see if this project could be saved. I flew to California to meet with de Passe and the director Allan Arkush. I have always been a sucker for creative talent, and I bonded right away with Allan. It took only a few hours, and I knew I had to find a way to get this show delivered. Allan was a very experienced TV director, but far

more interesting than that was his knowledge and love for the music of The Temptations. Allan was so deeply committed to the music of the era that as a young man he had blown out his eardrums listening to music, too loud, all day. He knew everything you could possibly know about their music and how they had become the stars of the Motown stable. He had been rehearsing the actors that had been cast for weeks, getting the moves down and the sound right.

The boys were really great, and my enthusiasm soared. I told Bob we had to save the show, and we did. Changes were made, the budget was reduced to $13 million and the show got green-lit. Detroit didn't work as a location, it was simply too expensive, so the Motown world was re-created in Pittsburgh and a long, grinding, challenging shoot began. Allan's prep with the boys was encouraging and Suzanne came through with the music, delivering an original Smokey Robinson song that led to a lovely moment in the film. Mostly it was Allan and the boys. His staging of the musical numbers and development of the individual characters is what made the show so impressive. In one number, "Papa Was a Rolling Stone", an entire segment between commercials was dedicated solely to the recording of the song, and Allan shot it in a style so unlike TV moviemaking I think it stands up with some of the best work I have ever seen. The show was a great success and after three showings on NBC, VH1 bought it from Halmi for millions of dollars. To top it off, the show was nominated for an Emmy, as was Allan Arkush, and the night he won, I was one proud executive producer. It was the highlight of my TV life, and to this day I can watch it and know it represents the best of its kind.

All things come to an end and in 2004, my career in TV ended. My friendship with the Halmis endures. They are no longer part of Hallmark. Senior is still making mini-series with Sci-Fi, FX, and channels around the world. He's the last angry man telling the world they're all idiots. A kidney transplant, two knees made of plastic, and a tongue that still spills acid. But he's still the captain of his ship and his son is still shaking his head. They don't build them like him anymore, or like Bob. They continue to be two of a kind.

Produced By

"Happy Valentine's Day!"
- Valerie Perrine

Here's the single most difficult challenge in analyzing how much anyone listed in a movie's credits has contributed to the film. You pretty much know what the cameraperson has done - or you should; makeup - easy; costumes - not too hard; editors and screenwriters - if you're a little sophisticated; teamsters - you probably can figure that out, too. But Producers, Co-Producers, Executive Producers? I defy you to know the real contribution of the people with those titles on any specific film unless you actually, and I mean *actually*, worked on that specific film.

So here's who the producer is, or should be: he or she is the person who has the belief in an idea for a movie and is responsible for developing it from its original source to life on the silver screen. Now, I understand it's rarely as simple as that, but in the ideal world the producer has taken the idea and put together the team to make a film - from writer to director to cast and crew. He or she will eventually work with the financier or distributor in planning the film's release. That's the ideal definition, but in today's world it's never as simple as that. When the studios controlled most of the product it was relatively straightforward. In today's complex world of financing and distribution, credits are far more complex and there are no rules of thumb. Producer, Co-Producer, Associate Producer,

Consulting Producer, Executive Producer are credits that can be granted ad hoc to anyone who has the muscle to get it. In a recent situation the financing partner wanted to give co-producer credit to his sixteen-year-old granddaughter. You often see an actor's agent with a producing credit. There have also been somewhat infamous examples of producing credits going to a star's hairdresser and personal trainer. See what I mean?

How do we know who, in fact and practice, worked as the Producer on the movie? The Producers Guild of America, not a union but a collective advancing and protecting the rights of producers, has recently come up with a definition of producing responsibility that must be met in order to get official credit and an identifying mark for those producers who *actually* produced their films; and the major studios have agreed to support it.

Having said all that, I thought I'd share some examples from my most interesting and challenging films as a producer:

Lenny (1974)

I understood a lot about the movie business. I knew marketing, international and domestic distribution, script development, production financing, and talent on every level from directors to writers to actors to agents. I knew producers - some terrific, some incompetent, some in between. I'd visited sets, seen dailies and rough cuts, talked content to filmmakers in detail, but never, not once, had I produced a movie myself. It was time.

As my time at United Artists came to an end, I began my three-picture producing deal; no approvals on content or cast, with the only condition being a budget limitation that was more than sufficient for my needs.

My first choice was a script I had acquired from the writer/producer Richard Alan Simmons with Don Medford attached to direct, but nothing seemed to be happening with it. It was agreed I could take it over from them. Its title was *Juggernaut*, about a bomb hidden on a luxury cruise ship by a madman blackmailing the shipping company. Exciting, visual, castable. It seemed a natural and fun. The other two projects were to be agreed upon. I was

set to go to London to put it all together when Sam Cohn, the uber-agent in New York in the 60's and 70's, came by to see me.

I had recently made a deal with him for Bob Fosse to produce and direct the hit Broadway show *Lenny*. Fosse had acquired the rights himself from a successful television writer/producer named Marvin Worth. Marvin had known Lenny Bruce's widow Honey and her daughter, acquired the rights to Lenny's story, and co-produced Julian Barry's script *Lenny* on stage. Sam said that when Fosse heard I was leaving UA as an executive, he wanted me to join him as producer on the film. The deal was simple. Fosse would have total control, but would rely on me to work with him as producer and partner. It was irresistible, exciting and, of course, I said yes. But what about Worth? No problem. Worth had the title "producer", but Fosse had taken complete control and Worth could visit the set once during the production. In other words he had his title, his piece, his fee, but no involvement in the production, distribution, marketing or anything else.

I called Marvin and asked him if he would share the producing credit to read "Marvin Worth and David Picker". He said no. Could I have made an issue out of it? Probably. And legally I would have prevailed. I guess looking back I just didn't want the aggravation, so I became Executive Producer. What a mistake. Even now, thirty years later, I still regret that decision, mostly because he lived off his credit for the rest of his life. All those Academy nominations on *his* wall, etc, etc. etc. He's gone now, but clearly he was pissed at Fosse and me, and to the day he died he dined out on having produced *Lenny* when, in fact, all he had done was sell his rights *not to produce it*. He didn't even visit the one day he was granted. What it proves, however, is that credits don't mean a thing unless you know the story behind them.

I'm producing my first movie. I know what I want to do, and what I said to Bob was simple. "I'm here for one reason and one reason only: to enable you to make *Lenny* exactly the way you want to. I'll give you my opinions and insure that the team we put together is the best it can be. I'll watch the budget, I'll work with

the cast and crew. I'll do anything and everything I can - and I'll never be able to thank you enough for giving me this opportunity." He welcomed me along for the ride.

The budget that I had approved before the transition from behind the desk to behind the camera was $3.25 million. Dustin Hoffman had signed on for $750,000. Bob was getting $200,000 and so was I. Dustin Hoffman was set. The script was locked. The rest of the cast and crew were next. Bob wanted to use Geoffrey Unsworth, who had won the Oscar working with him on *Cabaret*, as cinematographer. There was, however, a problem. Mr. Unsworth was an Englishman. In those years, the union representing DPs in the eastern half of the US had approval of anyone who did not reside within their jurisdiction, and they refused to permit this talented Brit to take a job from one of theirs. We said we'd pay one of theirs *not* to work, but they refused, so Mr. Unsworth was out.

The next choice was Bruce Surtees from Los Angeles. He was approved by New York under a reciprocal deal they had with the west coast. The production manager and assistant were as good as New York had to offer: Bob Greenhut and Neil Machlis. Hair and makeup came from Bob's theatrical experience, the aforementioned "Salad Sisters", Fern Buchner and Romaine Greene. Casting was Marion Dougherty, simply the best. The big challenge was who was going to play Honey Bruce, Lenny's wife. Two hundred actresses came in to read for the role, including Raquel Welch, who we read as a courtesy to her agent. Her career was hot at the time, but in no way an option for Honey. Barbara Hershey, seven months pregnant, came in to read (a little bizarre). The field was cut to seven, and Bob decided to film test each one.

A small suite in the Warwick Hotel on Sixth Avenue and 54th Street was rented and the tests were shot. The choice came down to two wonderful actresses as divergent in their approach to the role as one could imagine. Jill Robinson, who sadly died in a fire some years later, exquisitely tender yet with a spine. Valerie Perrine, real, gritty, sweetly, tragically weak, but a knockout physically. And their tests showed them at their best. Bob was on the fence, though I always believed Valerie was his first choice. He decided to show

the tests to Dustin, so one morning in the UA screening room the three of us looked at them. When the lights came up Dustin looked at us kind of stunned. The film was coming to life. "So?" Bob asked. "Valerie," Dustin answered. Valerie got the role.

Dustin Hoffman is an incredible talent. The world knows that. What they don't know is what that really means because all they see is the end result. This is what he did for months before we even started rehearsals. Yes, *Lenny* the movie had three weeks of rehearsals - an almost unheard-of process in filmmaking then and now. But Bob wanted it, Dustin wanted it, and we built it into the budget. Even before that, Dustin made a decision for himself. Lenny Bruce performed his routines before live audiences. On Broadway there was a live audience every night, and Cliff Gorman, who played the part, could play off a different audience every performance. But we were making a film. We had to film Lenny's routines on a set, even if that set was a real nightclub, and we had to do each one several times at least. Dustin had obviously never done anything like this, so on his own, with no publicity, Dustin ventured forth into this unknown world of live standup. He hit small clubs where he could do live performing to feel it, experiment with it, test himself. I never went to one, nor did Fosse to my knowledge. This was Dustin doing his homework.

We decided to shoot the film in Miami Beach. Why? One reason. When filming a comic routine before an audience of extras, the first take is new to them and they'll react naturally as they should. They might, even with a few changes in the material, react naturally a second time. More than that, no way would we get the response that Fosse felt would be natural and spontaneous enough to make Dustin comfortable. It was decided that no audience of night club extras would hear more than two takes. Multiply that by the size of the audience needed for the scene, the length of the routine and so on, and you get thousands of extras needed for *Lenny*. Miami Beach was not covered by the actors union SAG for extras, so we were free to negotiate the price ourselves. The deal was $25 a day, and we had thousands of extra available to us at a price we could afford. One other factor went into the decision.

Although we were shooting in Miami, the routines in the film were taking place in New York City, the Catskills, San Francisco, Los Angeles, and so on, and the extras had to match the venue that was being shot on any particular day. They were in no more than two takes, they must look location-appropriate, and must agree to a full day's work for $25; I decided I could only trust myself to cast extras. Bob didn't have the time, and I wasn't going to leave it to a Miami extras casting office. So I personally picked through several thousand faces saying "New York, LA, Catskills, San Francisco, not right".

We also had one other challenging decision. There's a scene in the film with a ménage a trois between Lenny, Honey, and another girl who has to appear both nude and comfortable in a very erotic scene. And once again Bob trusted me to get it right for him. It meant potential actresses had to come in, strip to the waist and discuss their comfort level about the scene with me. Needless to say, I always had a female assistant in the room. It came down to two choices, but because one of them was built more like Valerie we offered her the job of Valerie's stand-in and the other girl with the greater physical contrast got the job in the film. It was very delicate stuff.

Other secondary roles were cast, and the part of Lenny's mother went to Jan Miner. Bob never seemed happy directing her, never quite satisfied with what he was able to get, but we had simply never seen anyone we liked better. The key role of Lenny's manager was difficult. It was decided to cast in Miami to save money. George DeWitt, a standup comic, came in and blew us away. He got the role.

It was near the start of shooting, and again the unique challenge of filming *Lenny* was facing us. In Lenny's later years he grew a beard and, of course, it was during that time that all the bad stuff started to come down on him. Bob and Dustin correctly decided that a makeup beard would work against the realty of the film. Okay, so what? Well this is what. You have to shoot all the bearded stuff first because you obviously don't have the luxury of time to shut down production and grow a beard. Okay, so? So this. That means the later stuff when Lenny's humor had evolved into bitter diatribes

and dismal failure all had to be shot first. Not easy for the production, and very hard on Dustin. But Dustin is Dustin. He understood, agreed and it was scheduled. Five days of him doing routines from the sad end of Lenny's career - with a real beard.

It's the first day of shooting. Bob and I are staying at the Jockey Club in Miami Beach. Dustin has a suite at a hotel on the ocean. Bob has asked me to drive him to the set each morning so we can chat about the day. His routine is simple. He wants to be on the set thirty minutes before crew call so he has time to quietly absorb the day's work alone on the set. Done. I'll be downstairs at 6:30 in the morning.

The phone rings. I look at the clock. It's 5:30 a.m.. "It's me. We've got a problem with Dustin. Meet me downstairs in ten minutes, we're going to see him."

"I'm not funny." Those were Dustin's first words as we walked into his suite. "I'm just not funny." After an hour Bob had convinced him that these routines with the beard toward the end of Lenny's career were not the sardonic, brilliantly funny style of the early Lenny. This was tough, bitter stuff, yet laced with humor, but hard and angry as well. And there were three different routines to be shot in the first few days. Dustin finally agreed to do a different one than originally scheduled even though he wasn't quite as comfortable with it. Bob convinced him he'd be fine and we got past the brilliant actor's understandable terror not only of performing in front of a live audience but also a rolling camera.

And so began an eighteen-week, six-days-a-week shooting schedule. And Dustin working every day but one.

In the mid-70's, 99.99 percent of films were shot in color. Bob wanted to shoot the film in black and white and I had okayed that when I initially made the deal. No problem. Well, yes there was a problem. Kodak, who supplied our film and was based in Atlanta, agreed that they would deliver enough black and white stock for our needs. Little did they, or we, know at the time what that would entail. Negative available for each day's workload gave you about 11-12 minutes of shooting time on each reel. On all the standup routines, in order to maintain the spontaneity, and give himself as

many editing options as possible, Bob would shoot with two and sometimes three cameras. The routines might run as long as 5, 6, or 7 minutes, so very often you could only get one take on a reel, leaving many short ends (unused but nonetheless paid-for negative). On *Lenny* we shot over 1,350,000 feet of film (this was required for editorial content, not directorial indulgence; see "Elaine May"), all black and white, for which in those days Kodak had no inventory. They were making raw film just for us. There were days when we were down to a thousand feet of film, and had a driver at the Miami airport waiting to pick up the shipment from Atlanta and bring it directly to the set.

At the end of each day's shooting, we'd ship the negative to Atlanta for processing. It would be returned within 24 hours, so at the end of the second day of shooting, Monday's "dailies" were scheduled to be screened. Usually the producer, director, editor, and department heads attended the screening to check their work out on a big screen. Today everything is computerized, but then it was a scheduled rite. So everyone showed up after a long day on the set. Bob had chosen his "selected" takes and we all eagerly awaited the results; in this case, Dustin doing his first routine as the bearded Lenny. The lights dimmed and two and a half hours later they came back on. Two and a half hours of dailies. That was the last time anyone showed up other than Bob, myself and the editor. It was just too much after a long day's work. After a few nights it was too much for any of us and we left it up to the editor, Alan Heim, to make sure everything looked good.

We got through the first week, and now Dustin could shave his beard and we could move on. It was the first day to shoot with George DeWitt playing Stanley Kaufman, Lenny's manager. He arrives, he's nervous, I can see it, I can feel it. When we shoot I'm often on the set, just in case there's a problem. I've got the team of Greenhut and Machlis in the production office. I want to be near Fosse this morning, but not too near. This morning there's a problem. Bob calls for rehearsal. DeWitt is unsure, uncomfortable, jumpy. I see Bob trying to calm him down. It is, after all, a new gig for George and he's not familiar with the way things work.

But soon it's obvious, it's not going to work with George. Too many questions, the words don't come out right, and after a half hour or so Bob turns his head to where I'm standing in the back, stares at me and I read his eyes. George has got to go. Back at the office I call Marion Dougherty to think of some alternate ideas, and I call Stanley Kaufman, Dustin's manager to fill him in and get input. I go back to Bob, bring him up to date and he says to me, "I think Stanley did some acting. See if he's interested." Who knew? The next day Stanley Kaufman, Dustin's manager, replaces George DeWitt as Lenny's manager. And that's the way it goes.

It was a tough shoot and a long one. The work was exhilarating but exhausting. There were two highlights, both unforgettable.

Valerie's first day of shooting was February 14. She's scheduled to do a strip tease number in a cheesy night club where Lenny sees her for the first time. It promised to be exotic and erotic. Shortly before her call to the set, the second assistant director tells Bob and me that Valerie wants to see us in her dressing room. Uh-oh. Her first day. Was this to be a repeat of the nerves Dustin had shown a few weeks before? When we open the door to her dressing room, Valerie is standing in front of a full-length mirror wearing a lovely short silk robe. She has a big smile on her face. Instantly I felt relief. "Close the door," she says. It's impossible to take our eyes off her, so I just kick the door shut behind me. Smiling, she says, "I want to wish you both a Happy Valentine's Day," and with that she slips off her robe and stands there totally naked. I gulp. She is magnificent. Then both of us break out laughing as we see her Valentine's Day gift. She has shaved her pubic hair in the shape of a heart. Valerie is a true beauty, a force of nature, pure, demure, and totally sensual, all wrapped up in a bundle of beautiful womanhood. Who could forget such a moment? Who would want to?

Dustin Hoffman. Here's what great actors do. There's a scene near the end of the film in which Lenny is an utter failure. Drugs have taken over his life, the addiction that would soon lead to his death. He's appearing in a nightclub where only 10 people have shown up. He has stripped himself of any pretense or professionalism and staggers on stage raving and ranting, dressed only in his

raincoat, shoes and socks. He's a drugged-out mess of a human being. Although Fosse had three cameras covering the take, it was pretty clear to both of us that the whole scene should not have a cut in it; that one angle would provide the movie audience with the total discomfort they would have felt had they been in the night-club itself. It is also hard to think that Dustin could do more than two long takes. It was tough stuff. Dustin had asked that we sched-ule the scene for a Monday shoot and although we were shooting six-day weeks, could he possibly have at least half of Saturday off. Since he was in almost every scene, it was a difficult request, but somehow we found a way to make it work. Half of Saturday off, Sunday off, and Monday early the big scene. He didn't explain why he made the request. He didn't have to; it was enough that he asked.

Monday morning, Dustin's call is 8 a.m.. We've got the set ready for Lenny to do his thing.

The second assistant director says "Dustin has arrived." We all wait ready for whatever he needs. The door opens and Dustin walks in. He is accompanied on each arm by an assistant. He is not walking steadily. I can see Bob is concerned.

"Are you okay?" he asks.

"Yes," says Dustin. "But I have to play this stoned. I couldn't take drugs so I decided I'd stay up for the last three nights, and these guys have been keeping me awake." And that's how Dustin played it, sleepless for 72 hours, out on his feet, stoned from lack of sleep. Just look at that scene. One take, one camera, no cuts to break into the reality. Dustin was nominated for an Oscar for that performance, and the film received a total of six Oscar nomina-tions, including Best Picture, in 1974.

Juggernaut (1974)

Producing is really fun if you look it as a constant challenge. How can you get the most for the creative goals of the director, while at the same time being economically responsible?

Here are a few examples of how challenges can be met. *Juggernaut* is a classic tension-filled thriller about a madman

blackmailing a shipping company by threatening to blow up a cruise ship filled with holiday travelers. It was directed by the brilliant Richard Lester, starred Omar Sharif as the ship's captain, and Richard Harris as the lead British commando trying to find the bomb and defuse it. Most of the action took place on a ship at sea, and Lester and I felt it was imperative that we actually get one to be our floating set. With such a real prop, the suspense of the story could play to its utmost believability.

A deal was struck with the German American Line to use their ship the Bremen during one of its cruises. We would have access to the entire ship as needed and we could house crew, cast and enough extras to add to the paying passengers and make it appear real. Preparation for the film began, and then we received a telex from the shipping line saying they had sold the Bremen to a Russian company who were renaming it "Maxim Gorky". By contract the Russians were not obligated to honor the deal we had made with the Germans, but after some consideration, they said they would permit us to shoot the refitted Maxim Gorky on a ten-day shakedown trip where they were giving the captain and crew a chance to familiarize themselves with their new charge - the only problem was there would be no passengers. We agreed, and I came up with an unusual idea. Let's get people to pay us to go on a cruise *and* be extras in the movie. We'll give the money to the shipping line and it will give the new Russian crew, chefs and entertainers a chance to familiarize themselves with actual passengers. They happily agreed, and we advertised A CRUISE TO NOWHERE, £250 per person for a full eight days at sea. It sold out overnight.

I was preparing *Lenny* at the time, but I was able to fly over for the ship's departure from Southampton. In one day the Bremen had become the Maxim Gorky, then the next day it was the renamed "Brittanic" for shooting. Before the departure we gave the Russian captain a Rolex watch as a gift for his cooperation; he was ours forever. Three cameras covered the boarding and as I watched the ship sail away, standing almost alone on the wharf in Southampton, I felt such envy that I couldn't share the next week with my friends onboard.

The Cruise To Nowhere went smoothly, although I gathered subsequently that there were several divorces, a few pregnancies, and various other social challenges attributed to that unique enterprise. The extras paid *us*, and the cost of the ship was so negligible as to be almost embarrassing. The Cruise To Nowhere was what producing can do.

Smile (1975)

Smile presented a different challenge. A satire on beauty pageants in small-town America, it was written by Jerry Belson and directed by Michael Ritchie, who had made *The Candidate* and *Downhill Racer*. The big challenge on this film was the casting. Ten teenage girls were featured as the entrants in The Young American Miss Pageant. And we wanted fresh faces. Marion Dougherty recommended that we use four professionals and the balance from the local area of Santa Rosa, California, our location. Bruce Dern was the star and Michael Kidd, the brilliant Broadway director/choreographer, was set as the director of this low-level pageant. We used a local choreographer to stage the events because Michael would have been creatively unable to stage the mediocrity we needed. It occasioned a lot of inside laughs. The major challenge faced was the intermingling of the four professional actresses with the local amateurs. All the girls tried their best to make it work and, for the most part, they succeeded. There was one hurdle we had to face, however, and that was who was going to win the contest. Deliberately the script did not indicate the winner. In fact, between Michael, Jerry, Marion and myself we decided not to make the decision until just before filming. It goes without saying that the professionals from Los Angeles thought it would be one of them, but the subject was simply not up for discussion and it added a terrific competitive edge to the show.

Finally the day came for the winner to be announced. The night before, Conrad Hall, our Oscar-winning cameraman, Jerry, Michael, Marion, and I met to make the big decision. It was unanimous *not* to have the winner be one of our professionals. It was to be a local, and her name was Sean Christensen. The one thing that

would make the revelation work on-screen was if nobody knew who it was until the name was spoken. The first take had to be perfect. The plan was simple. Seven cameras and at each camera, one of us to tell the operator who to focus on. One wide, four on our pros from LA, and two on the locals, one tight on Sean. One take to get real reactions, and did it work! *Smile* is really an under-appreciated film, one United Artists was never sure how to market. To this day I'm proud to have produced such a terrific film. If you haven't seen it, you should. And when the host announces "The winner of The Young American Miss Pageant for this year is ... Sean Christensen", perhaps you'll choke up like we all did.

One added note - and not a minor one. Working with hundreds of actors over the years you learn to deal with their needs, idiosyncrasies, egos, and their impact on the chemistry of each film. There are the totally positive, the selfishly negative, the grateful, the thoughtful, the secure, and insecure. And then there is Bruce Dern. Unique is the most misused work in the English language. You can't be *very* unique or *somewhat* unique. You can only be unique - one of a kind - or not. Bruce Dern is unique. He is totally dedicated to his work and his connection to his fellows actors. He gives his all. And when it's over he gets in his car and leaves. Usually with no goodbyes because I think they are too painful for him. His talent, generosity and commitment is a wonderful thing. As is his friendship.

The Crucible (1996)

The final decision as to where a film is to be shot is based on content and cost. The days of shooting everything on a backlot are long gone. Naturally, studios want their lots used because it supports the cost of having the lots in the first place. But reality has taken precedence in the last few decades, and now with CGI assistance, anyplace is reachable.

The Crucible is the play Arthur Miller wrote using the Salem witch trials of the late seventeenth century to espouse his anger and venom at a society that permitted the McCarthy witch hunts of the early 1950's. The film was the second in the career of the now

Sir Nicholas Hytner, the stage and opera director whose first film was *The Madness of King George.*

The challenge now was where to shoot the film. Salem, Massachusetts, and its neighboring towns on the Massachusetts coast, Danvers and Ipswich, would have been ideal. Shooting on the East Coast, however, could be extremely expensive, so our first choice was Canada. We scouted New Brunswick, Newfoundland, and Nova Scotia and found nothing that worked. Desperate, we hired a location manager to scout Massachusetts, and he found what seemed to be gold.

Just off the coast of Ipswich was an island owned by a charitable trust. It was uninhabited, having only one small wooden shack for hikers who might be caught in a rainstorm. Its only access was by boat and there was only a small wooden dock that could handle an outboard craft at best. We scouted the location with our production designer, Lilly Kilvert. There were open fields, wooded areas, stony beaches - all perfect to re-create 1792 Salem. The distance between the mainland and the island's dock was about 500 yards. Not far from the dock on the mainland was an abandoned state facility, formerly an institution for the mentally ill (in other words an insane asylum), that had been closed for decades. The administration building could house all the production offices necessary to manage a show as complex as *The Crucible,* as well as hair, makeup and wardrobe.

The Massachusetts Film Office had found all this for us. It was terrific. It did, however, have one problem, and it was a big and expensive one. How were we to get the cast and crew and up to 400 extras in some scenes over to the island? All movie transportation was under the control of the Teamsters union, and they were famously firm for insisting on their rights to the last decimal point of their contract. (As an aside, I must say that in my personal experience with New York Teamsters, I'd had nothing but terrific relationships. I knew them, they knew me, and we trusted each other.) We needed some help here, and once again the Massachusetts Film Office came through. Knowing that having *The Crucible* made there would bring millions of dollars to the state, we went first to

the Massachusetts National Guard and asked them to provide the film with boats and ferries to transport the large cast and crew back and forth from the mainland to the island. Then we needed the Teamsters to give us a waiver allowing the National Guard, not Teamsters, to run that large part of our transportation. They understood the economic value of the production to the region, agreed, and everybody won.

Then came the reality of what we had achieved. Hair, makeup, costume for all the secondary and tertiary roles, as well as extras would be done at the asylum. Principal and featured players would be on the island, stars in their own trailers, the rest in a large tent. Because the film took place in the 1690's, costume call for extras had to be done hours before the shoot. An hour to get everyone dressed, touched up if necessary, down to the boats and across to the island was a huge organizational challenge. It meant a four a.m. call to be on the set ready to shoot at seven. It meant a long shooting day, back to the boat, back to the asylum, undressed and home. It meant double costume, hair and makeup crews, because not only couldn't the show afford overtime, a single crew couldn't survive the hours. With the help of Diana Pokorny and Mary Jo Winkler, our production managers, the torturous challenge of how to make the location work was solved.

Of course on every show there are challenges. On this one I had a big problem with the cinematographer that Nick had picked. His choice of Andrew Dunn was understandable. A fellow Brit, he had shot Nick's only other film. I found him distant and uncooperative. He seemed resentful of any conversation with "the producer." At dailies he huddled with the director in a corner and no one was let in. In addition, I found his choices for the balance of his department, all from Atlanta, bizarre. I had shot there several times and had first-rate work on the low budget work I supervised. This was a big studio film, New York was only an hour away, yet he chose Atlanta and his choices were, in some instances, dismal failures. We were constantly changing camera personnel, many shots lost because of poor work in movement or focus. All in all I thought he was a disaster. Nick protected him, I believe, more from friendship

than performance, but I was unable to do anything to resolve what I thought was a real weakness. Arthur Miller visited the location several times. I got the feeling that he really wanted to stay for the entire shoot, but he recognized that he would be an unnecessary distraction. On his initial visit as we shook hands he said, "Do you remember we've met before?" I almost choked. Of course I remembered. Who could ever forget Gable, Monroe and the night with Sinatra? And irony of ironies, it was on the set of *The Crucible* that Daniel Day-Lewis met Arthur's daughter Rebecca and subsequently married her.

Daniel Day-Lewis, Paul Scofield, and Joan Allen: their names say it all. They are world-class, a tribute to their craft, their art, their humanity, their graciousness, and their professionalism. All they wanted was to be the best they could be, as artists and co-workers. I wanted to provide whatever they needed to accomplish that. They asked little and gave everything. Daniel and Joan wanted privacy; Daniel, particularly, to be left alone on the days he was working. He also insisted in joining the construction crew in building the John Proctor house (his character) on the location site. He worked with them for several weeks before his acting call date. At lunch, Daniel ate alone. Joan wanted to be given time to prepare, watch, and absorb so when she was on camera she was already on point. And Paul, dear Paul, had a few special food needs and his favorite British crossword puzzle. Although I still cannot fathom Daniel not being nominated for an Academy Award, Joan was nominated for Best Supporting Actress, and Paul Scofield won Best Supporting Actor from BAFTA, the British Academy Awards.

So what is producing? Perhaps the book has given some insight into the process, but the end result is always the same: a movie has been made. And now audiences everywhere will have the opportunity to share the experience until the end of time and beyond. What a profession. What a privilege.

A Few Final Thoughts

There's an old adage: a bad day of fishing is better than a good day at the office. I never felt I worked in an office. I lived in a world of ideas and possibilities not confined by four walls. What a privilege.

You know how sometimes on a flight the person sitting next to you wants to get acquainted by asking what you do for a living? I find the best way to discourage this is to simply admit I run a funeral home just outside St.Paul, Minnesota. Or sometimes I'm a dentist. That usually ends the conversation.

Jack Pearl, an old vaudevillian, once said, "It takes thirty years to become an artist and thirty seconds to become a critic."

I take special delight seeing pictures in which I was involved used as a frame of reference: *A Hard Day's Night* as a cultural signpost in a *New York Times* editorial, the impact of *Women in Love* on Alan Bennett in his autobiography, seeing movies (all UA, not that he knew - he just chose them) mentioned as Paul Theroux's well-needed break on his journey through Africa, and this list goes on and on.

I really miss those dinners with Herb Gardner, Paddy Chayefsky, Bob Fosse, and Sam Cohn. Well, maybe at some future date, somewhere.

I have always respected, enjoyed and learned from the critical writings of Clive James and Pauline Kael, even when I disagree.

Consider this: the combined negative cost of these movies from the 1960's and 1970's - *Dr. No, A Hard Day's Night, Last Tango in Paris, Lilies of the Field* and *Never on Sunday* - was less than two thirty-second spots on the 2013 Super Bowl. That's right - the entire negative cost of those movies, less than two thirty-second spots on the Super Bowl. Times have changed.

I grew up in what was, in my opinion, a watershed time in creative filmmaking. United Artists put a wedge in the studio control of content in the mid-twentieth century, but eventually it, too, succumbed to the financial support provided by institutions that didn't comprehend the nature of the businesses they acquired. As delivery methods expanded, soon the very nature of the film business changed. The studios became part of larger corporate entities which looked at movies as a marketing tool to a larger end than the movie itself. The movie became not the message, but the route to the next TV series, amusement-park ride, almost a product placement in and of itself. And the audience to be reached became younger and younger. Surely there still exists, and hopefully always will, a vibrant independent film business, but the fiscal challenge, and complexity, as well as the enormous marketing costs attached to any film occasions the brave auteurs to fight an unending and merciless battle to bring their art to life.

My commitment to the Producers Guild of America, and in particular the Producers Guild East, is a source of pride and pleasure. The organization has succeeded in appropriately identifying and recognizing those who actually do the work of "the producer" on a film.

So where's it going? To movies shown on a 3"x4" iPhone, or streamed on your laptop or wristwatch? Will there always be a screen watched by 900 pair of eyes held in total absorption by the creative efforts of a group of dedicated artists? I surely hope so. We can't lose the experience of watching movies in the shared

environment of a darkened theater. After all, they are everybody's business.

On a long flight some years ago I started to write a list of people who were part of my movie life. After many pages I realized there were tears in my eyes. Their names are in this book.

The End. That's what it says at the end of most movies, but of course movies never end. They live forever. *And that's what makes them so special.* But, first there's much to do. Another book I plan to write, some movies I'd like to produce, and, of course, many movies to see. How lucky can anybody be?

About The Author

DAVID V. PICKER is a third generation motion picture executive, as well as an Oscar, Emmy, and Golden Globe nominated producer. He has been President of three major film studios - United Artists, Paramount, and Columbia - and responsible for such iconic films as *TOM JONES*, the JAMES BOND series, The Beatles' *A HARD DAY'S NIGHT* and *HELP!*, *MIDNIGHT COWBOY*, *LAST TANGO IN PARIS, LENNY, THE CRUCIBLE, THE JERK*, and many others. Among the many European filmmakers he brought to United Artists were Federico Fellini, Ingmar Bergman, Francois Truffaut, Louis Malle and Sergio Leone.

Mr. Picker is a member of the board of The Producers Guild of America and is Chairman Emeritus of the Producers Guild of America East. He has also served on many boards and committees, including The American Film Institute, The Brooklyn Academy of Music, The Board of Overseers of The Hopkins Center of the Performing Arts and The Hood Museum of Dartmouth College.

Index

CPSIA information can be obtained at www.ICGtesting.com
Printed in the USA
LVOW12s1545240214

374967LV00020B/1632/P